THE
DOGIST

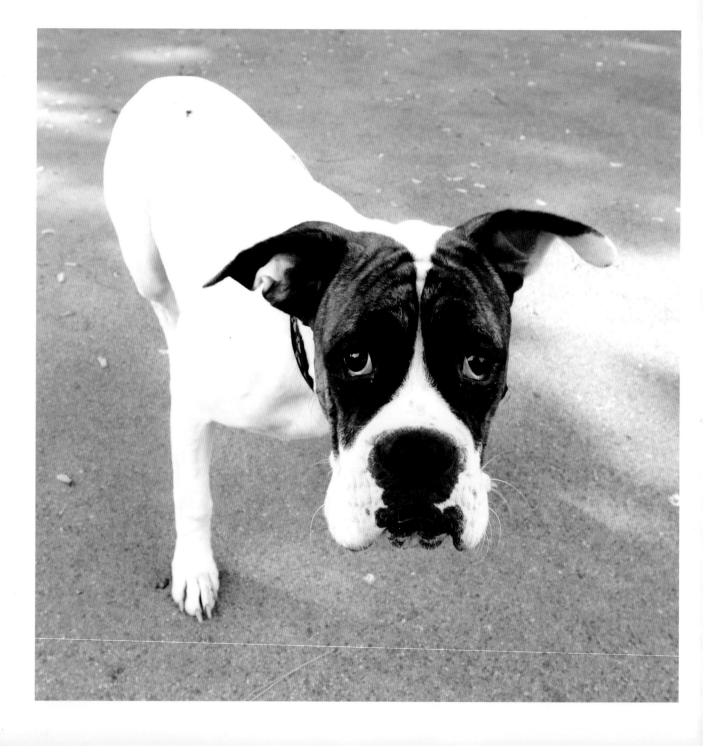

PHOTOGRAPHIC
ENCOUNTERS WITH
1,000 DOGS

THE
DOGIST

ELIAS WEISS FRIEDMAN

ARTISAN

NEW YORK

Library of Congress Cataloging-in-Publication Data is on file.

ISBN 978-1-57965-671-3

Design by Toni Tajima

Artisan books are available at special discounts when purchased in bulk for
premiums and sales promotions as well as for fund-raising or educational use.
Special editions or book excerpts also can be created to specification. For details,
contact the Special Sales Director at the address below, or send an e-mail to
specialmarkets@workman.com.

Published by Artisan
A division of Workman Publishing Company, Inc.
225 Varick Street
New York, NY 10014-4381
artisanbooks.com

Published simultaneously in Canada by Thomas Allen & Son, Limited.

Printed in China

First printing, September 2015

10 9 8 7 6 5 4 3 2 1
1 3 5 7 9 10 8 6 4 2
1 2 3 4 5 6 7 8 9 10

To the dogs I've met and the people who love them

Introduction

Dogs are fascinating on so many levels. They are one of the only species of animal that will look you in the eye to show affection. They can do all kinds of specialized tasks and jobs. Dogs make their humans' lives better in countless ways. A dog is unfazed by the things we stress about, keeping its owner even-keeled. A dog gets you out of the house and introduces you to new people and new places that you might otherwise never encounter. They bark, they crap, they shed, they get themselves into trouble, and yet we love them despite all of that because they love us, too, unconditionally.

Dogs have always been one of my obsessions. Once when I was a toddler and my grandmother was watching me, she went inside to grab a coat, and when she returned, I had vanished. The police were called; my family thought the worst. As it turned out, I had simply decided to go for a walk with my grandmother's black Lab, Oreo. I was eventually spotted on a busy street by a roofer working nearby: Oreo was walking street-side, keeping me out of harm's way.

When I was growing up, my family had bunch of dogs. Ruby, a portly black Lab, was mine. I was a shy kid, and she was my best friend. Over the years, my parents and my other immediate family members got many more dogs—Matilda, Snowy, Maggie, Rigby, Biggie, Bialy, T-Paws, and Willy (not to mention the litters they had). Dogs were always an essential part of our household, and it never occurred to me that my life *wouldn't* include dogs.

When I moved to New York City after college, I missed having a dog—*dogstalgia*, I call it. Many of my family's dogs had passed away, and I was living on my own in another city. As anyone who has walked down a New York City street on the weekend knows, dogs are everywhere, and I was constantly reminded of how awesome dogs are. They make every aspect of life better. Yet I knew that having a dog of my own in

New York City wouldn't make sense until I could figure out how to take care of myself, but I hoped that in the meantime I could enjoy the next best thing: other people's dogs.

"Dog photographer" wasn't one of my career options growing up. I come from a family of physicians and scientists, and although it was never said, there was always that inevitable pressure on me as the oldest son to pursue a conventional career. While I entertained the idea of being a doctor, it never really made sense to me. Why couldn't I have a career that allowed me to have fun every day, travel the world, meet interesting people (and animals), make art, and get paid to do it?

I started taking photos at a young age with simple cameras like Polaroids and disposables. I always loved shooting pictures; as a shy kid, holding a camera gave me a sense of purpose. When we were growing up, my dad would photograph each of my siblings and cousins with his Rolleiflex, and I eventually became curious about what he was doing in his darkroom. I got my first *real* camera—a Nikon FG—when I was 12. Over the next 10 years I spent a good deal of time in the darkroom, too. I taught a photography class for teens, and I made prints, most of which, at the end of the day, weren't anything remarkable. The only images I ever liked enough to frame were of my black Lab, Ruby.

I moved to New York City after attending college in Boston. I started working at a big-brand strategy agency. For two years I worked on the accounts for all types of mega-brands and learned the importance of simplicity in storytelling. I learned so much, but I never felt like I was giving it my all. Then, after a round of layoffs, I found myself, for the first time in my life, at age 25, completely removed from any obligation. I had no boss, no imminent tasks, no need to put on a collared shirt. It felt awesome (and a bit scary). Yet I felt in my heart that this was the moment I had been waiting for from the time I was a kid— finally, an opportunity to do whatever the heck I wanted.

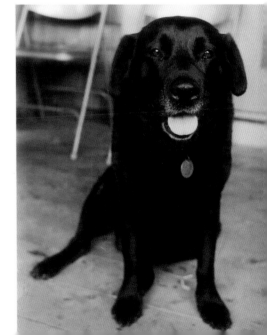

Ruby, *Labrador Retriever*

My friends were all designers and engineers at various startups in the city, and I had always been envious of their sense of daring creativity and autonomy. After relaunching and selling a company, Wefollow, with my close friends Adam and Jeff, I was hooked. There was no way I saw myself going back to the corporate job circus, at least not willingly. I turned my focus, literally and figuratively, back to dogs.

I started a web-comedy series called *Barking at Dogs* with my buddy Pasquale, who is a staunch believer in the viability of ludicrous ideas. We walked around New York City interviewing people's dogs on world news and topical issues, after which I would subtitle in my interpretation of their responses. I had always spoken on my dogs' behalf as a kid, and I was now revisiting a part of my brain that had been suppressed by the expectations of adulthood. I loved having dogs back in my life, but I also knew the series couldn't support me.

In the midst of coming to terms with my status of being, as my friends liked to put it, "the unemployed loser," I booked an extended trip through Europe. Toting along my Nikon D600, I rediscovered something else I loved from my childhood: taking dog portraits. I came across a very funny-looking Boxer in Vienna. I got down on one knee and had a photographic standoff that resulted in a very dubious-looking portrait. I posted it to Instagram and noticed that it earned more likes than anything else I had posted. "Of course!" I thought, "People love dogs!" It was the beginning of what would come to be my resurrection as a photographer.

A week later, I woke up in the middle of the night with an idea: "What if someone could do *The Sartorialist* for dogs? Like . . . *The Dogist*?" I checked to see if the name was available, snagged it across several platforms, bought the .com, and went back to sleep.

A few weeks later I was strolling around Williamsburg, Brooklyn, and snapped a photo of a brindle Frenchie. "What's this for?" his owner asked. "The Dogist," I said. It just felt right. The next day I made my first posts—the nameless Viennese Boxer, followed by the hipster Frenchie.

I knew from day one that the blog would catch on. Nobody was telling this awesome story! Everybody sees beautiful dogs strutting down the streets, and we are all

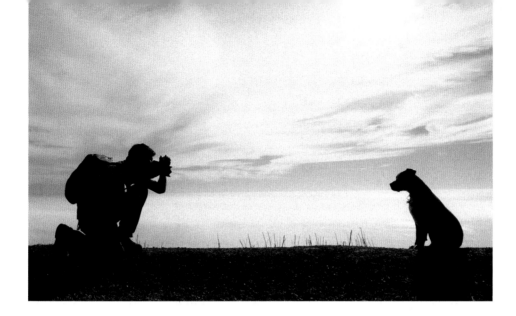

painfully curious about the dog and that dog's story. Armed with a camera, a squeak toy, kneepads, and a crazy idea, I decided that The Dogist would be my project, and *I* would tell the dogs' stories.

I started photographing 20 to 30 dogs a day. I developed a signature style—isolated focus on the eyes. A sensation started to emerge about my images: it seemed like the dogs *knew*. It felt like the dogs understood that I was a photographer, and they obliged me by posing for the camera. Just as I had done with *Barking at Dogs,* I was personifying dogs, but now with portraits.

The blog got some press and traction immediately—suddenly I had 50,000 followers. Everything in the media is so serious; I was happy to be putting smiles on people's faces. Not only was I giving owners a nice photo of their dog, but I was making the dog famous! My joke of a life was turning into a *good* joke that I was in on. My work took on a new sense of purpose: entertain people every day by telling the story of dogs, and in doing so, become the definitive dog photographer.

Soon I started noticing nuances in dogs that had never occurred to me and breeds that I didn't know existed. A Norwich Terrier's ears point up, while the Norfolk's ears point down. Corgis can be either Pembroke or Cardigan. One breed can come in

For the gear nerds out there, here's what I currently use.

- Nikon D750
- Nikon 24, 35, 58, 85mm (F1.4), 14-24mm (F2.8), and 16mm (F2.8) Fisheye lenses
- Right-angle viewfinder (it's a neck saver when shooting small dogs)
- Adobe Photoshop Lightroom
- iPad mini
- Kong Air Dog Squeakair Ball
- Salomon Quest boots (or anything with a rubber toe rand)
- Alta kneepads

various sizes, like standard, miniature, and toy. A dog's coat can have all sorts of patterns and colors: brindle, harlequin, dappled, merle, mantle, tuxedo, tricolored, fawn, ruby, liver, black, yellow, chocolate, and wheaten. Some dogs are hairless. Some have eyes of different colors (it's called heterochromia). So many breeds can be crossed with poodles to create "doodles." I've met drug and explosives detection canines, guide dogs, medical alert dogs, therapy dogs, and search and rescue dogs. I've spotted rarer breeds, like the PBGV, Bergamasco, Kleine Münsterländer, Tamaskan, Belgian Malinois, Tervuren, Bouvier des Flandres, Xoloitzcuintli, Komondor, Kerry Blue Terrier, Catahoula Leopard Dog, Thai Ridgeback, Lagotto Romagnolo, and Barbet. Some dogs come from breeders and others are rescues.

I can go on about my admiration for dogs, but the images I've put together in this book tell the story better. I've met thousands of dogs, and I've gathered an audience of dog lovers that grows incredibly every day. I don't see myself ever stopping; I love it too much, and the story keeps getting better.

People ask me how I get the dogs to look so good in the photos. There are a few things I've learned as a professional dog photographer. I'm happy to share a few tips so dogs everywhere can look their best in front of the lens.

The Dogist's Ten Commandments of Dog Photography

1. Establish basic trust between yourself and the dog. Let the dog smell you.
2. Get down to the dog's level.
3. Have something the dog wants, like a treat or a toy.
4. Move that thing around the lens.
5. Learn to bark and make strange noises to get different facial expressions.
6. Underexpose for black dogs.
7. Have patience. Every dog is different and some may require more time.
8. Practice, practice, practice. I still learn something new every day.
9. Don't wear anything you wouldn't want a dog toenail to go through.
10. Reward a dog's efforts with a pet or a treat.

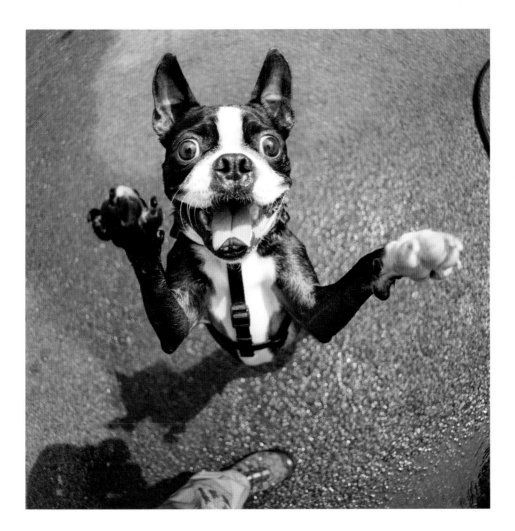

Piggy, *Boston Terrier, 2 years old*

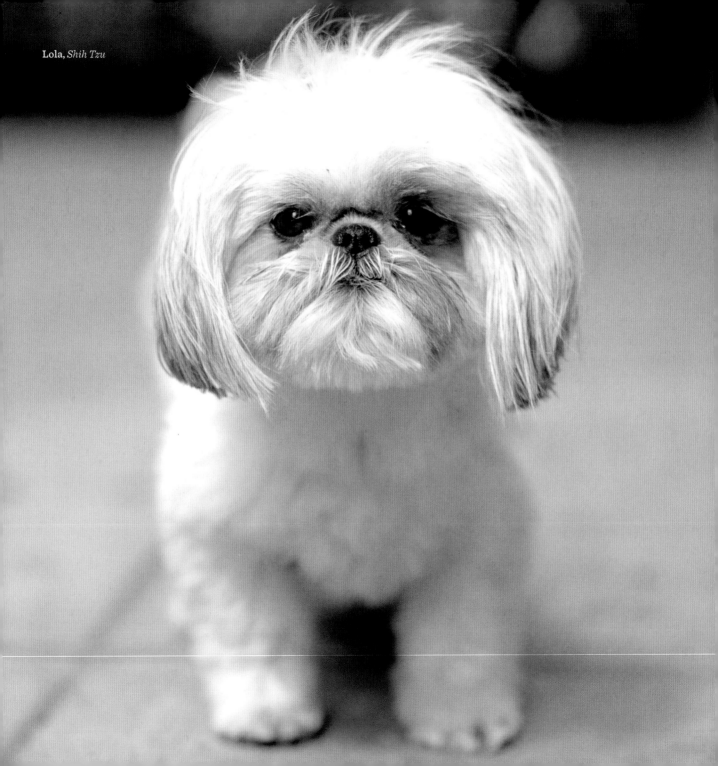

Lola, *Shih Tzu*

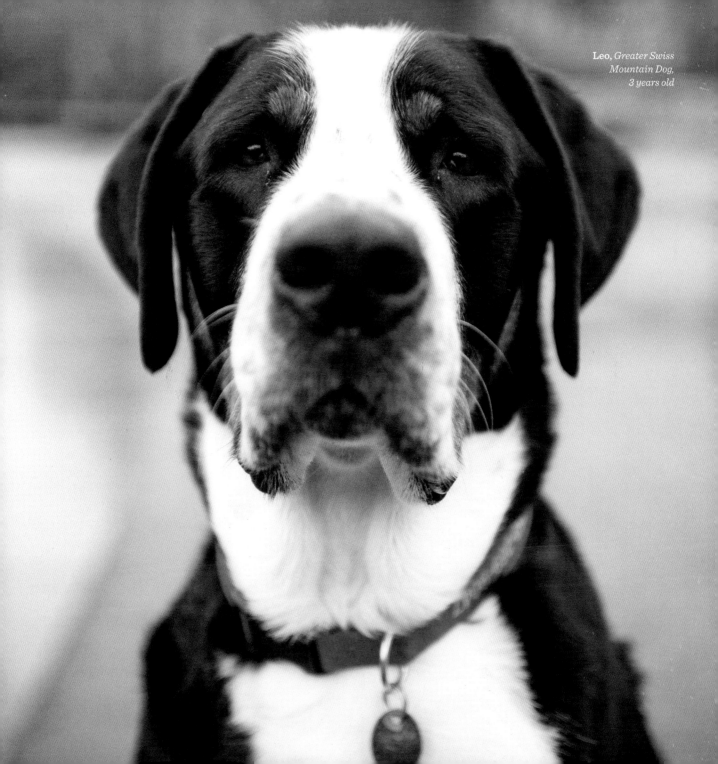

Leo, *Greater Swiss Mountain Dog, 3 years old*

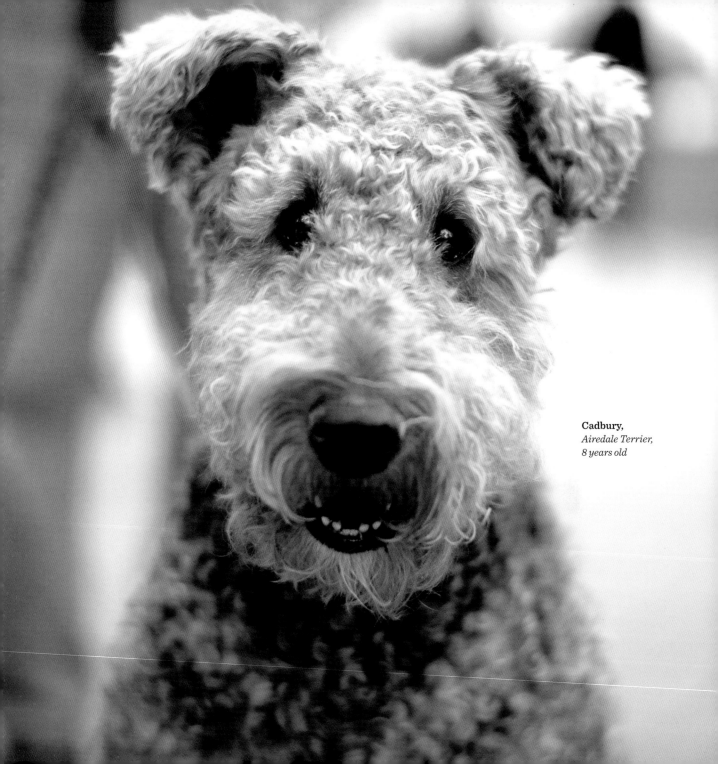

Cadbury,
Airedale Terrier,
8 years old

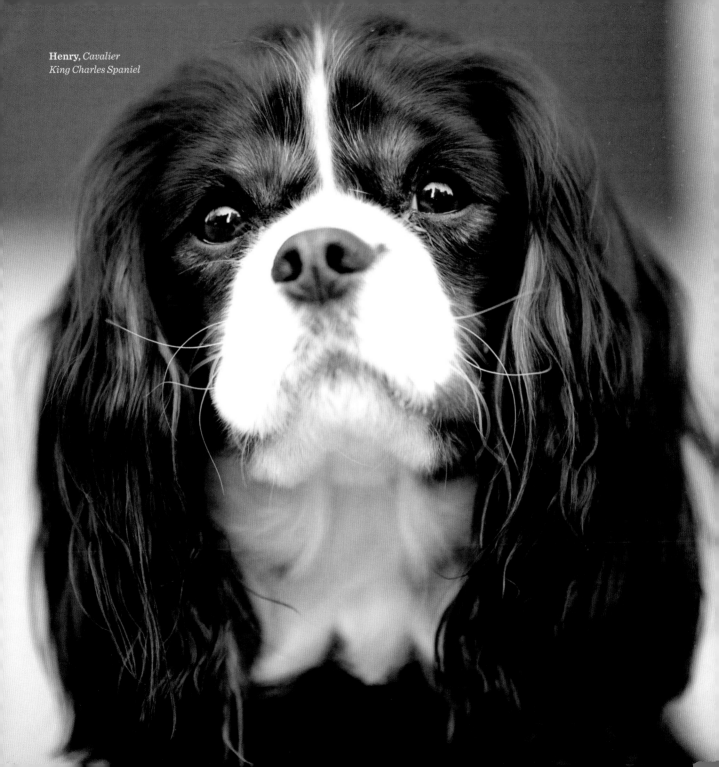

Henry, *Cavalier*
King Charles Spaniel

Puppies

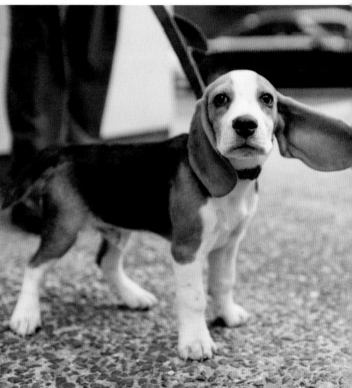

Dino, *French Bulldog, 3 months old*

"We're narrowing the names down," *Beagle, 3 months old*

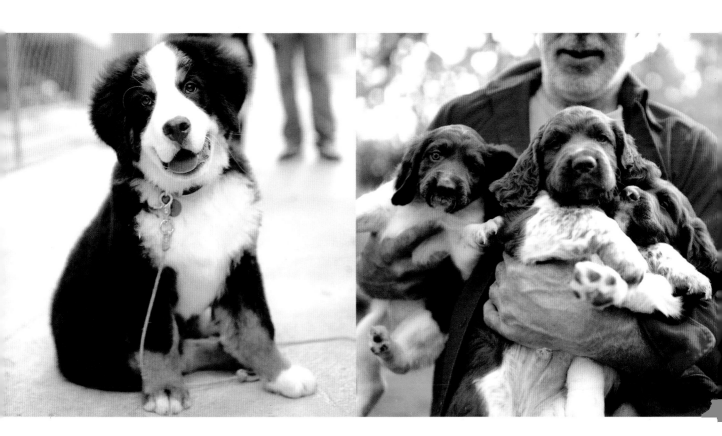

Thunder, *Bernese Mountain Dog, 2 months old*

Kleine Münsterländers, 2 months old

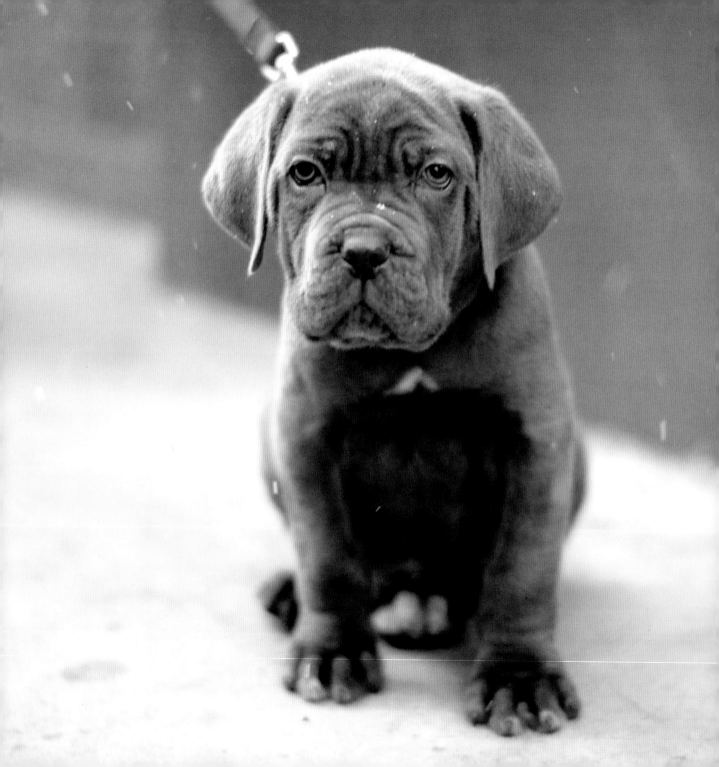

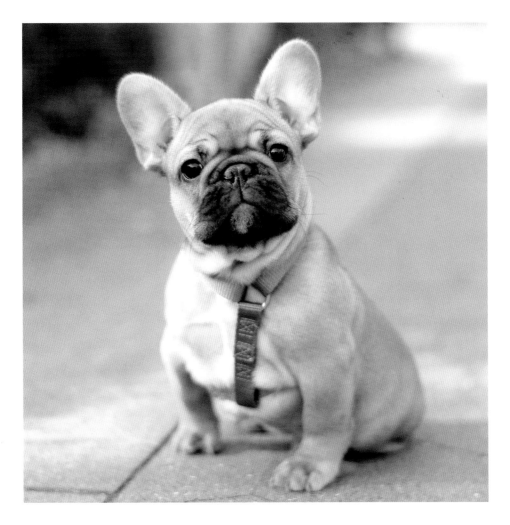

Theodore James Franco Gatsby,
French Bulldog, 2 months old

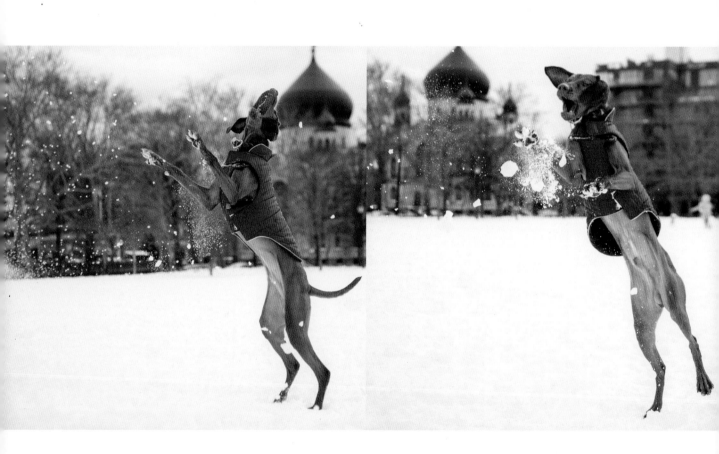

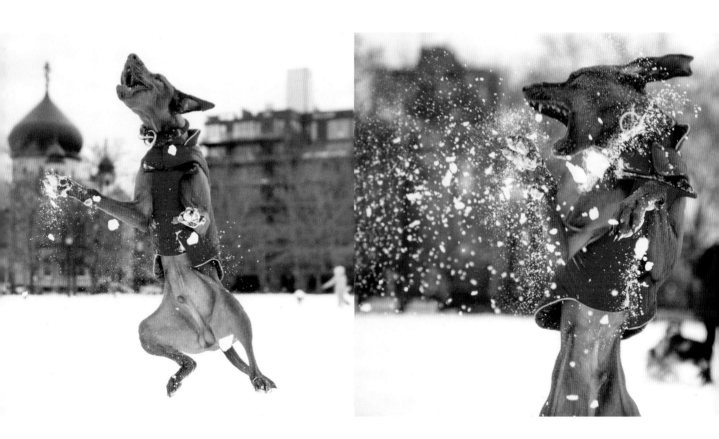

Carrick, *Vizsla,*
8 months old

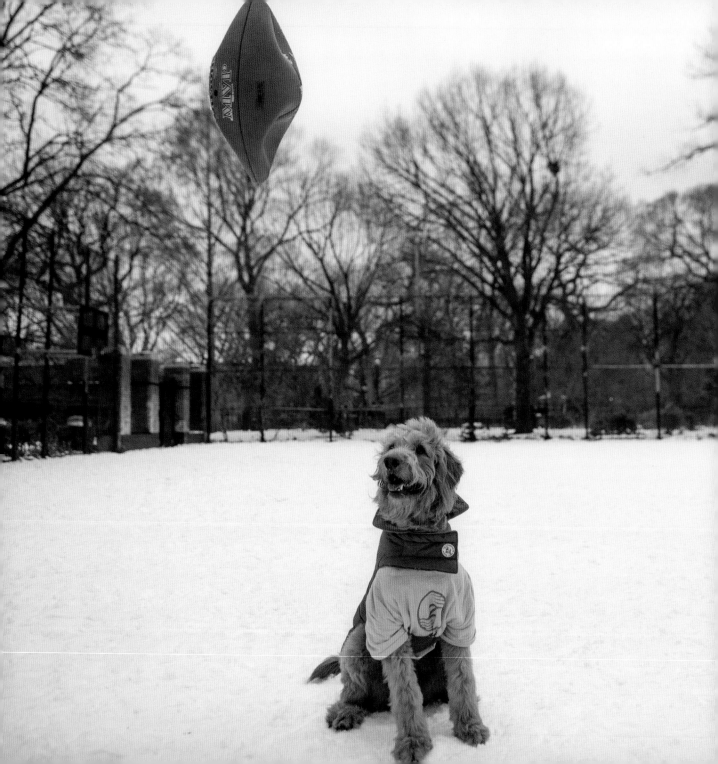

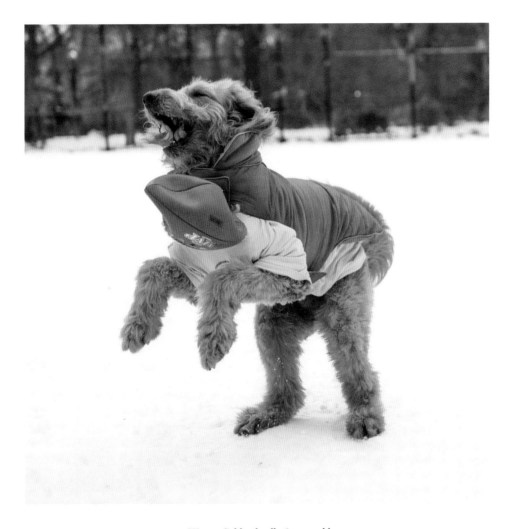

Wyatt, *Goldendoodle, 3 years old*

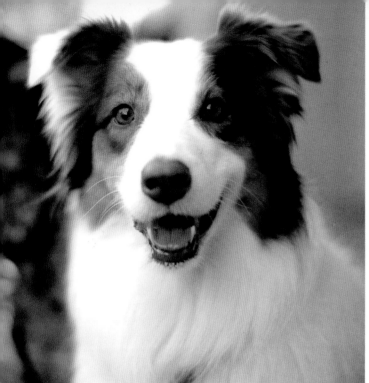

Smiles

TOP ROW,
LEFT TO RIGHT

Zebra, *Australian Shepherd, 5 years old*

Sirius, *Pembroke Welsh Corgi, 1 year old*

Lucy, *Weimaraner*

BOTTOM ROW,
LEFT TO RIGHT

Moose, *Bernese Mountain Dog, 8 years old*

Dog, *mix*

Delilah, *Rottweiler*

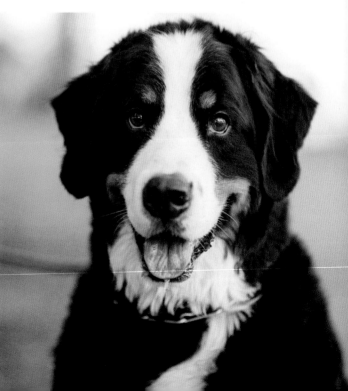

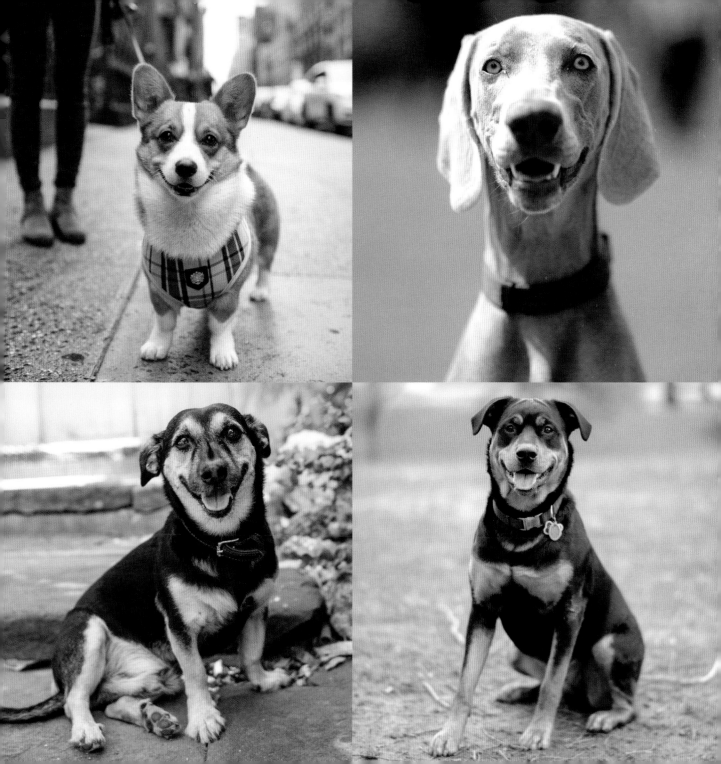

Beautiful Blends

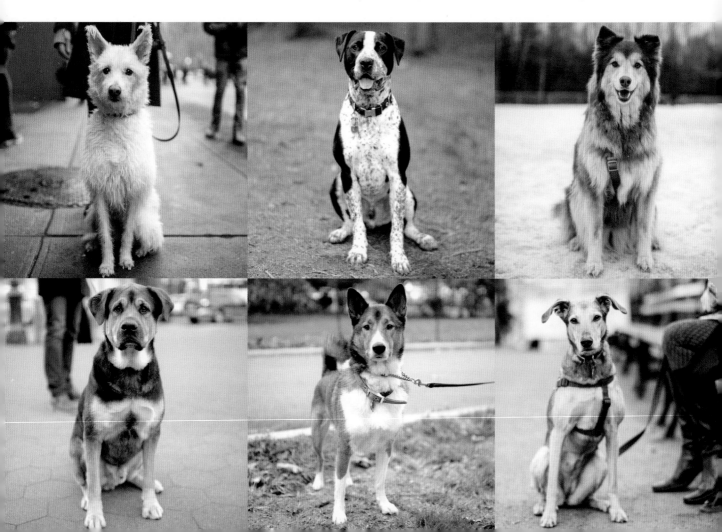

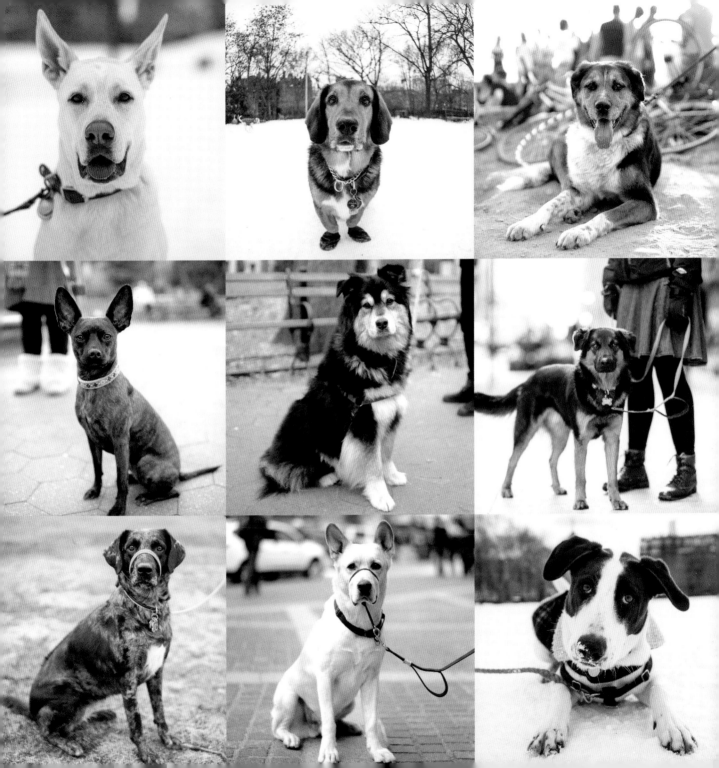

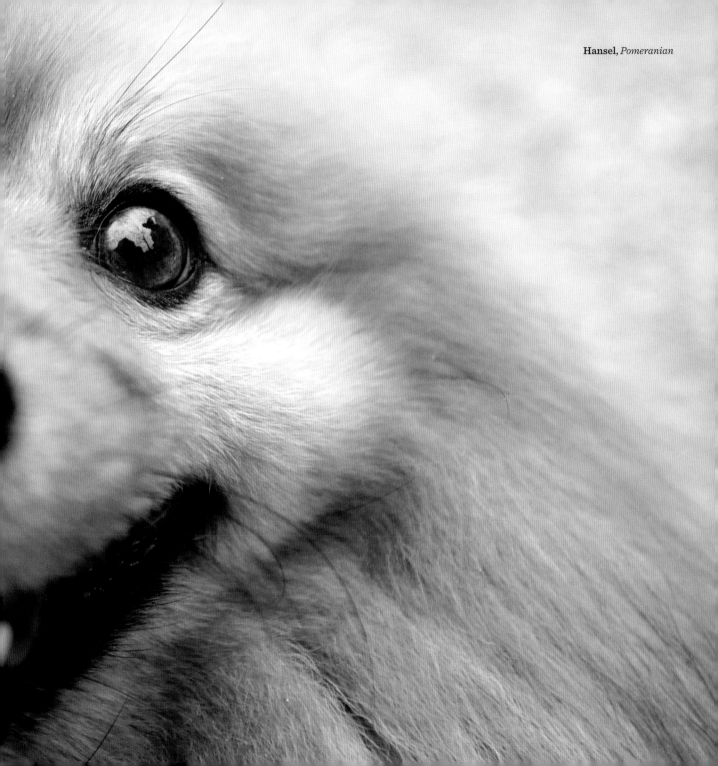

Hansel, *Pomeranian*

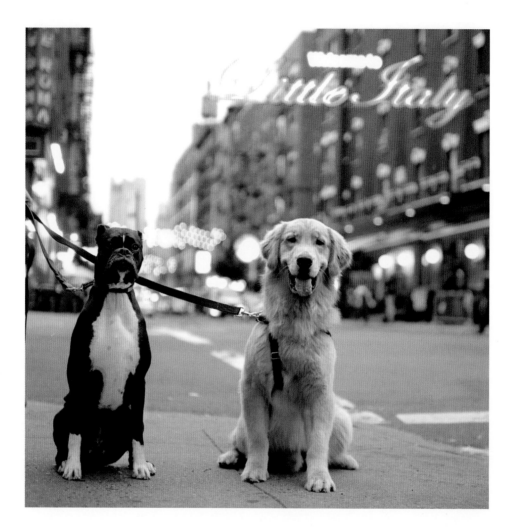

Coco and **Knox**, *Boxer and Golden Retriever*

"They're girlfriend and boyfriend."

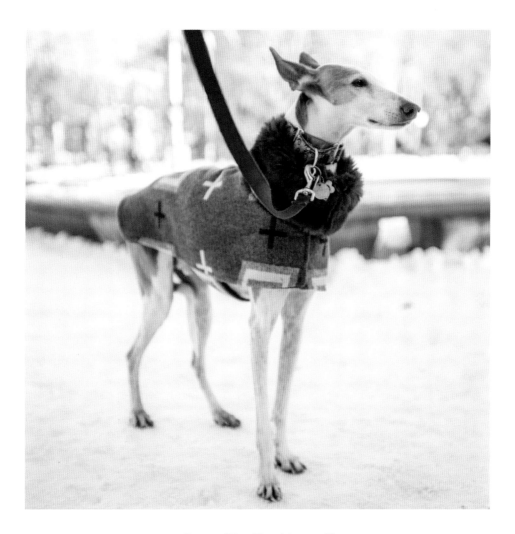

Deacon, *Ibizan Hound, 9 years old*

(shakes bag of treats)
"He's above that."

Pit Bulls

TOP ROW, LEFT TO RIGHT

Scout, *1 year old*

Hambone and **Petunia**

Prophet

CENTER ROW, LEFT TO RIGHT

Lionel

Luigi, *7 years old*

Luna

BOTTOM ROW, LEFT TO RIGHT

Buddy and **Sugar**

Patsy Cline

Finn Rizz

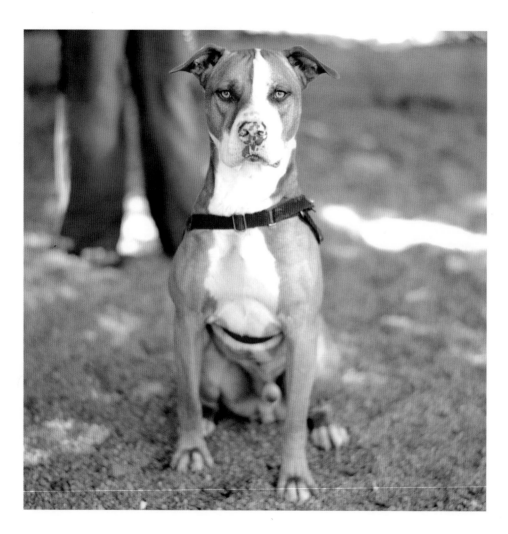

« Rayland

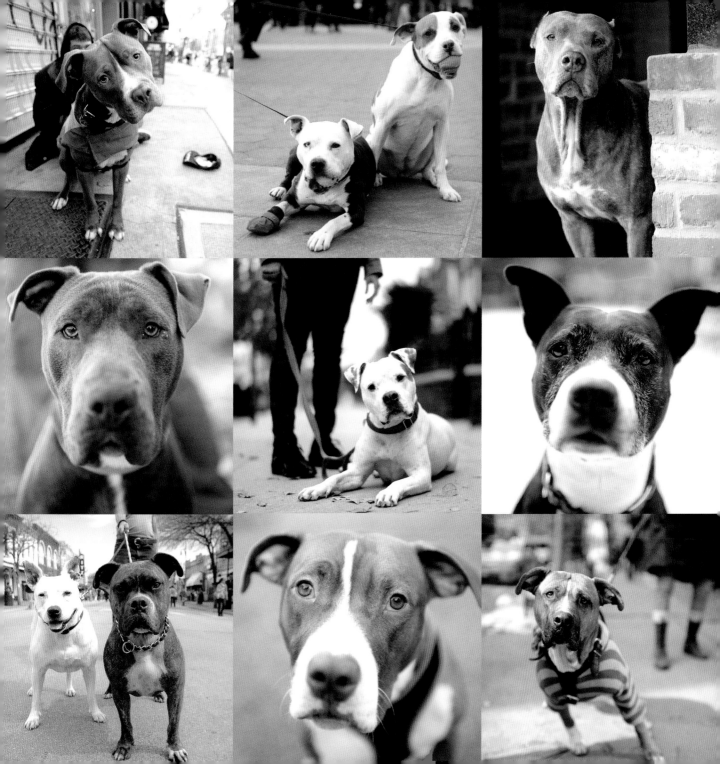

Pudding is a victim of breeding abuse. This was the first time I felt emotional about photographing a dog. Pudding had clearly suffered trauma in her past, and yet she had enough trust to sit for a complete stranger. It felt as if she knew who I was, and that she posed for the world to see her, thinking, "Look what they did to me." I realized that my images had the power to tell stories beyond words.

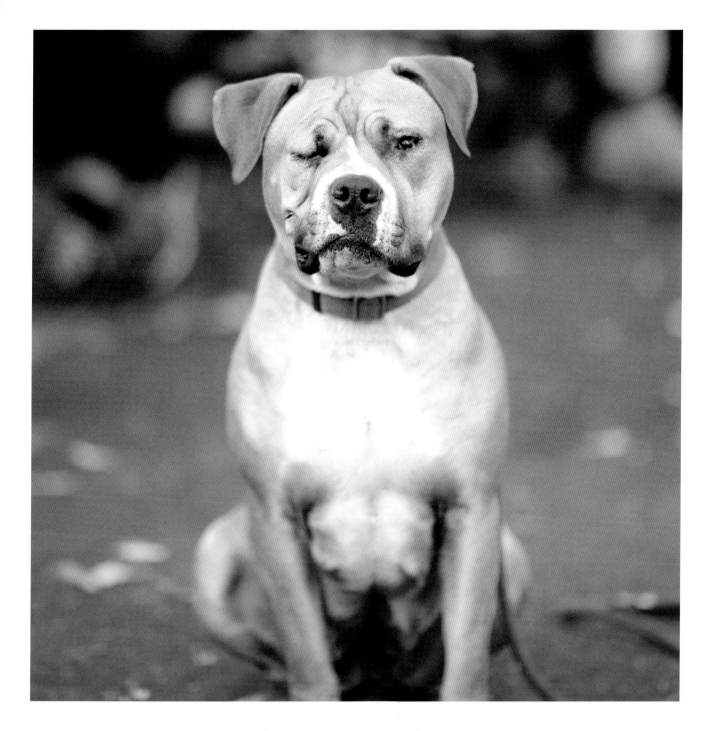

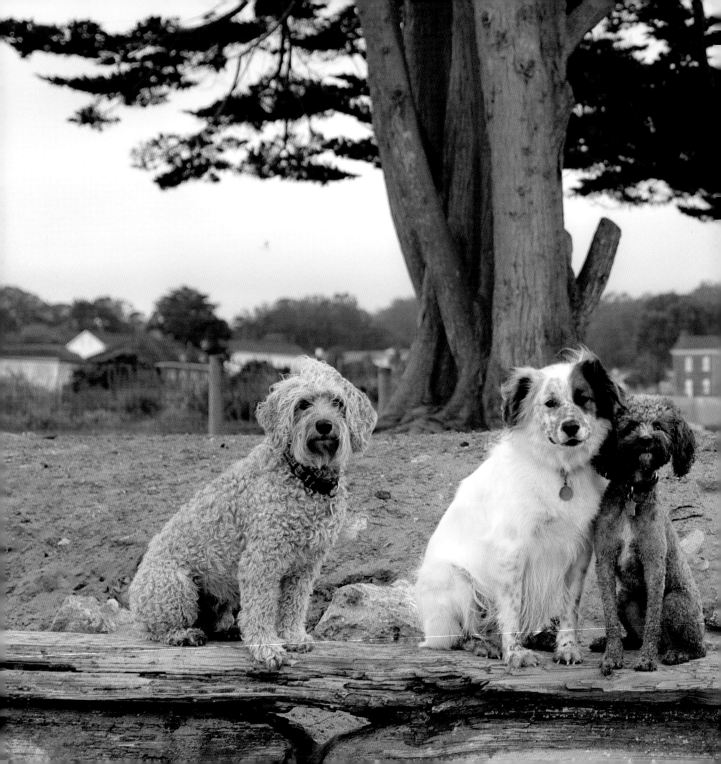

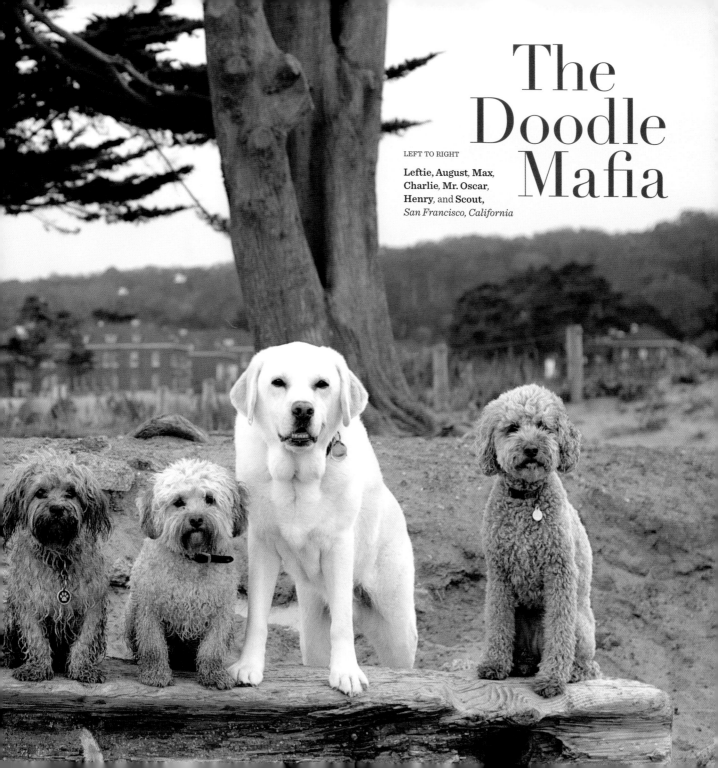

The Doodle Mafia

LEFT TO RIGHT

Leftie, August, Max, Charlie, Mr. Oscar, Henry, and **Scout,** *San Francisco, California*

Pairs

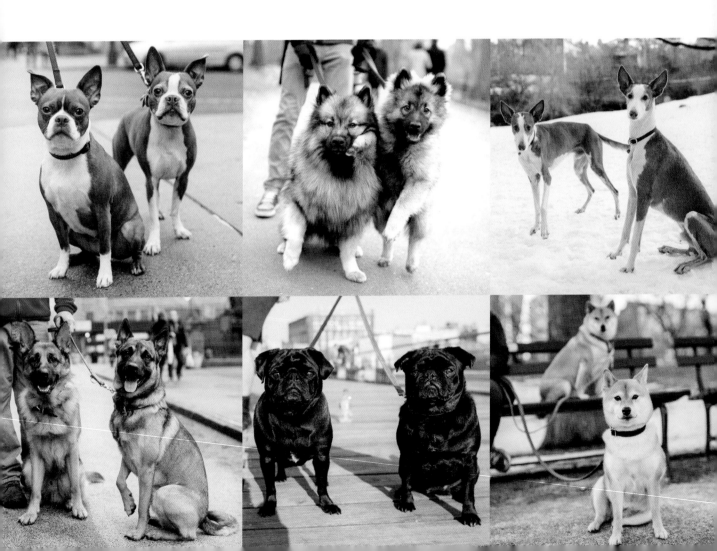

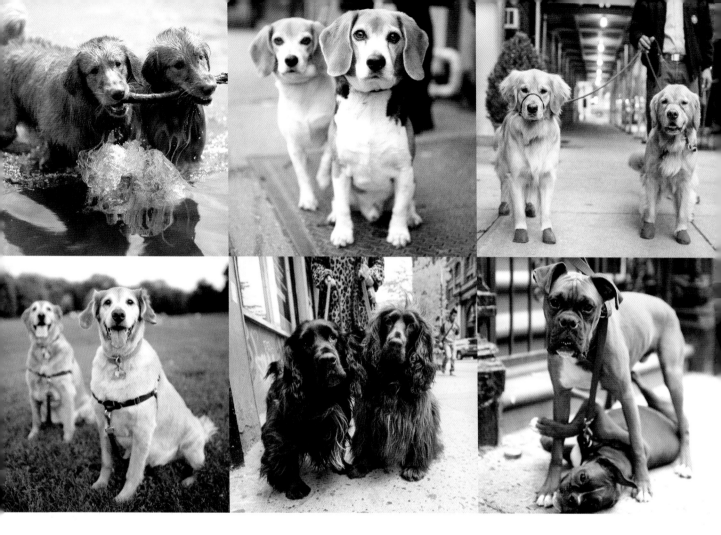

TOP ROW, LEFT TO RIGHT

Butters and **Athena,** *Golden Retriever/Hovawart mixes*

Hicks and **Big Time,** *Beagles*

Yack and **Obermeyer,** *Golden Retrievers, 2 years old*

CENTER ROW, LEFT TO RIGHT

Roxy and **Oliver,** *Boston Terriers, 3 and 5 years old*

Yoshi and **Waldo,** *Keeshonds*

Phobos and **Demos,** *Ibizan Hounds, 5 years old*

Fenway and **Yankee,** *Golden Retrievers*

Frankie and **Edith,** *Field Spaniels*

Charlie and **Bowie,** *Boxers, 6 and 8 months old*

BOTTOM ROW, LEFT TO RIGHT

Klaus and **Dax,** *German Shepherd and Belgian Malinois, 1 year old*

Olive and **Athena,** *Pugs, 3 and 4 years old*

Lily and **Dora,** *Shiba Inus, 3 and 2 years old*

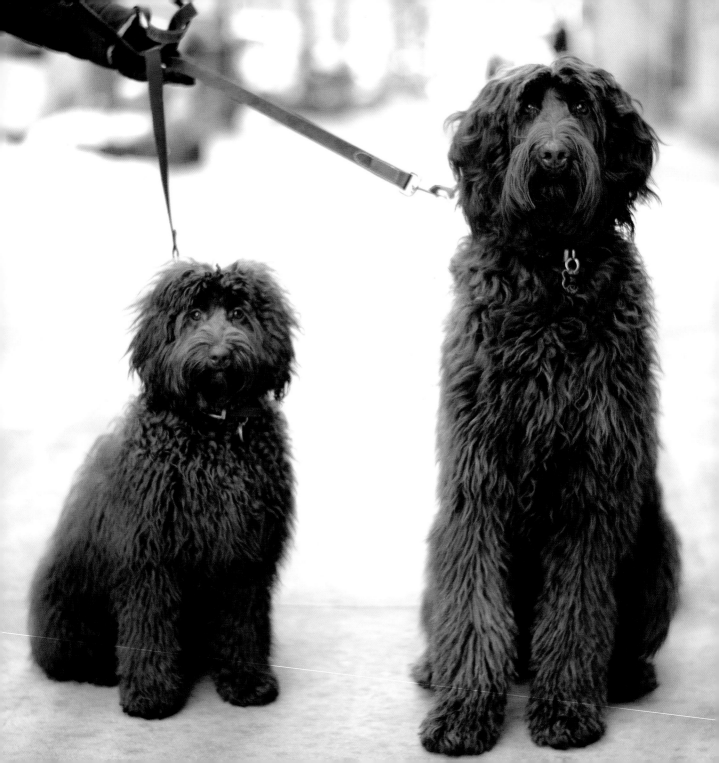

Big and Small

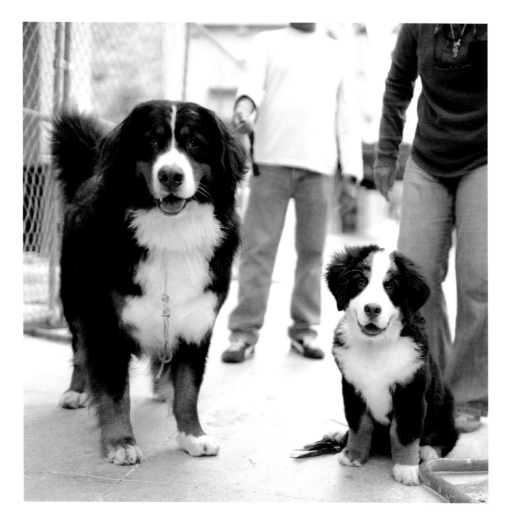

Sonny Jackson and **Thunder,**
Bernese Mountain Dogs

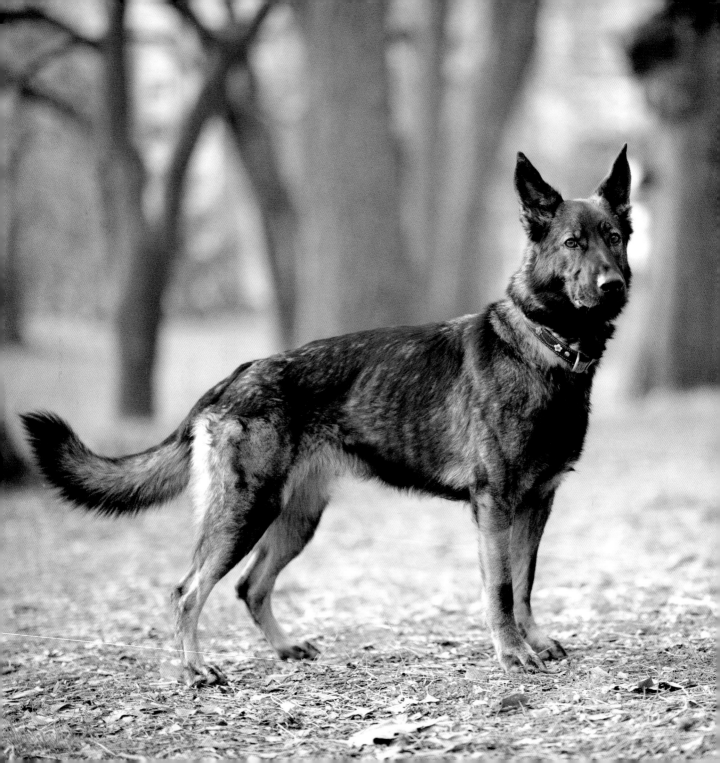

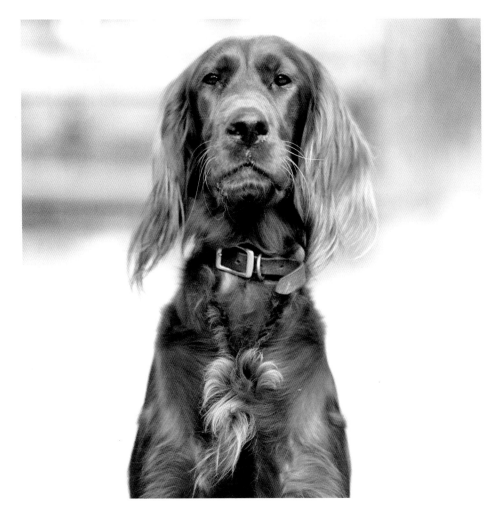

Rosie, *Irish Setter*

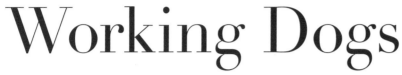

Working Dogs

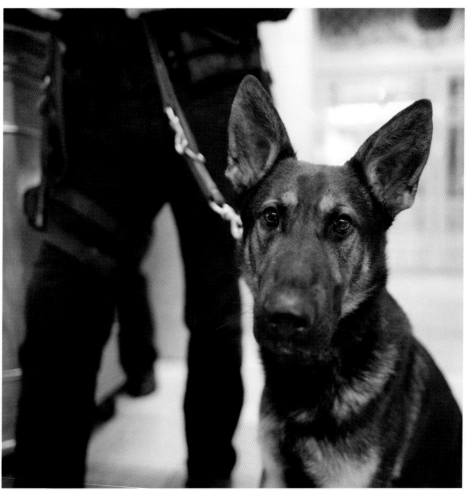

Johnny, *German Shepherd, MTA Police Department*
Explosives Detection Canine (EDC), Grand Central Station, New York City

TOP ROW, LEFT TO RIGHT

Officer Nico, *Belgian Malinois, NYPD K-9 Unit*

Nala, *Labrador Retriever, 6 years old, Amtrak Police, Vapor Wake Detection, 30th Street Station, Philadelphia*

Vixen, *Labrador Retriever, Amtrak Police EDC*

CENTER ROW, LEFT TO RIGHT

Ray, *Labrador Retriever, NYPD K-9 Unit*

Milo, *German Shepherd, MTA Police Department EDC, New York City*

Budo, *German Shepherd, 8 years old, Amtrak Police EDC, 30th Street Station, Philadelphia*

BOTTOM ROW, LEFT TO RIGHT

Rafferty, *Labrador Retriever, 8 years old, NYPD Bomb Squad EDC*

Lutsen, *German Shepherd, 4 years old, Avalanche Search and Rescue, Big Sky, Montana*

Tank, *German Shepherd, NYPD K-9 Unit*

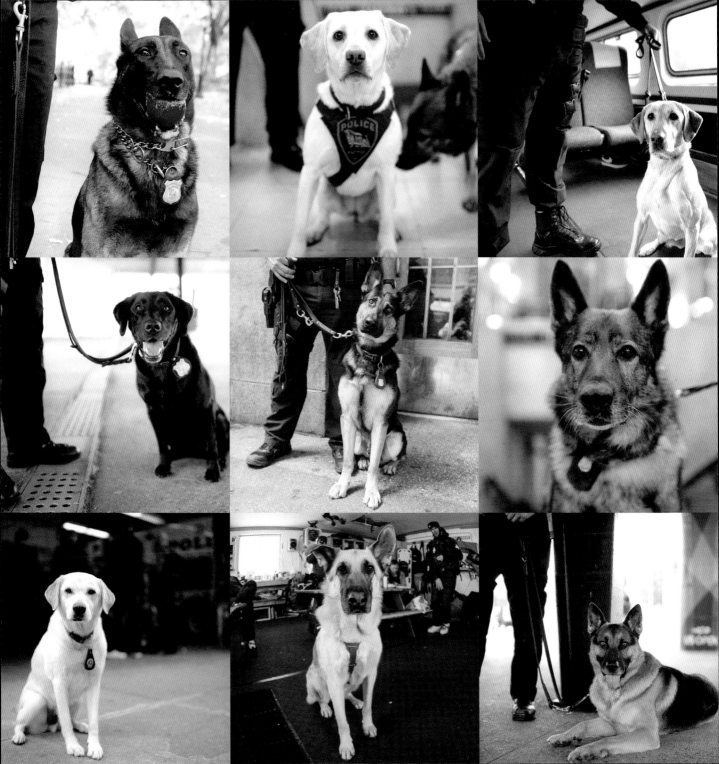

« Barney, *Labrador Retriever, EDC,*
Rockefeller Center, New York City

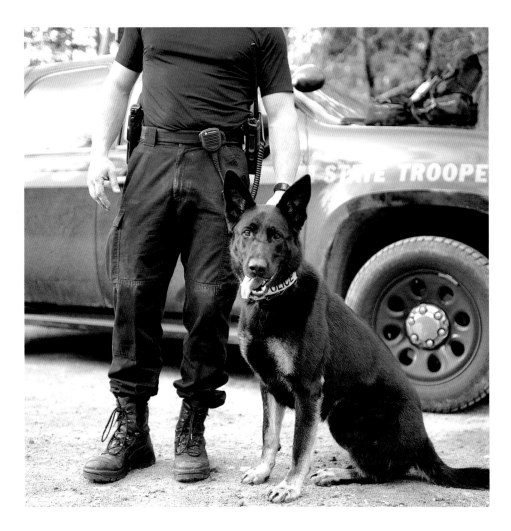

Trooper Dale, *German Shepherd, State Trooper K-9 Unit,*
Search and Rescue, Adirondack Loj, Lake Placid, New York

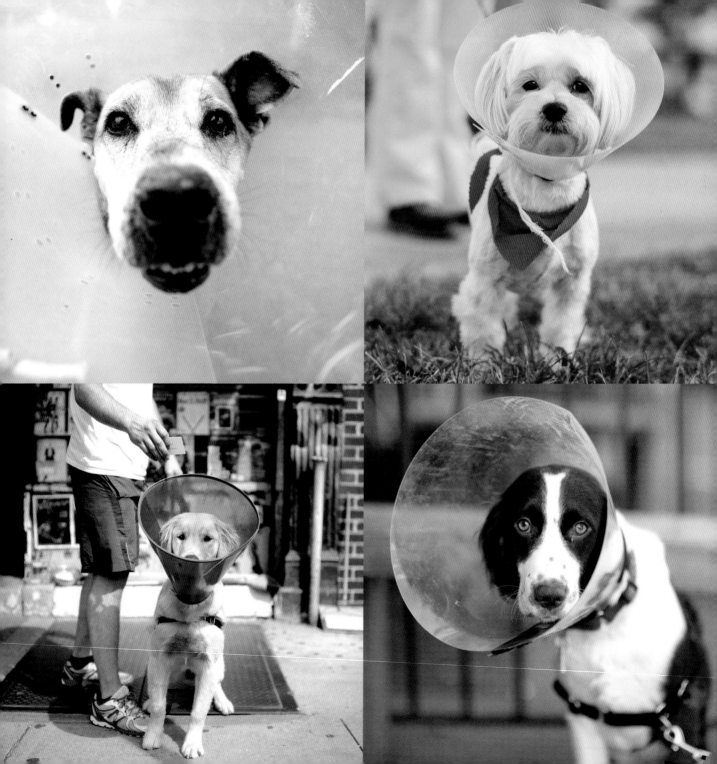

Lupo,
Shepherd mix

Snow,
Maltese,
3 years old

Jiggy,
Brittany/Springer
Spaniel mix,
6 months old

Barnaby,
Golden Retriever,
7 months old

Cones of Shame

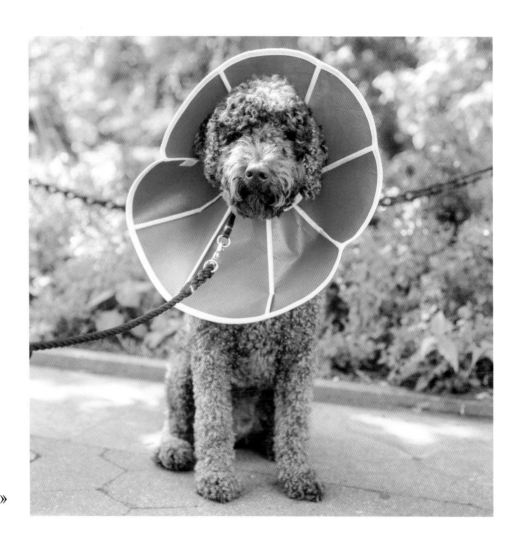

Kiko, *Labradoodle,* »
2 years old

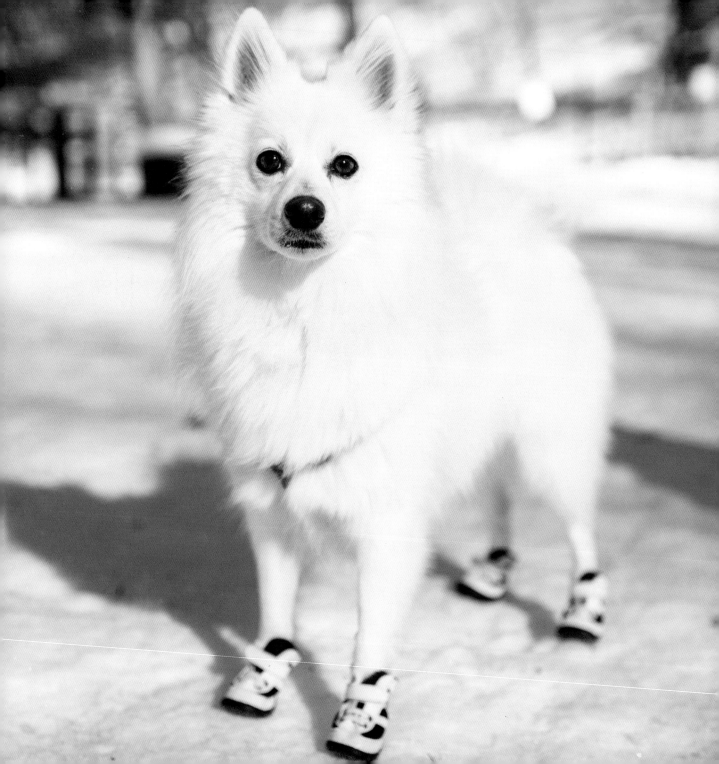

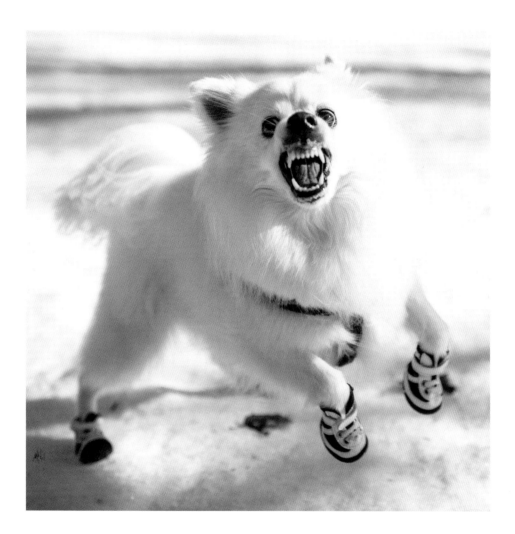

Zeus, *Japanese Spitz, 4 years old*

"He's shy."

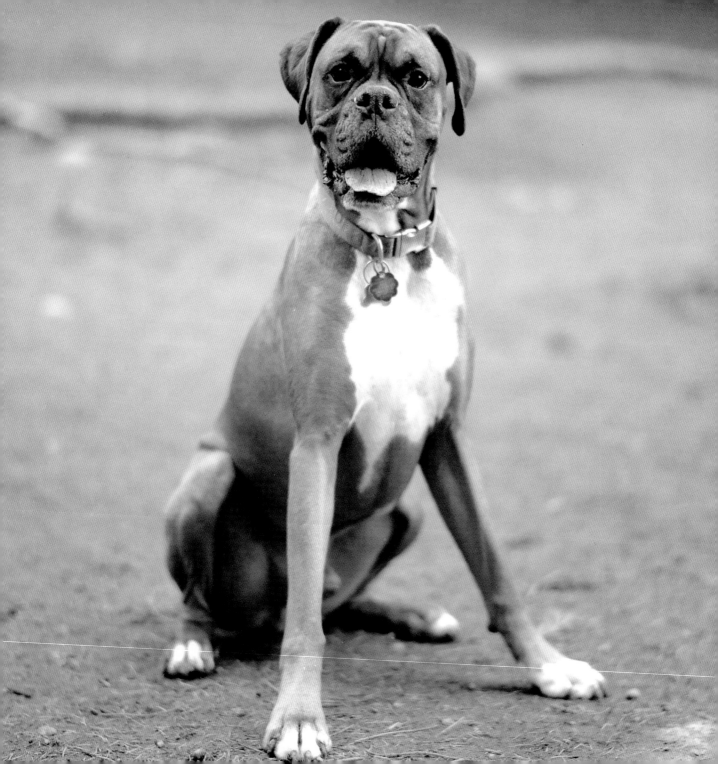

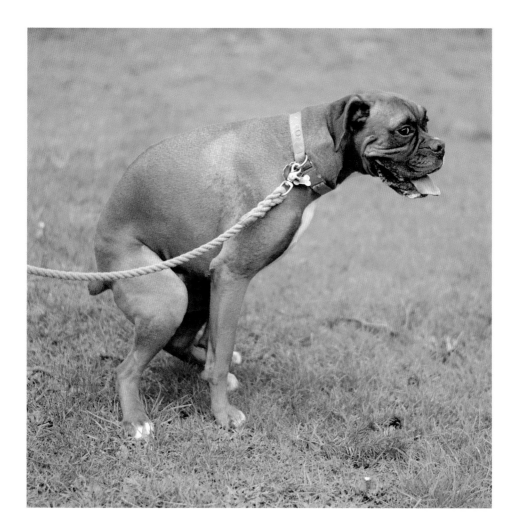

Cash, *Boxer*

He's not shy.

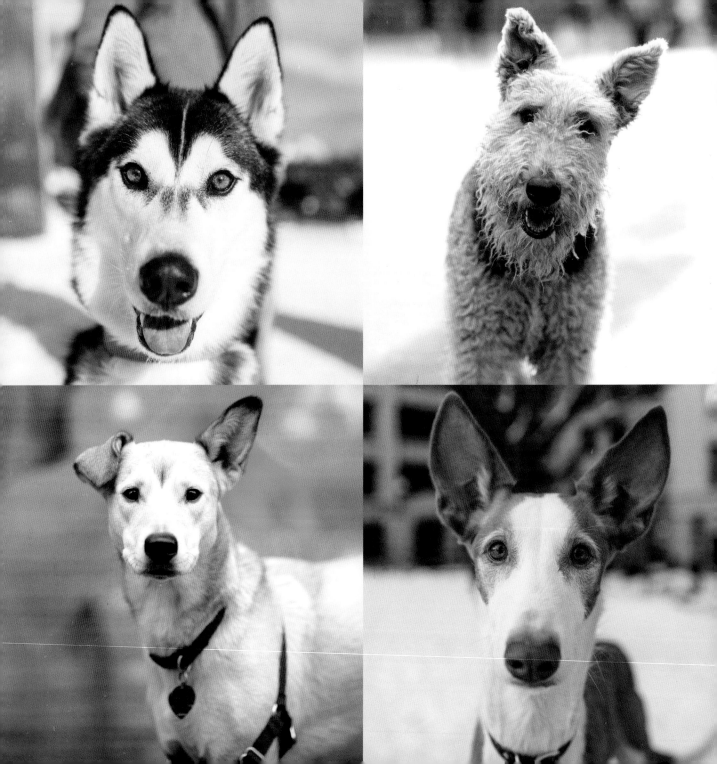

CLOCKWISE, FROM TOP LEFT

Tuck,
Siberian Husky,
3 years old

Alexandra,
Airedale Terrier

Demos,
Ibizan Hound,
5 years old

Ella, *mix*

Ears

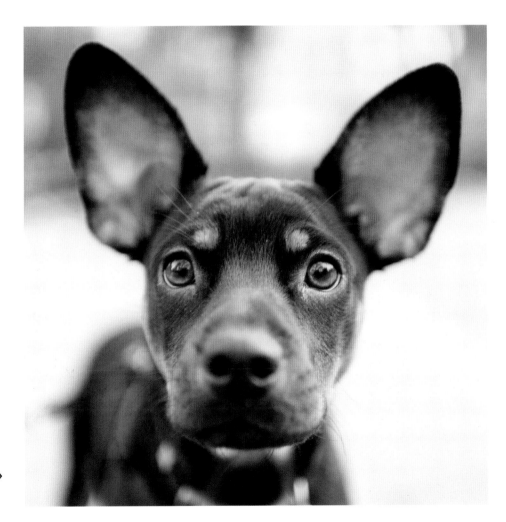

Bowzer, *Miniature* »
Pinscher mix,
4 years old

Eyes

TOP ROW, LEFT TO RIGHT

Dakota, *Cocker Spaniel;* **Bumi,** *Pit Bull/Boxer mix;* **Tiffany,** *Catahoula Leopard Dog mix, 5 years old*

CENTER ROW, LEFT TO RIGHT

Spike, *Siberian Husky;* **Frankie,** *Border Collie, 1 year old;* **Gerty,** *Border Collie, 1 year old;* **Nika,** *Siberian Husky;* **Ackee,** *Great Dane/ Weimaraner/Mastiff mix, 4 years old;* **Stark,** *Alaskan Klee Kai*

BOTTOM ROW, LEFT TO RIGHT

Scout, *Australian Cattle Dog;* **Gunnar,** *Alaskan Klee Kai, 1 year old;* **Summer,** *Weimaraner, 2 years old;* **Shaggydog,** *Australian Shepherd mix, 2 years old;* **Dallas,** *Boxer mix;* **Skye,** *Siberian Husky*

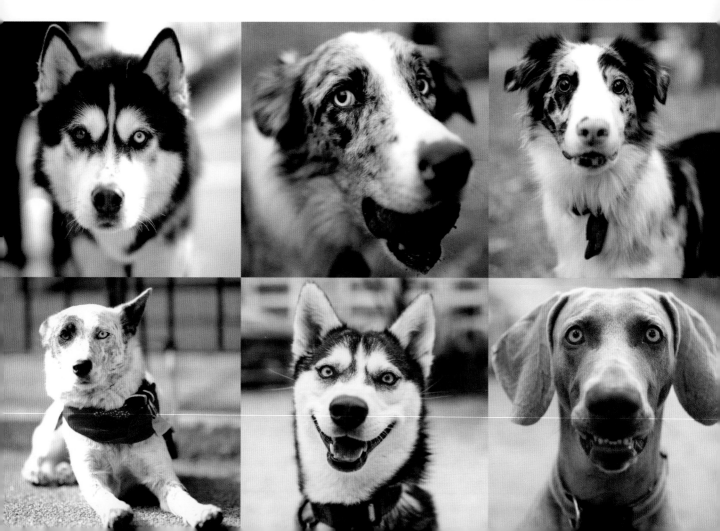

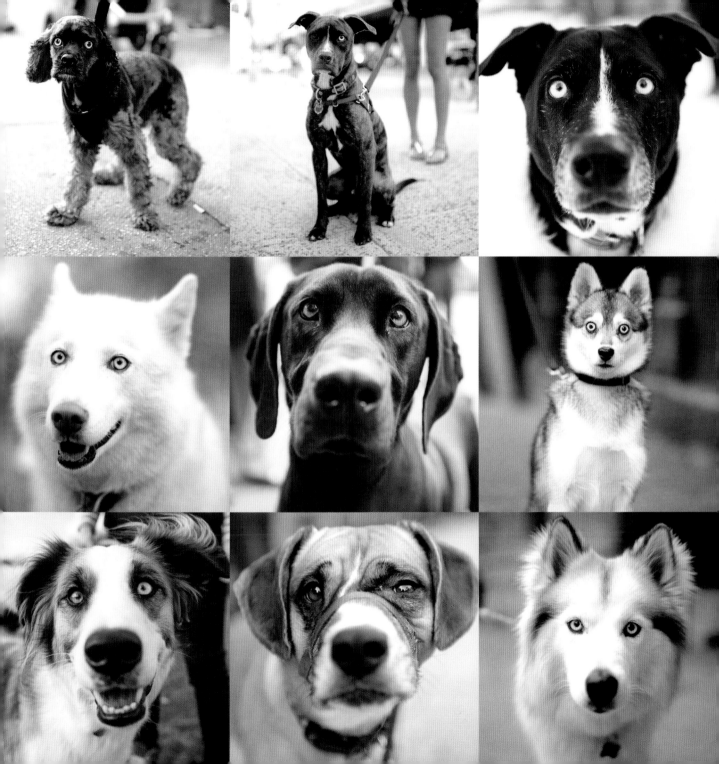

TOP ROW, LEFT TO RIGHT

George, *Golden Retriever*

Rosie, *Irish Setter*

Thomas, *Chihuahua*

Fievel, *Labrador Retriever mix*

Nova, *Alaskan Klee Kai*

Floyd, *Labrador Retriever/Siberian Husky mix, 6 years old*

BOTTOM ROW, LEFT TO RIGHT

Chloe, *French Bulldog*

Kuma, *Labrador Retriever, 8 months old*

Crosby, *Golden Retriever*

Barthlemy, *English Bulldog*

Lola, *Nova Scotia Duck Tolling Retriever, 4 months old*

Shum Shum, *Pit Bull*

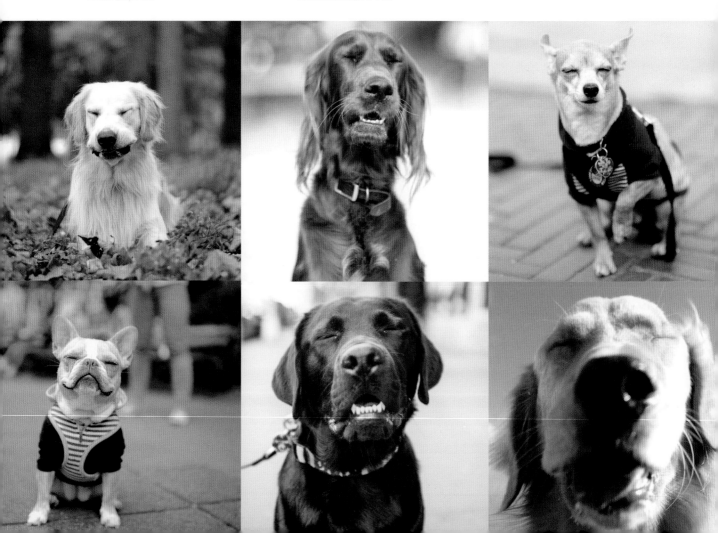

Eyes Closed

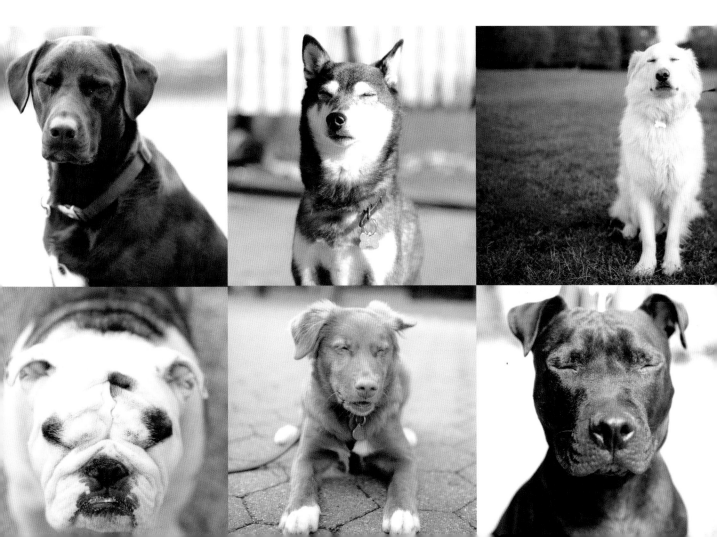

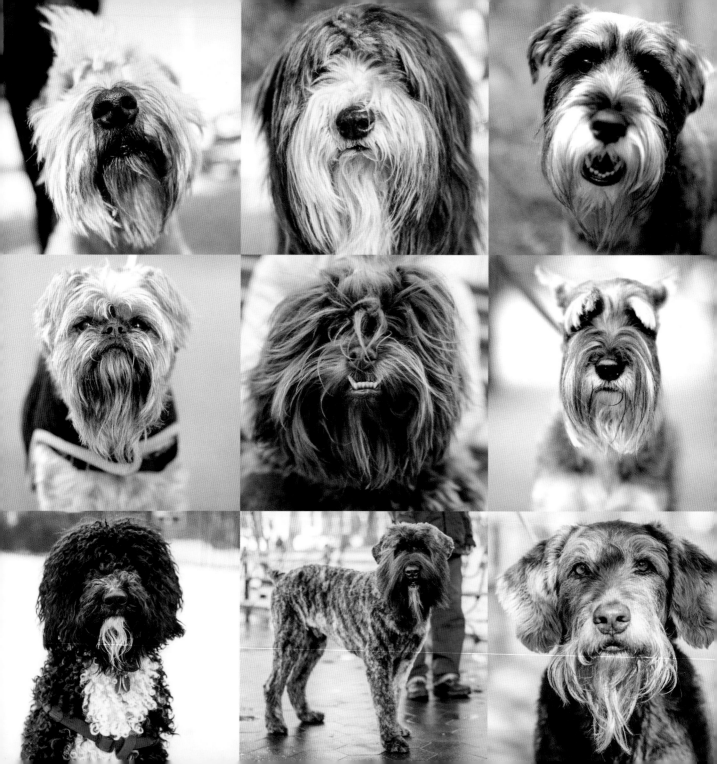

Beards

TOP ROW,
LEFT TO RIGHT

Banksy, *Wheaten Terrier, 3 years old*

Maya, *Bearded Collie, 9 years old*

Ilean, *Standard Schnauzer*

CENTER ROW,
LEFT TO RIGHT

Jackson, *Brussels Griffon*

Carmelo, *Havanese, 9 months old*

Stella, *Standard Schnauzer*

BOTTOM ROW,
LEFT TO RIGHT

Moby, *Portuguese Water Dog, 11 months old*

Earl, *Bouvier des Flandres, 2 years old*

Hazel, *Labradoodle, 11 years old*

Benny, *Brussels Griffon* »

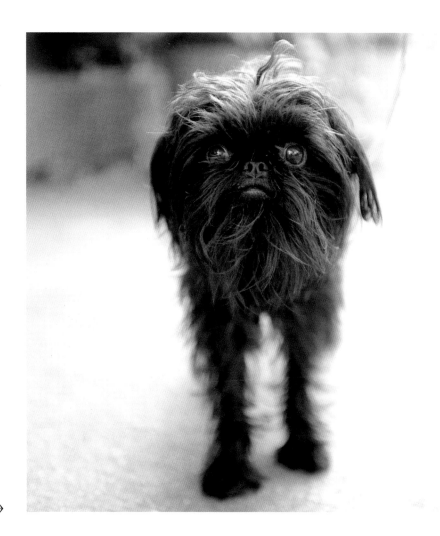

"I found him in the Arabian Desert in Jordan, tied to a short leash outside a Bedouin campsite. He could barely stand up, covered in insects and full of parasites. He followed me everywhere I went and would stay outside my dwelling at night to protect me. He knew instinctively from the very beginning that I would be his loving master, that I would change his life. Being alone in such vast and open wilderness, how could I not become attached to this remarkable creature?"

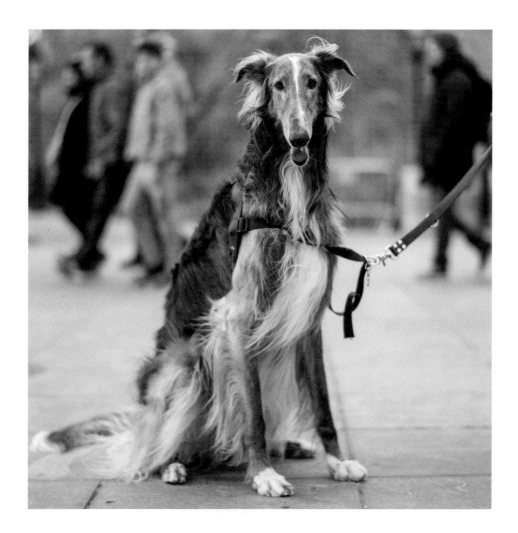

Atticus Finch, *Borzoi, 3 years old*

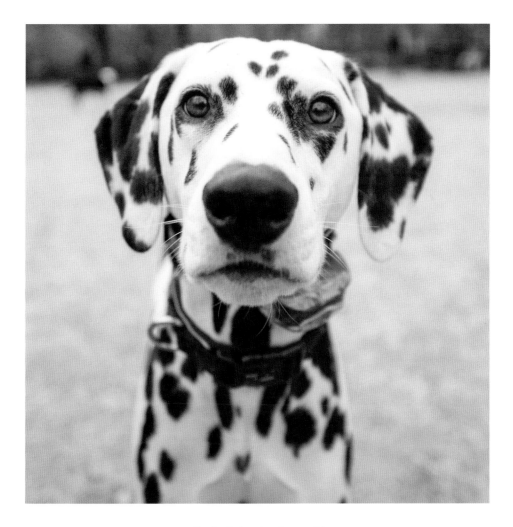

Brody, *Dalmatian, 3 years old*

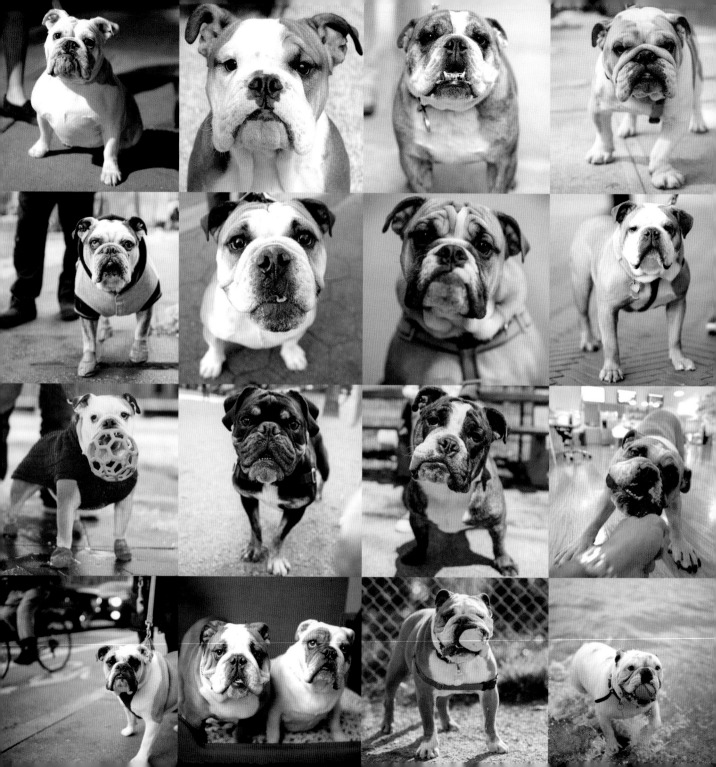

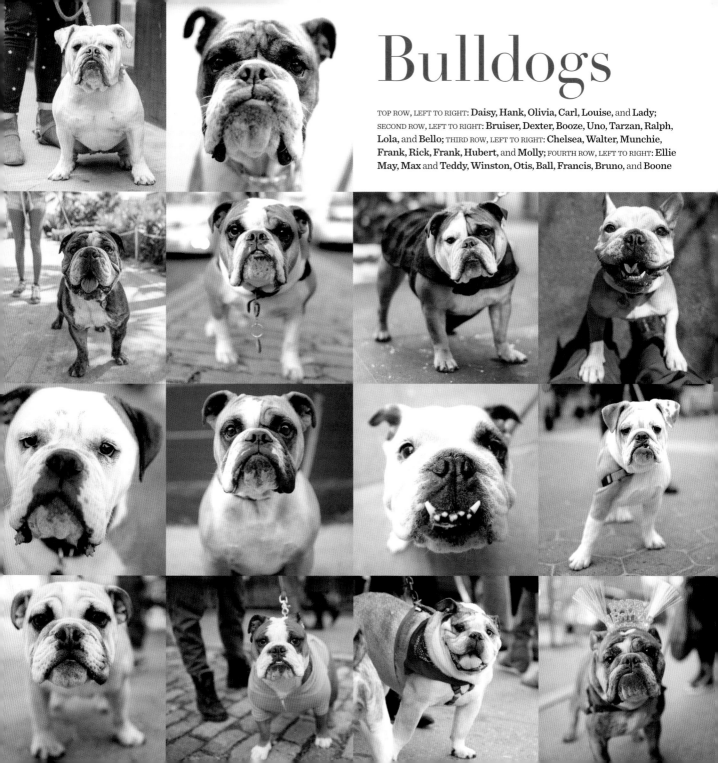

Bulldogs

TOP ROW, LEFT TO RIGHT: **Daisy, Hank, Olivia, Carl, Louise,** and **Lady;**
SECOND ROW, LEFT TO RIGHT: **Bruiser, Dexter, Booze, Uno, Tarzan, Ralph,
Lola,** and **Bello;** THIRD ROW, LEFT TO RIGHT: **Chelsea, Walter, Munchie,
Frank, Rick, Frank, Hubert,** and **Molly;** FOURTH ROW, LEFT TO RIGHT: **Ellie
May, Max** and **Teddy, Winston, Otis, Ball, Francis, Bruno,** and **Boone**

Field Trials

In field trials, dogs compete to find and point to game birds. Dogs are judged on their ability to run with their handler and point to the most birds.

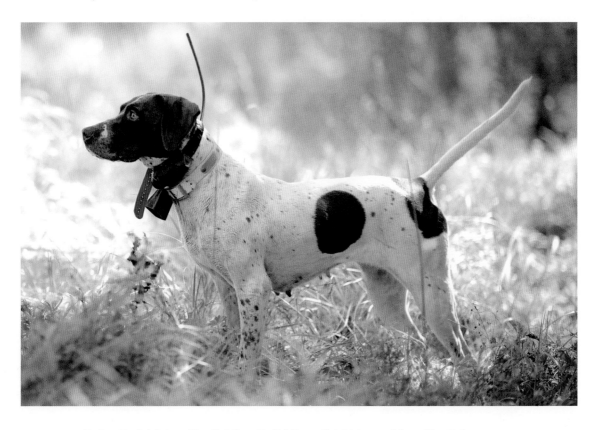

Foghat, *English Pointer, New York State English Setter Club, Livingston Manor, New York*

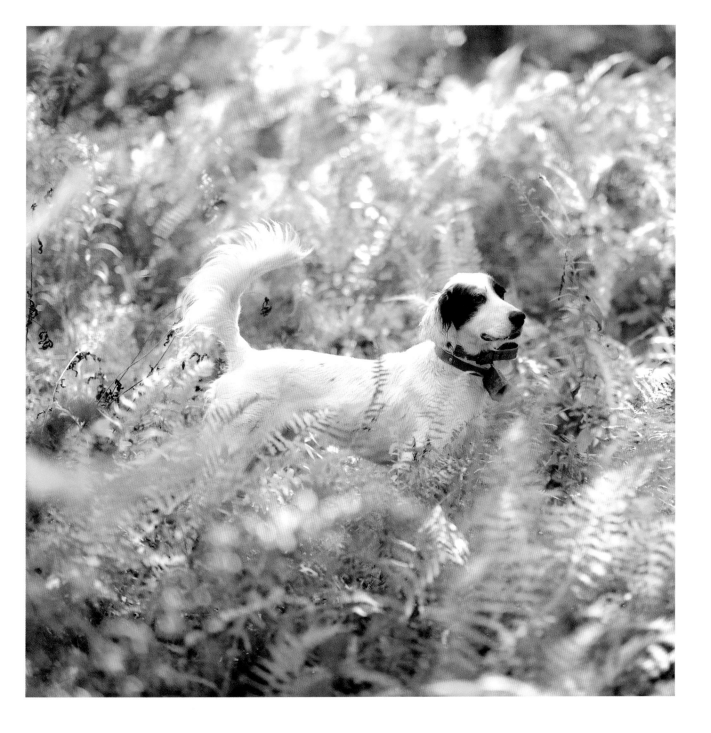

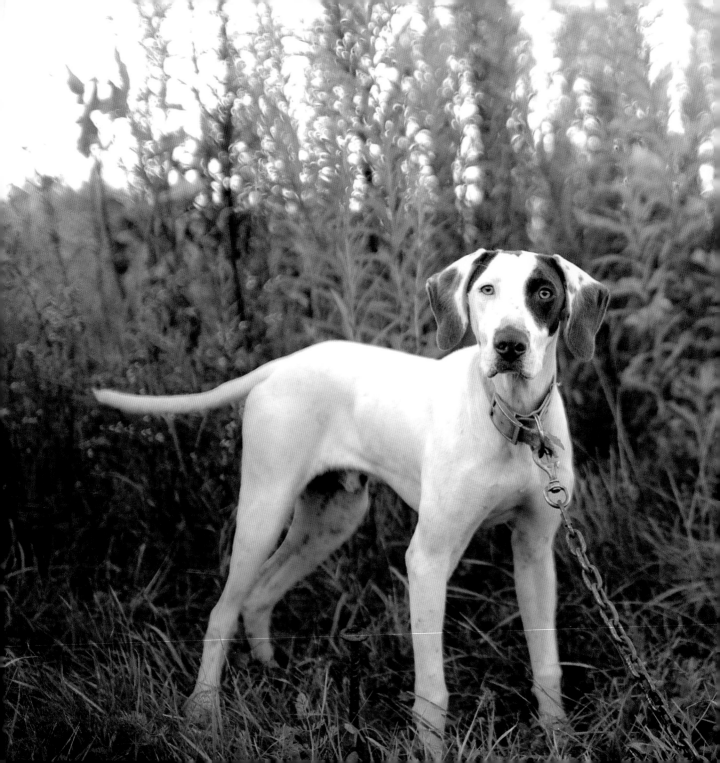

White Gold, *English Pointer*

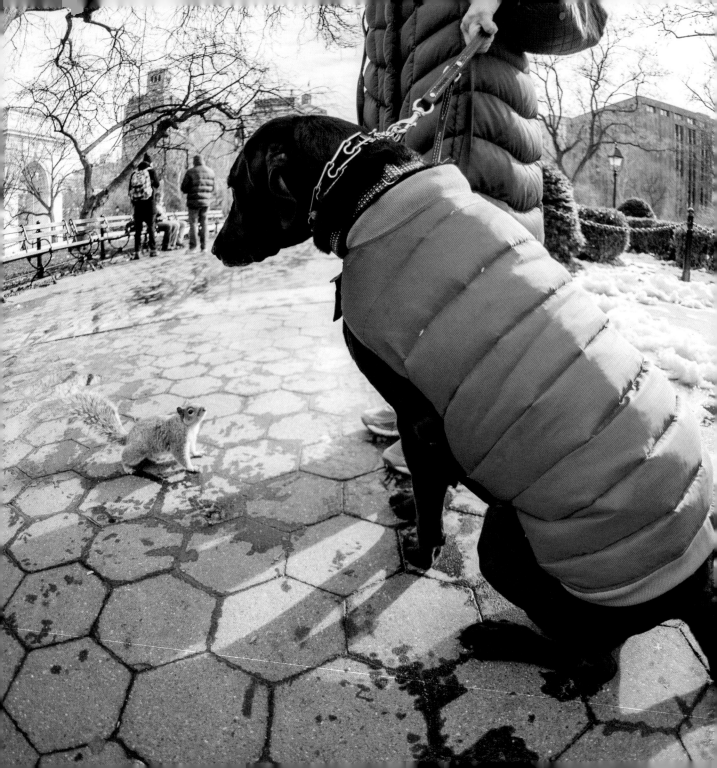

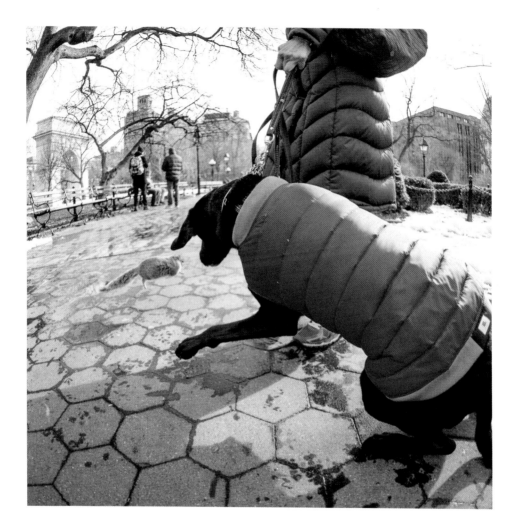

Mazzie, *Labrador Retriever/Hound mix, 6 years old*

Squirrel!

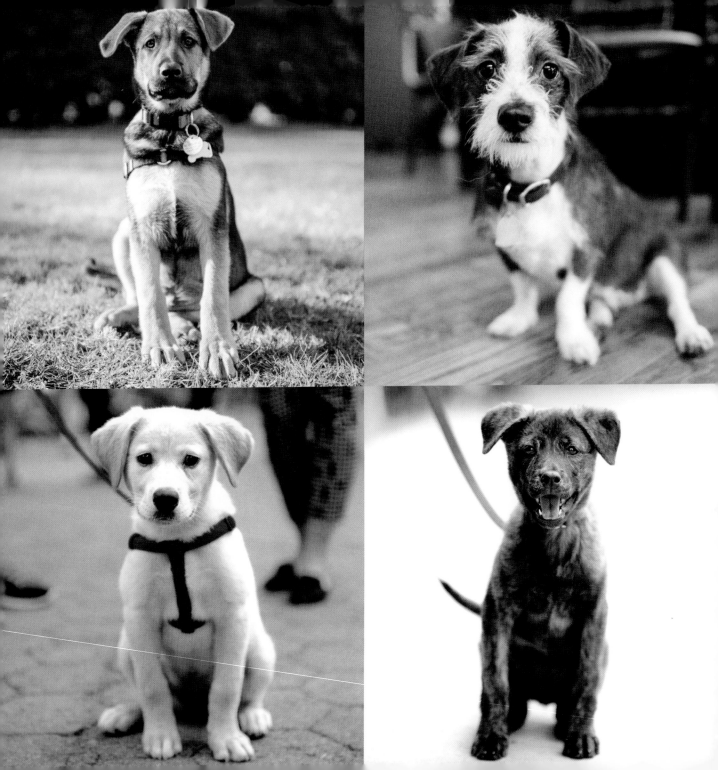

CLOCKWISE, FROM TOP LEFT

Gus,
German Shepherd/
Labrador Retriever mix,
14 weeks old

Lafitte,
Jack Russell Terrier mix,
10 months old

Pickles, *mix*

Sophie,
Labrador Retriever/
Border Collie mix

Puppies

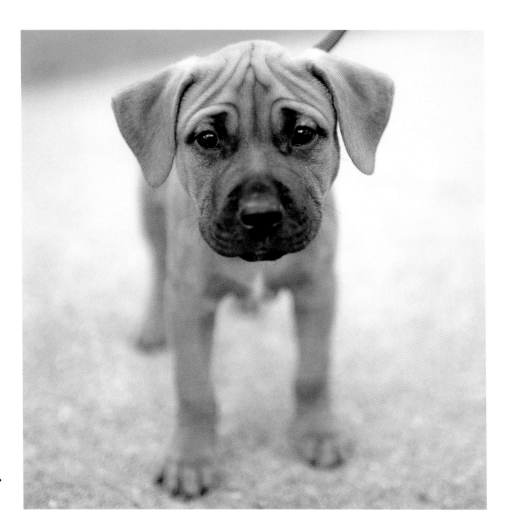

Lupo, »
Cane Corso/Pit Bull mix,
2 months old

Heavyweights

CLOCKWISE,
FROM TOP LEFT

Tolec, *Great Dane*

Nero, *Cane Corso,*
3 years old

Brew, *Bernese*
Mountain Dog,
1 year old

June, *Neapolitan*
Mastiff, 4 years old

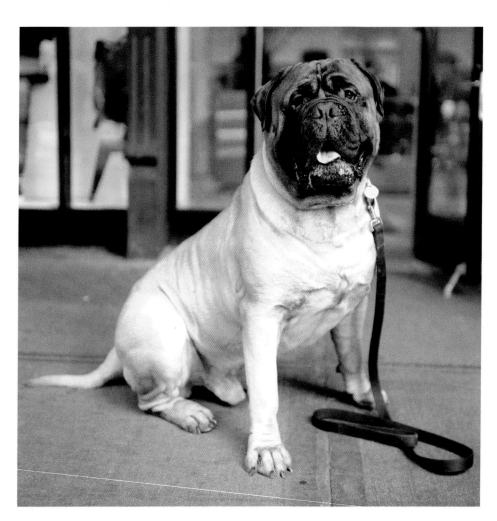

« **Titus,** *Bullmastiff*

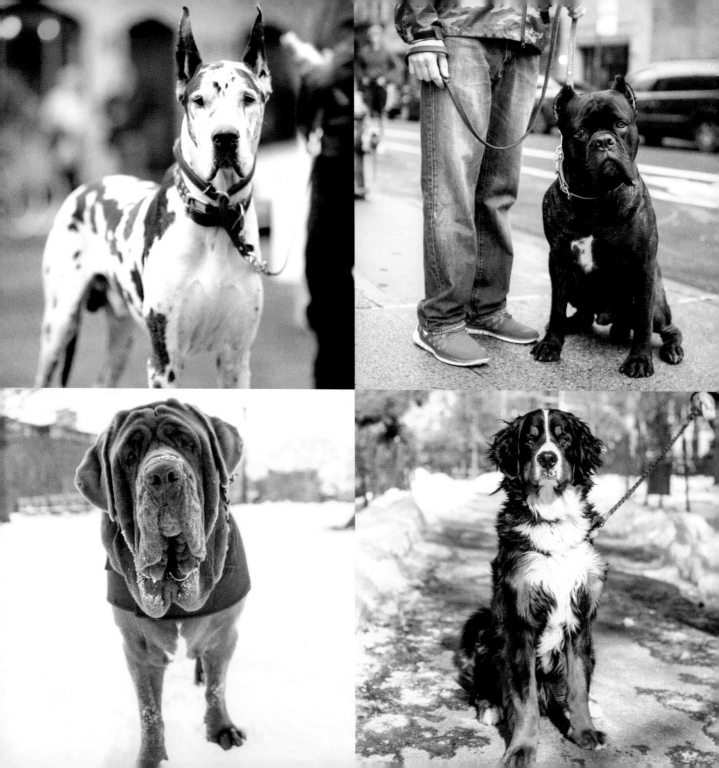

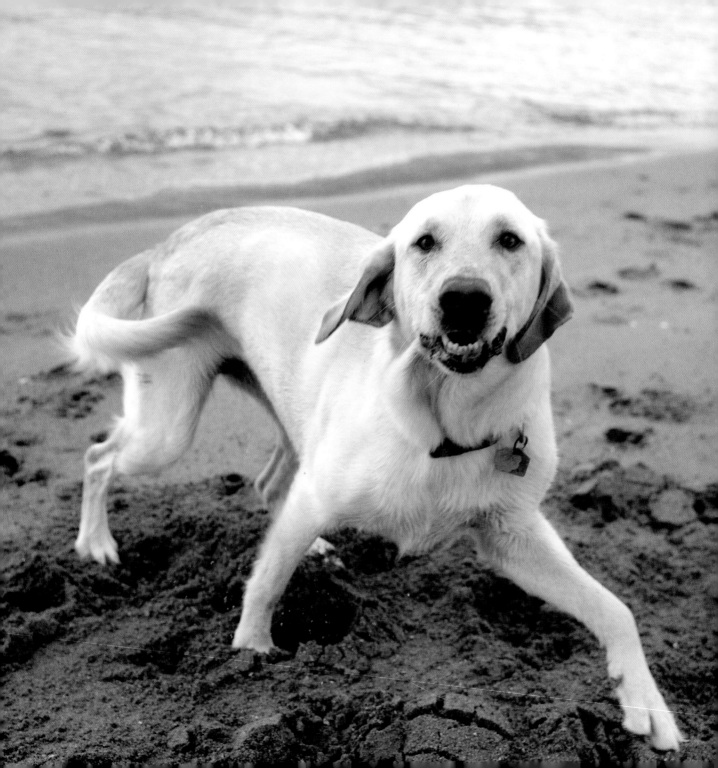

Basel, *Labrador Retriever,*
Vancouver, British Columbia

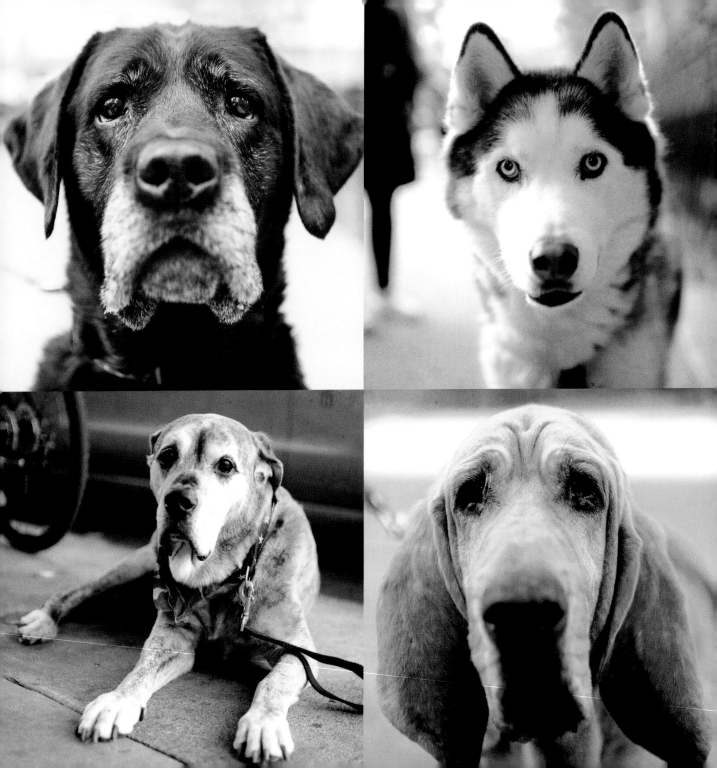

CLOCKWISE,
FROM TOP LEFT

Bob Marley,
Labrador Retriever,
11 years old

Ice, *Siberian Husky,*
10 years old

Daphne,
Bloodhound,
10 years old

Diggity, *Bullmastiff/*
American Bulldog
mix, 14 years old

Seniors

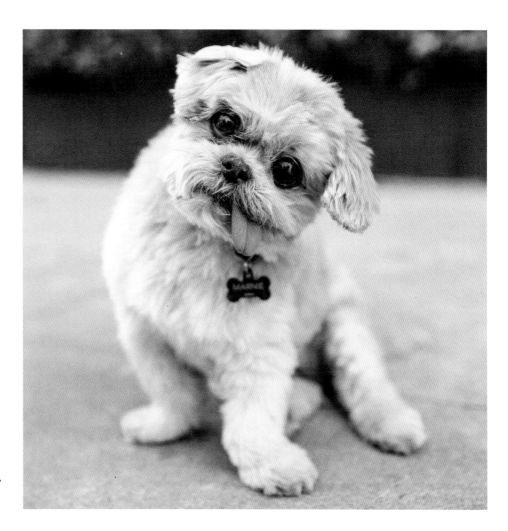

Marnie, »
Shih Tzu,
12 years old

Give a Dog a Bone

I created the Give a Dog a Bone program to tell the story of shelter dogs and to bring awareness to the plight of Pit Bulls. Since Spring 2013, the series has featured more than 50 adoptable dogs in more than 20 shelters, most of which have since found homes.

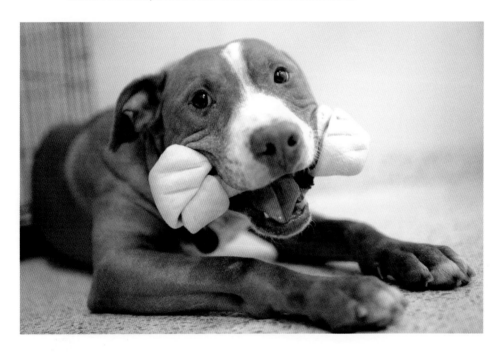

Larry, *Pit Bull*

TOP ROW, LEFT TO RIGHT

Europa, *Pit Bull mix, 2 years old;* **Adam Brody,** *Labrador Retriever mix, 10 years old;* **Lala,** *Pit Bull mix, 4 months old;* **Hampton,** *mix, 2 months old*

SECOND ROW, LEFT TO RIGHT

Lionel, *Boxer mix, 7 months old;* **Sparrow,** *Foxhound mix, 1 year old;* **Derbie,** *Labrador Retriever, 10 years old;* **Jesse Pinkman,** *Pit Bull mix, 3 years old*

THIRD ROW, LEFT TO RIGHT

Daniel, *Hound mix, 2 years old;* **Tom Selleck,** *Pit Bull mix, 4 months old;* **Pippin,** *Beagle, 5 months old;* **Dice,** *Pit Bull mix, 2 years old*

BOTTOM ROW, LEFT TO RIGHT

Gachas, *Terrier mix, 3 months old;* **Bill,** *Pit Bull mix, 3 months old;* **Tornado Jane,** *Pit Bull, 4 years old;* **Hercules,** *American Bulldog/ Pit Bull mix, 2 years old*

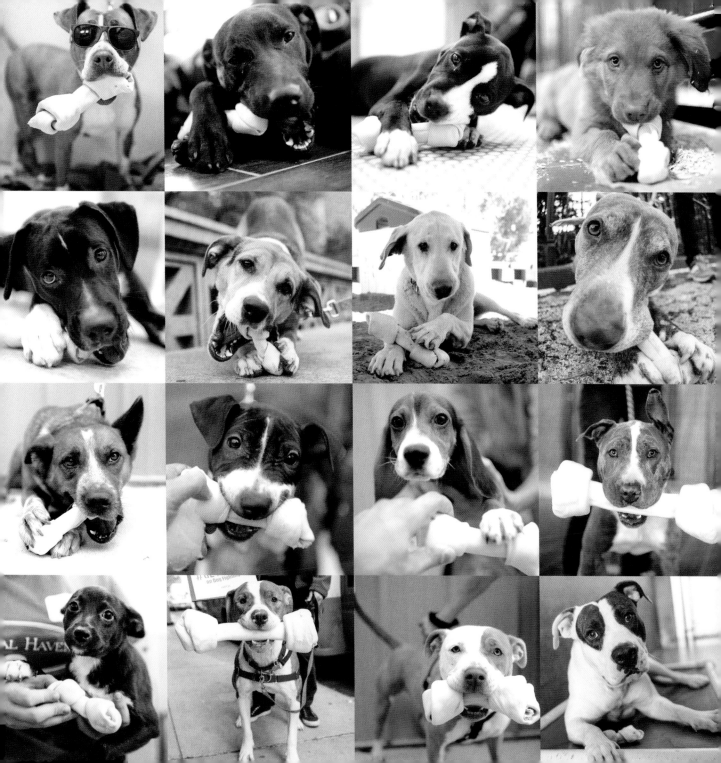

"Miles was found in the desert near Barstow, California.

Someone had wired his mouth shut, and then either thrown him away or he ran away. When his fur healed, it was scarred white. We weren't planning to adopt, but we flew him to New York and he found a new home with us—he's a great dog."

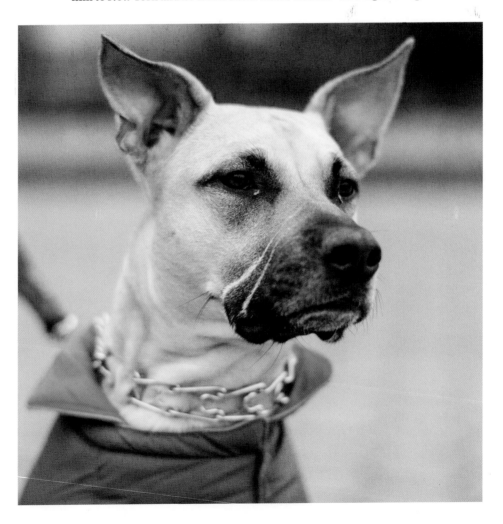

Miles, *Staffordshire Bull Terrier/White Shepherd mix, 2 years old*

"We found him wandering the streets on the 4th of July; his nerves were shot from the fireworks. It turned out he lived next door, but he kept showing up at our door after that. After a while, we met with his owners and they agreed to shared parentage. They are from Hawaii, and *Koa* means 'warrior' in Hawaiian."

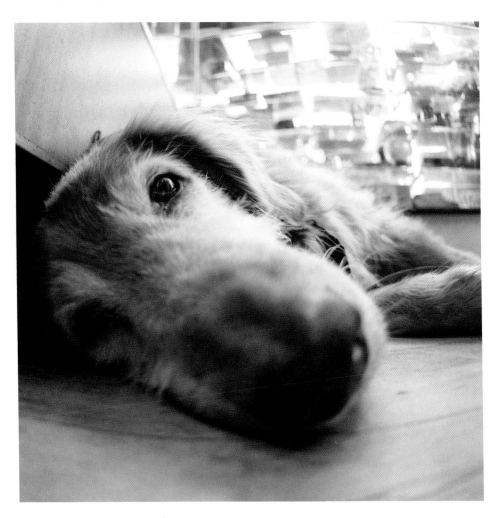

Koa, *Golden Retriever, 12 years old, Seattle, Washington*

Close-up

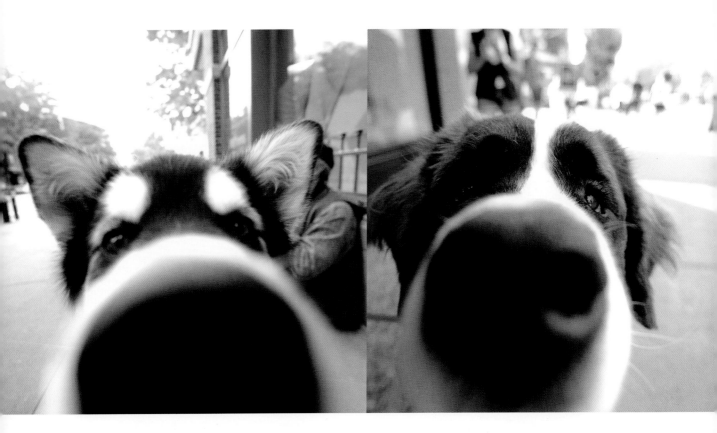

Kodiak, *Alaskan Malamute*

Mini, *St. Bernard, 1 year old*

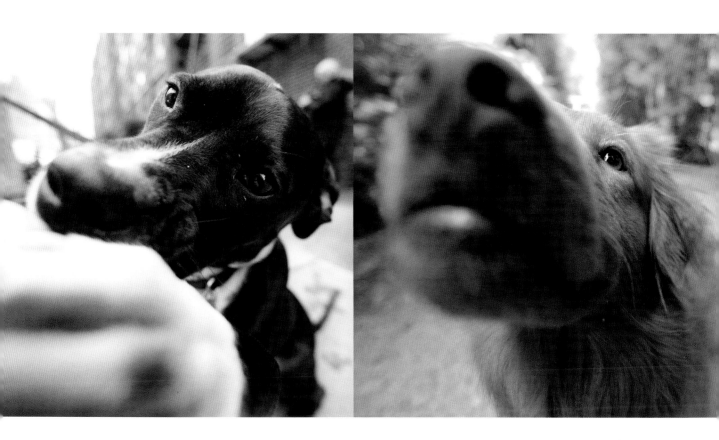

Boo, *Pit Bull/Great Dane mix, 1 year old*

Angus, *Nova Scotia Duck Tolling Retriever*

Costumes

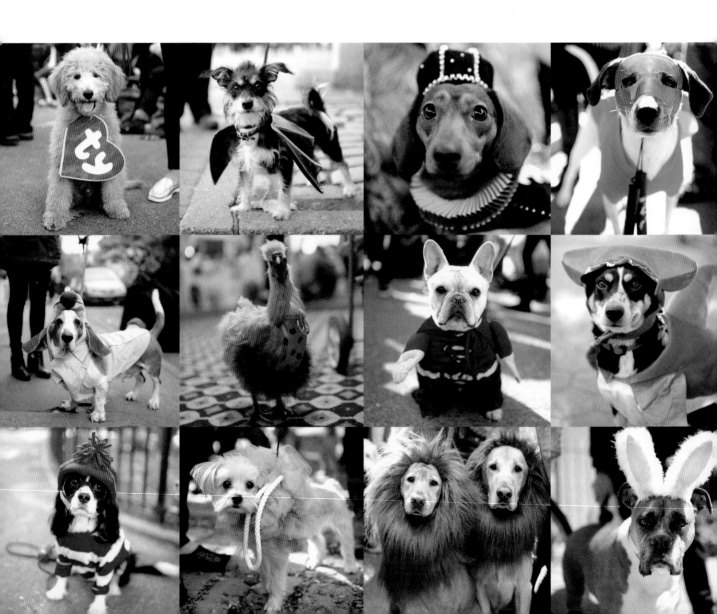

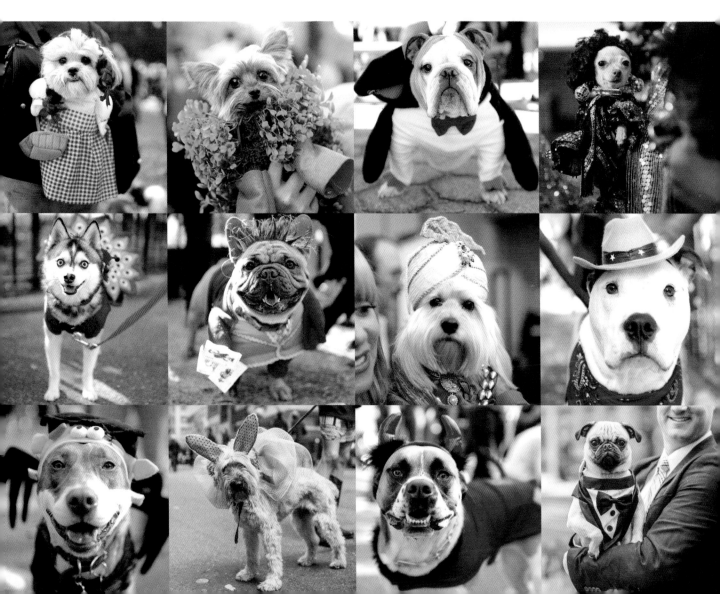

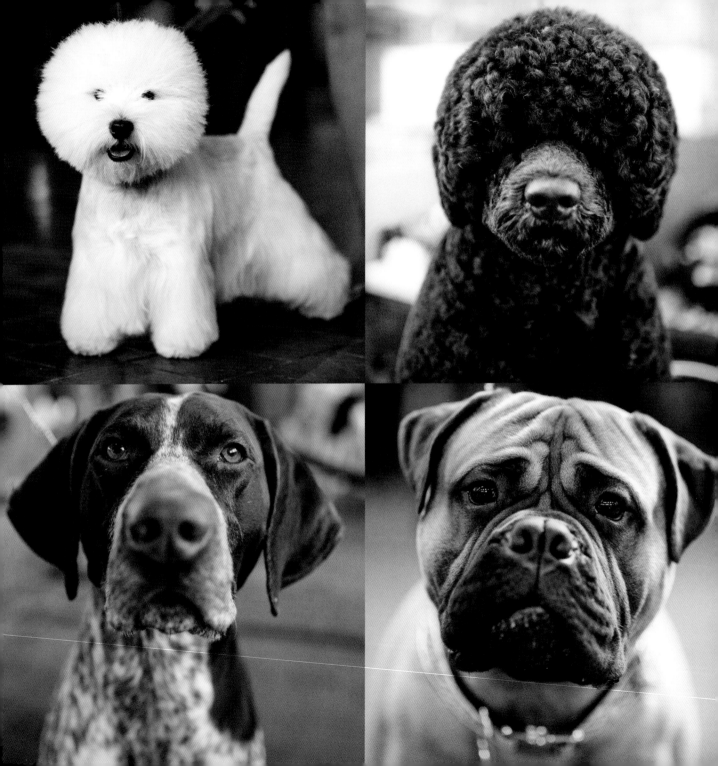

Boss, *West Highland White Terrier*

Matisse, *Portuguese Water Dog, 3 years old*

JP, *Bullmastiff, 15 months old*

Cyrus, *German Shorthaired Pointer, 3 years old*

Show Dogs

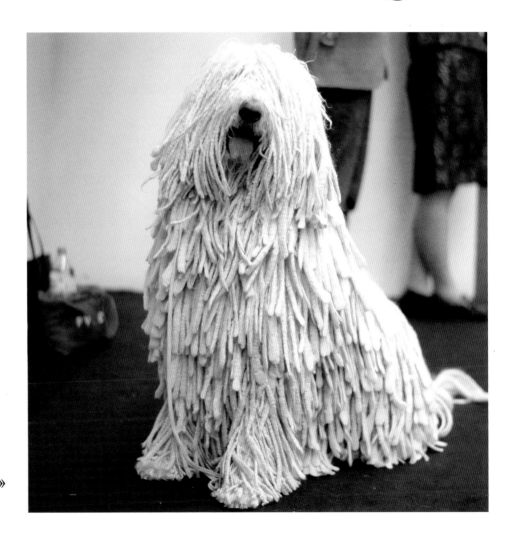

Chauncey, *Komondor,* 》
5 years old, Westminster Kennel Club Dog Show

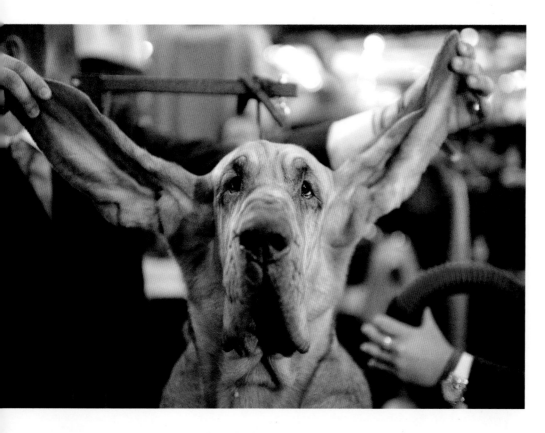

Nathan, *Bloodhound, 4 years old*

TOP ROW,
LEFT TO RIGHT

Nash, *Great Dane*

Sasha,
Tibetan Mastiff

Gilby, *Irish Red and
White Setter*

CENTER ROW,
LEFT TO RIGHT

Whippets

Swagger,
*Old English
Sheepdog,
4 years old*

Paparazzi,
Neapolitan Mastiff

BOTTOM ROW,
LEFT TO RIGHT

Dixie, *Redbone
Coonhound*

Victoria, *Beagle,
15 months old*

Angel,
Afghan Hound

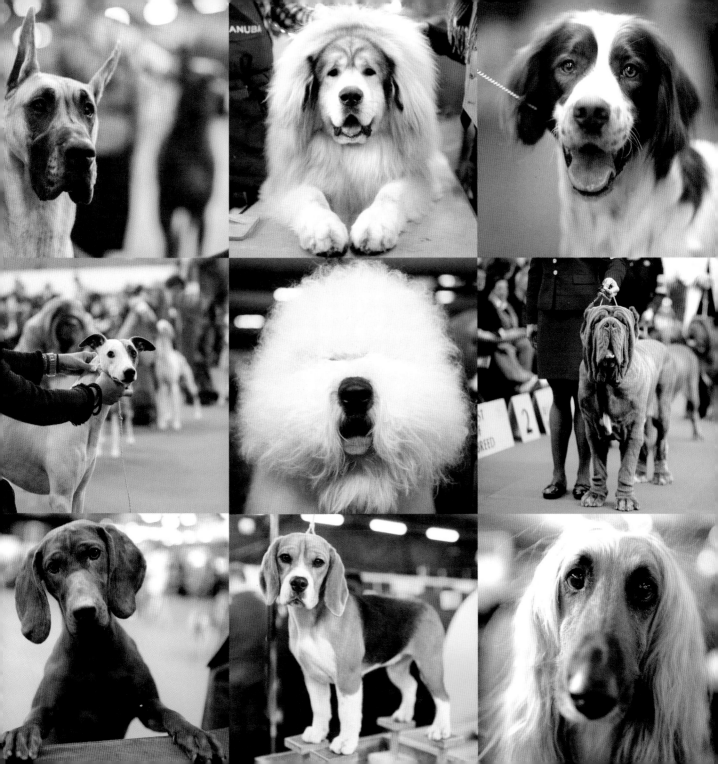

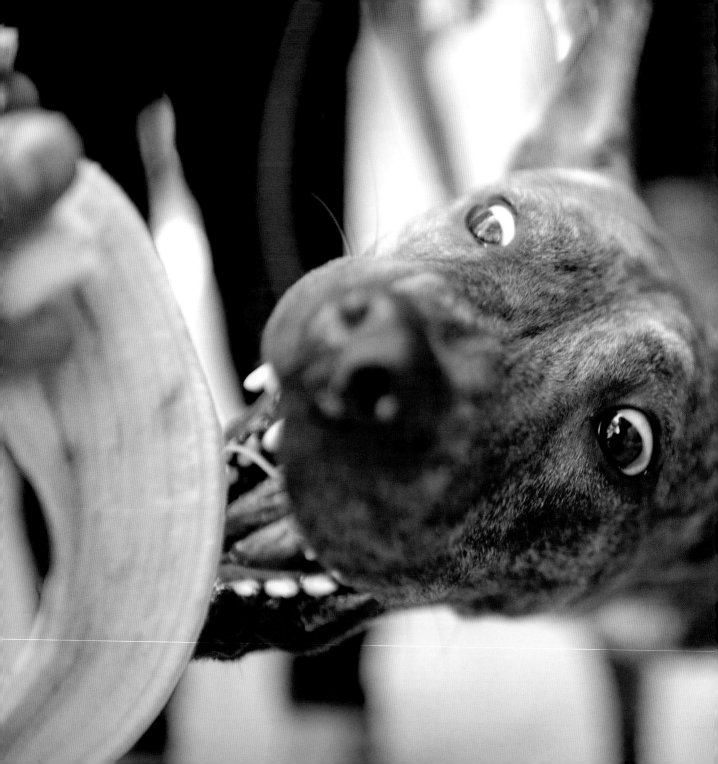

« **Payton,** *Dutch Shepherd/Staffordshire Bull Terrier mix*

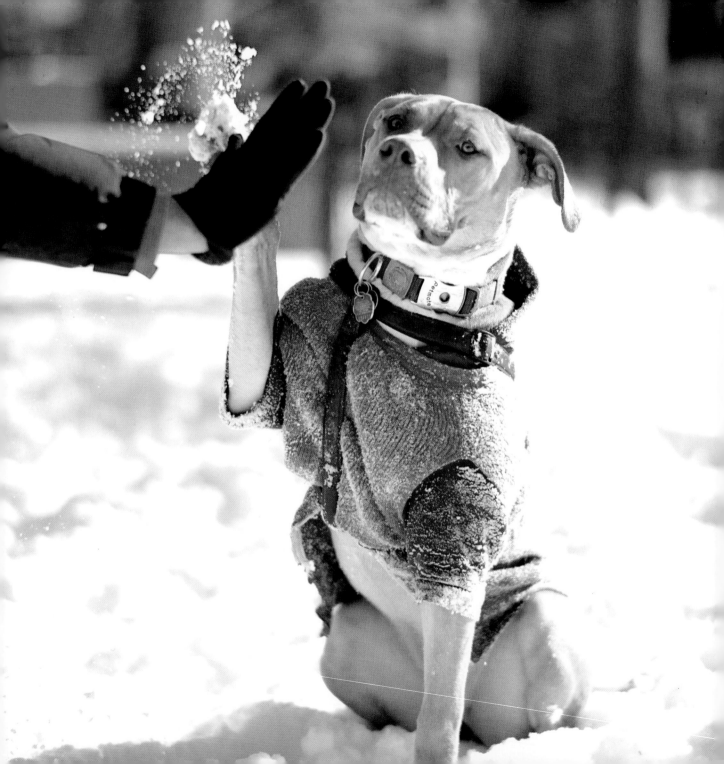

« **Nelly,** *Pit Bull*

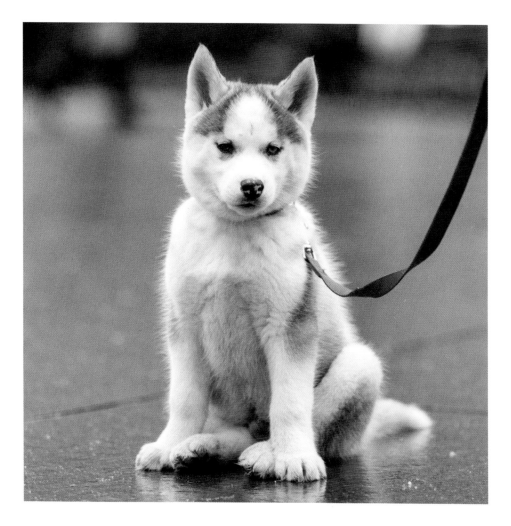

Storm, *Siberian Husky, 2 months old*

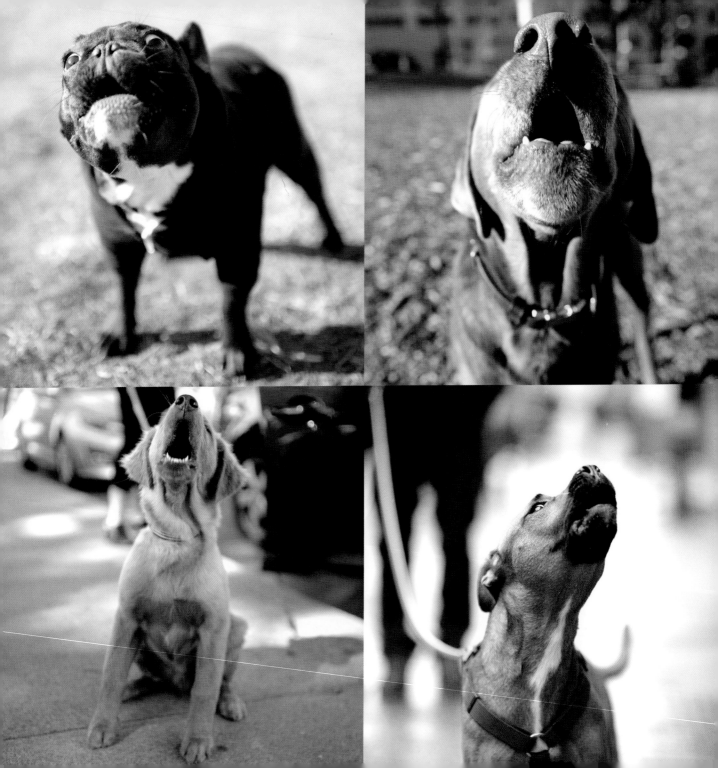

CLOCKWISE,
FROM TOP LEFT

Kiki, *French Bulldog*

Silas, *Silver Lab
(Labrador Retriever/
Weimaraner mix)*

Hennessy, *mix*

August,
*Golden Retriever,
5 months old*

Barkers

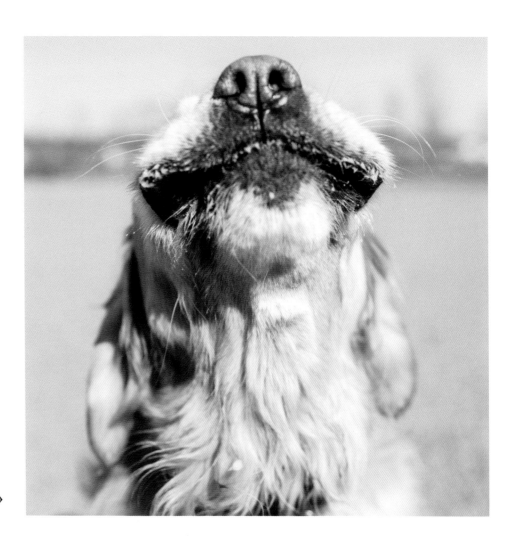

Oscar, *Golden Retriever,* »
5 years old

TOP ROW

Alphonse, *German Shepherd/ Labrador Retriever mix*

CENTER ROW, LEFT TO RIGHT

Cali, *mix;* **Steve,** *Dachshund/Corgi/ Jack Russell Terrier mix;* **Ralphie,** *mix;* **Diego,** *German Shorthaired Pointer/ Dalmatian mix;* **JJ,** *German Shepherd/ Shiba Inu mix;* **Kevin,** *mix, 8 years old*

BOTTOM ROW, LEFT TO RIGHT

Cuba, *Brussels Griffon mix, 4 years old;* **Jordan,** *Siberian Husky/Labrador Retriever mix;* **Boo,** *Rottweiler/ Rhodesian Ridgeback/Pit Bull mix;* **Archie,** *Labrador Retriever/Jack Russell Terrier mix, 6 years old;* **Rosie,** *St. Bernard/Collie mix;* **Smokey,** *Alaskan Malamute mix, 3 years old*

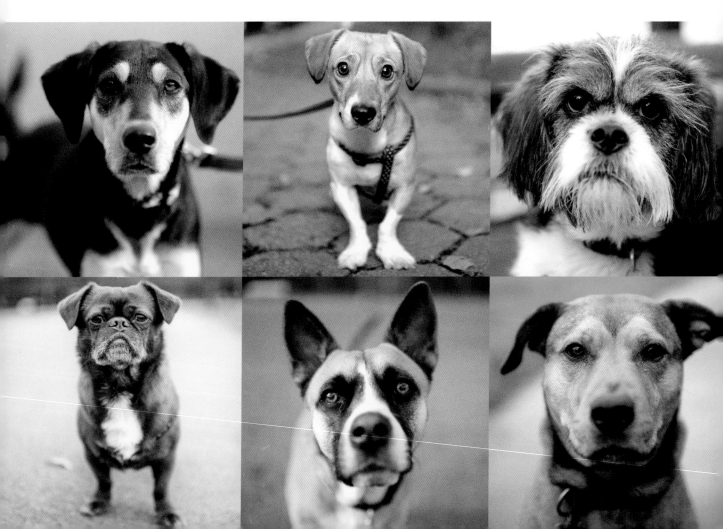

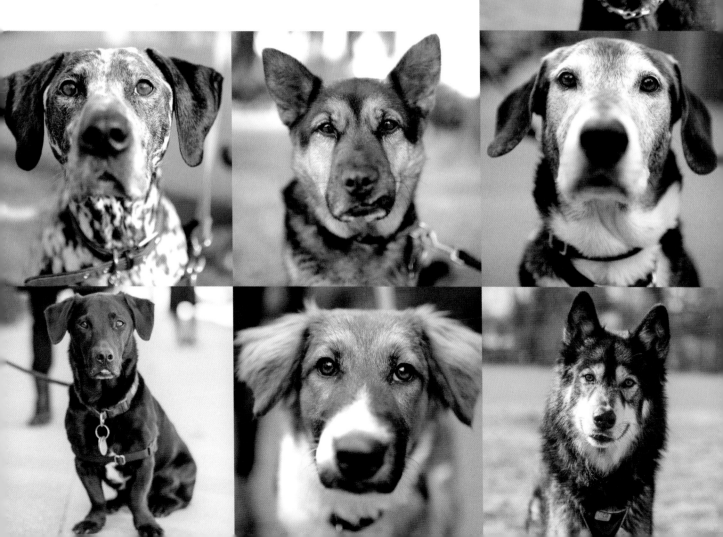

Beautiful
Blends

Puppies

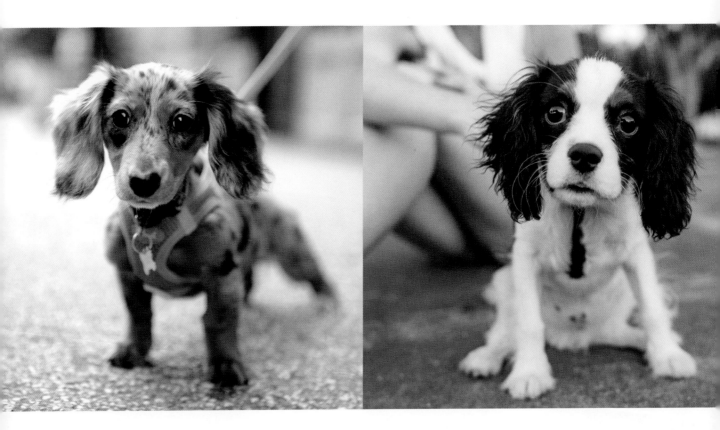

Rain, *Dachshund, 15 weeks old*

Ray, *Cavalier King Charles Spaniel, 4 months old*

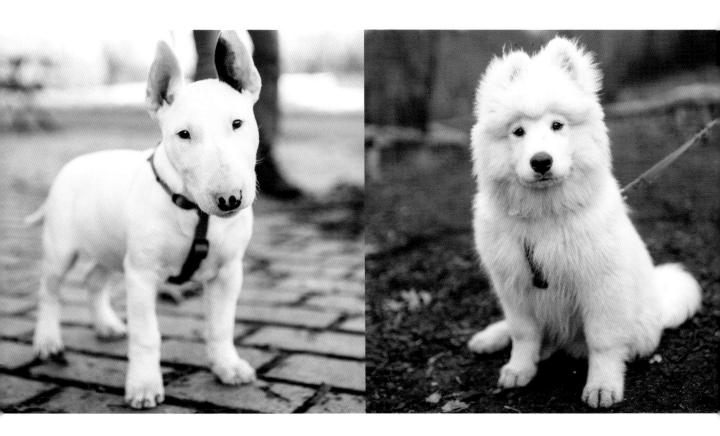

Oprah, *Bull Terrier, 3 months old*

Onslo, *Samoyed, 15 weeks old*

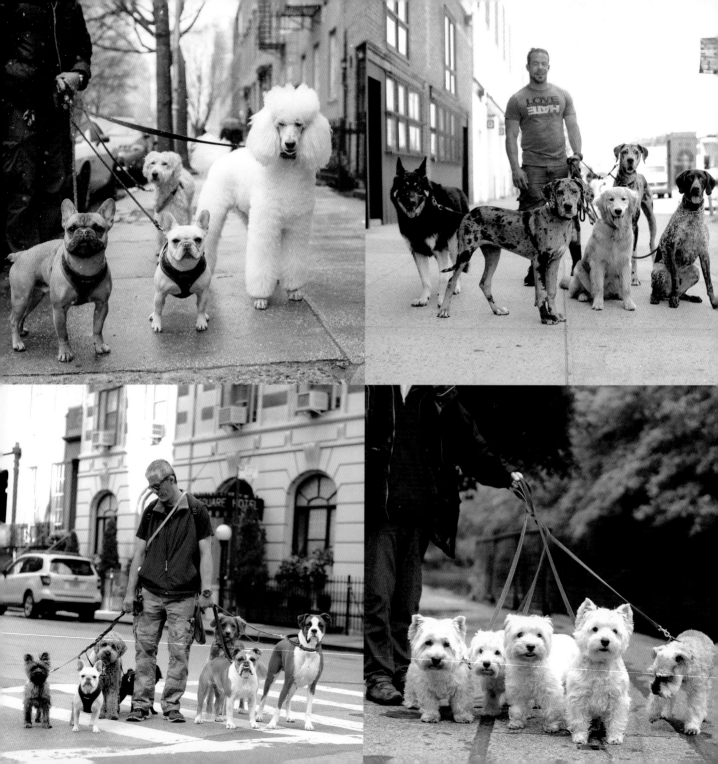

Packs

CLOCKWISE,
FROM TOP LEFT
(LEFT TO RIGHT)

Oscar, Constance, Emma, and **Sebastian,** *French Bulldogs, Wheaten Terrier, and Standard Poodle*

Petrus, Shadow, Riley, Puddle, and **Otis,** *German Shepherd, Great Dane, Golden Retriever, Great Dane, and German Shorthaired Pointer*

Tinker, Olive, Bubble, Hector, and **Pasha,** *West Highland White Terriers and Miniature Schnauzer*

Violet, Haddie, Louie, Betty, Hanley, Riley, and **Chester,** *Cairn Terrier, French Bulldog, Labradoodle, Pug, English Bulldog, Nova Scotia Duck Tolling Retriever, and Boxer*

(LEFT TO RIGHT)

Ronda, Tanya, Plato, Lexi, Matty, Carmel, and **others,** *English Bulldog, German Shepherd, Siberian Husky, and mixes* »

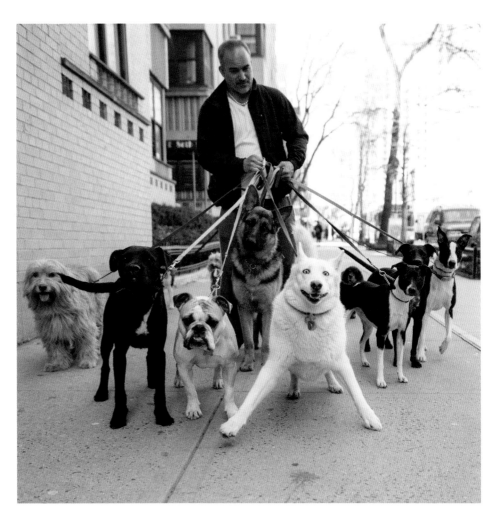

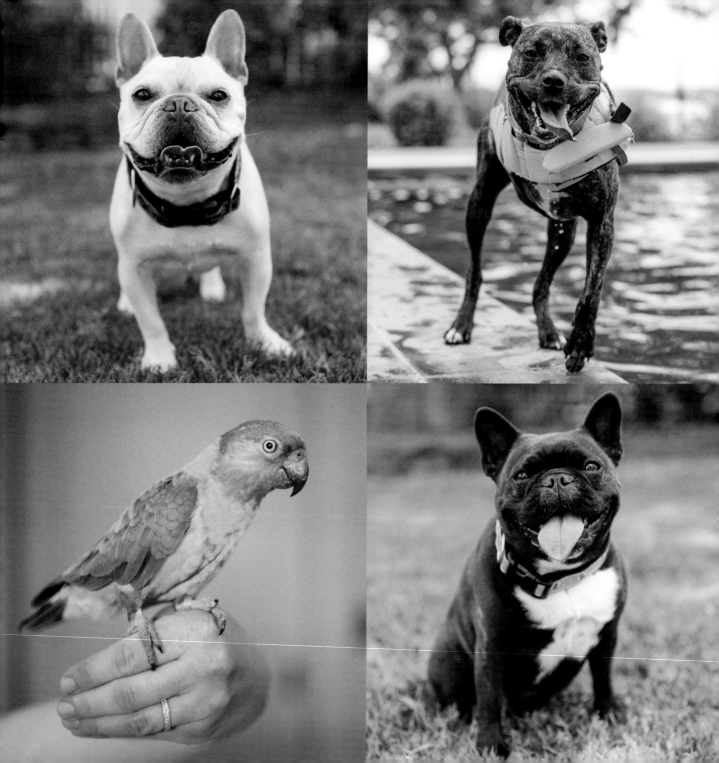

CLOCKWISE,
FROM TOP LEFT

Barkly,
French Bulldog,
7 years old

Lil' Dipper,
Pit Bull, 2 years old

Smudge,
French Bulldog,
6 years old

Jolene,
Senegal Parrot,
8 years old

A Rescue Family

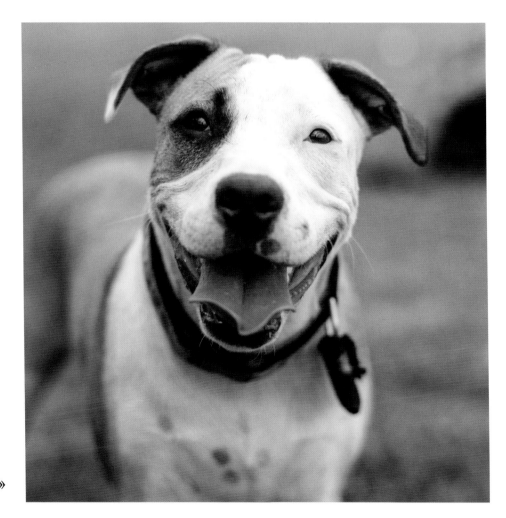

Scout, *Pit Bull,* »
9 months old

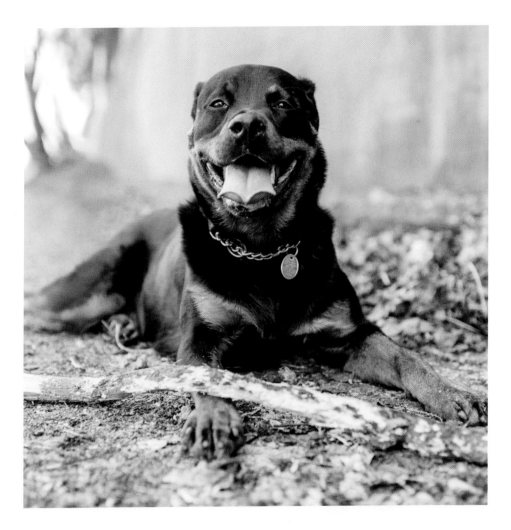

Osa, *Rottweiler, 1 year old, Seattle, Washington*

"The bigger the stick, the better."

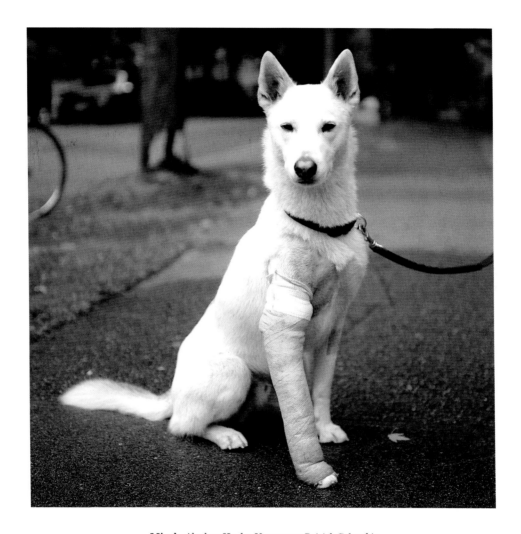

Micah, *Alaskan Husky, Vancouver, British Columbia*

"*He* ran into a car."

Only in New York City

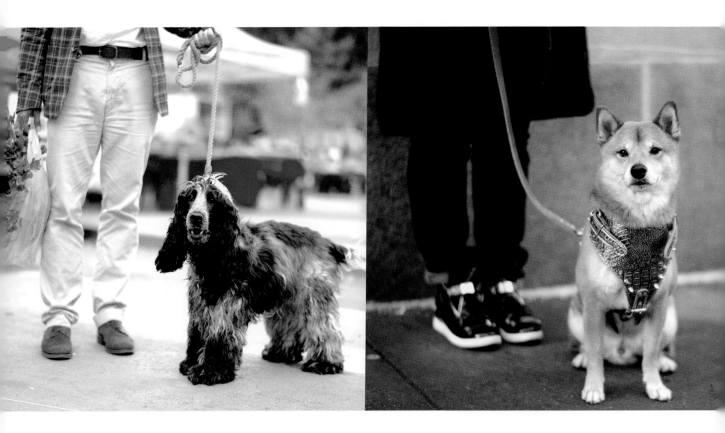

Innis, *Cocker Spaniel, 1 year old*

Ace, *Shiba Inu*

"Polo frequents hospitals as a therapy dog, participates in cancer awareness walks, and helps raise money for homeless shelters."

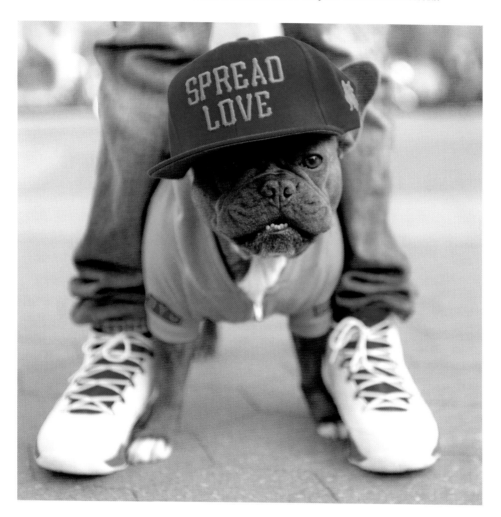

Polo, *French Bulldog, 2 years old*

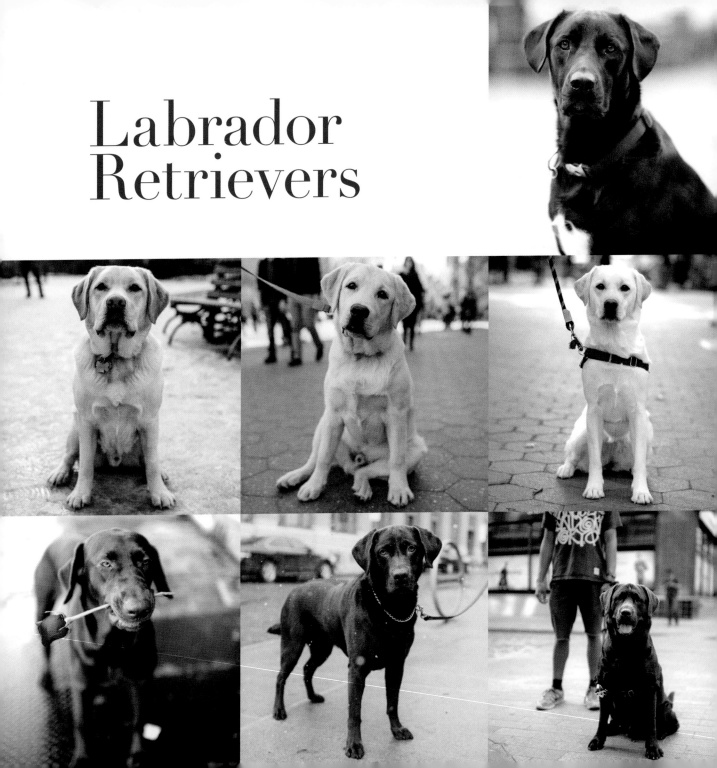

Labrador
Retrievers

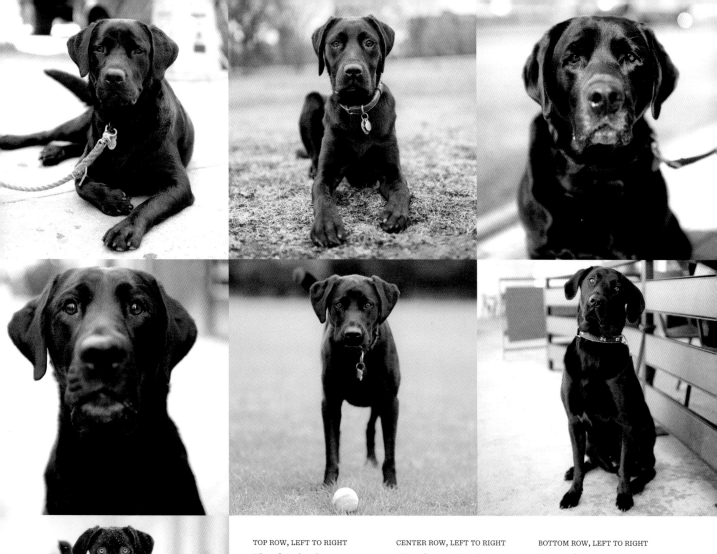

TOP ROW, LEFT TO RIGHT

Fievel, *Labrador Retriever/Rottweiler/ Bluetick Coonhound mix*

Dante, *10 months old*

Babette, *6 months old*

Butler

CENTER ROW, LEFT TO RIGHT

"Handsome" Hank, *2 years old*

Nico, *6 months old*

Teddy, *2 years old*

Té té, *2 years old*

Roddie

George

BOTTOM ROW, LEFT TO RIGHT

Beyoncé

Kirby, *6 years old*

Bruno, *2 years old*

Comet

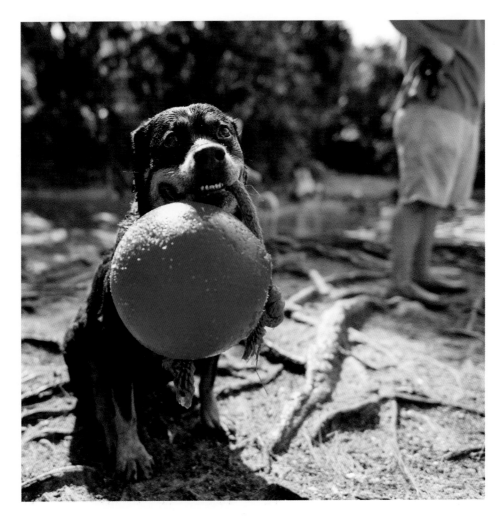

Rosie, *Rottweiler, 8 years old*

"She's been coming here for seven years."

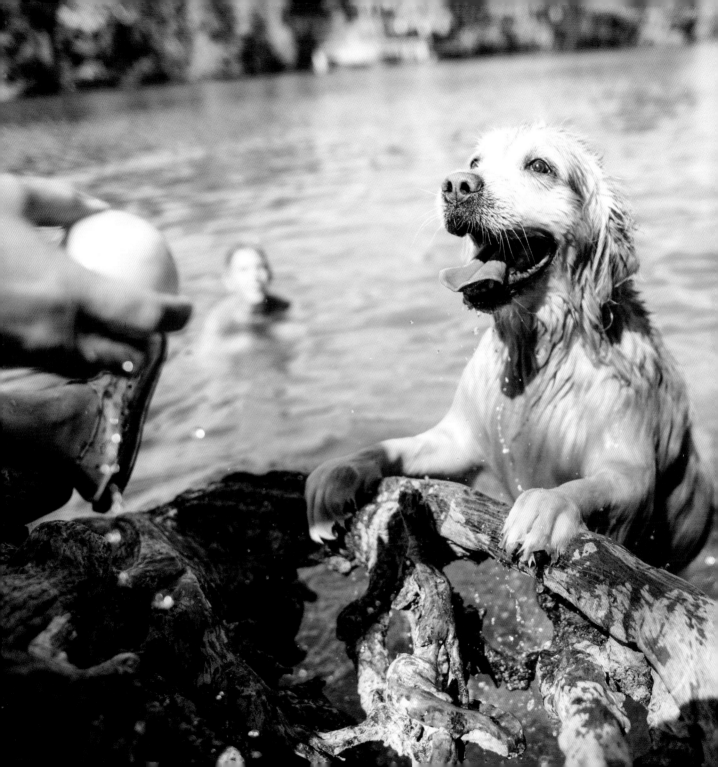

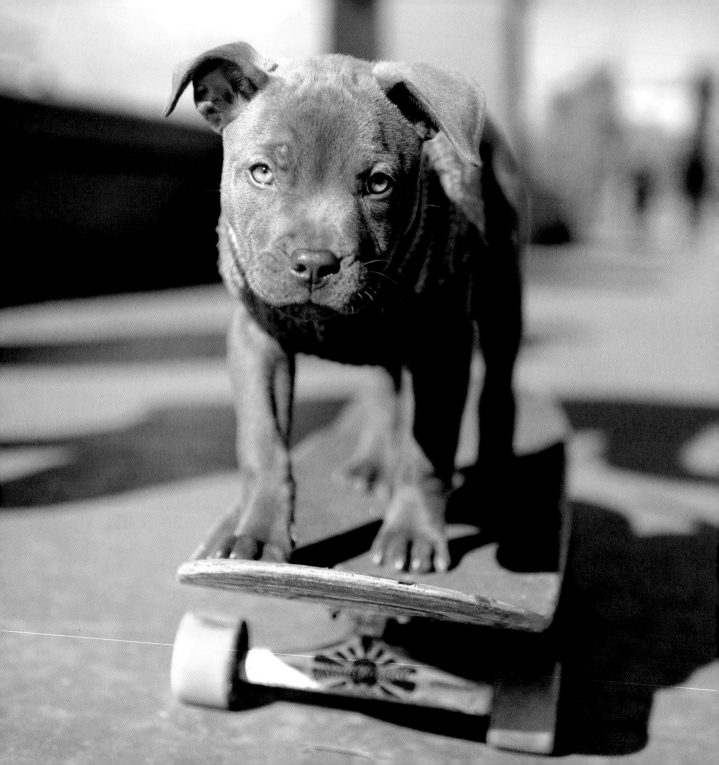

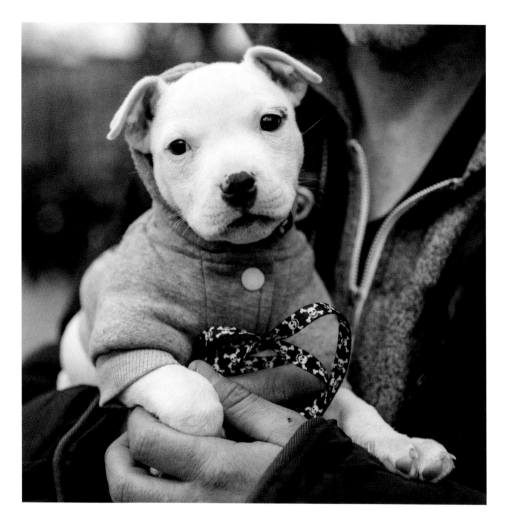

Bella, *Pit Bull, 3 months old*

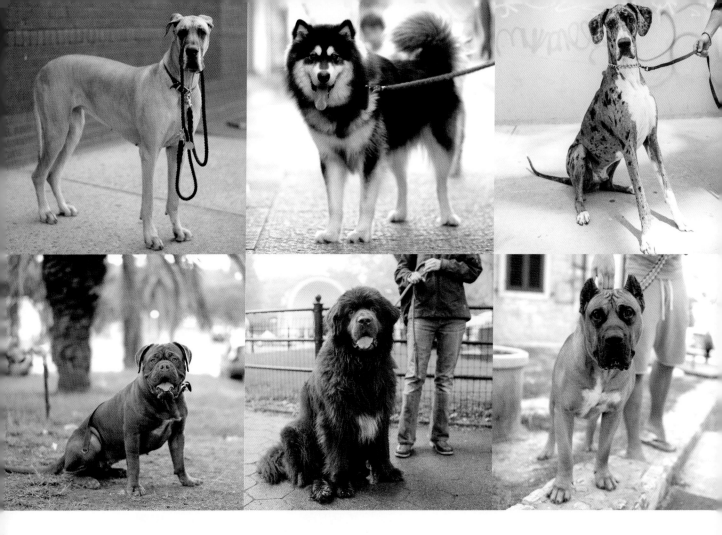

TOP ROW, LEFT TO RIGHT

Jane, *Great Dane*

Pàng Pàng, *Alaskan Malamute,*
Zhujiajiaozhen, Shanghai, China

Roquefort, *Great Dane, 1 year old*

Sidney, *Boxer*

CENTER ROW, LEFT TO RIGHT

Maggie, *Dogue de Bordeaux, 2 years old*

Sacha, *Newfoundland, 8 years old*

Hooch, *Perro de Presa Canario/*
Pit Bull mix

Porter, *Greater Swiss Mountain Dog,*
7 years old

Konan, *Perro de Presa Canario,*
8 years old

Max, *Bernese Mountain Dog, 4 years old*

BOTTOM ROW, LEFT TO RIGHT

Hugo, *Black Russian Terrier,*
18 months old

Koda, *Cane Corso*

Watson, *Newfoundland, 3 years old*

Heavyweights

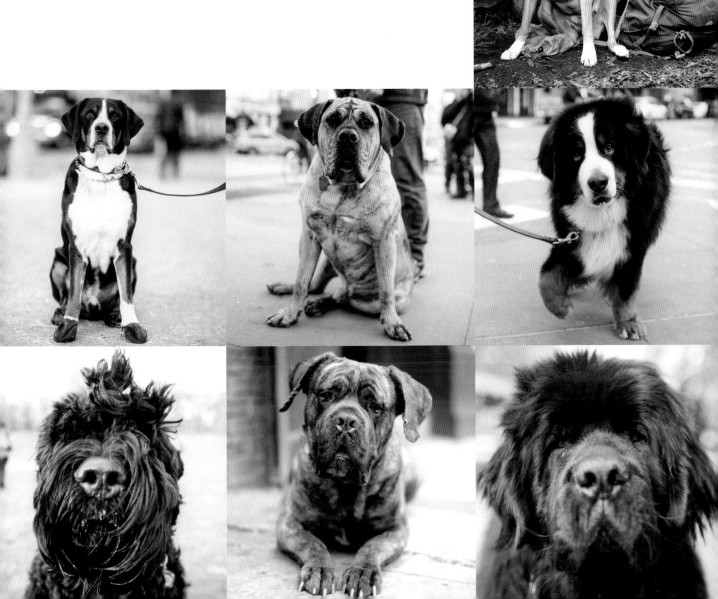

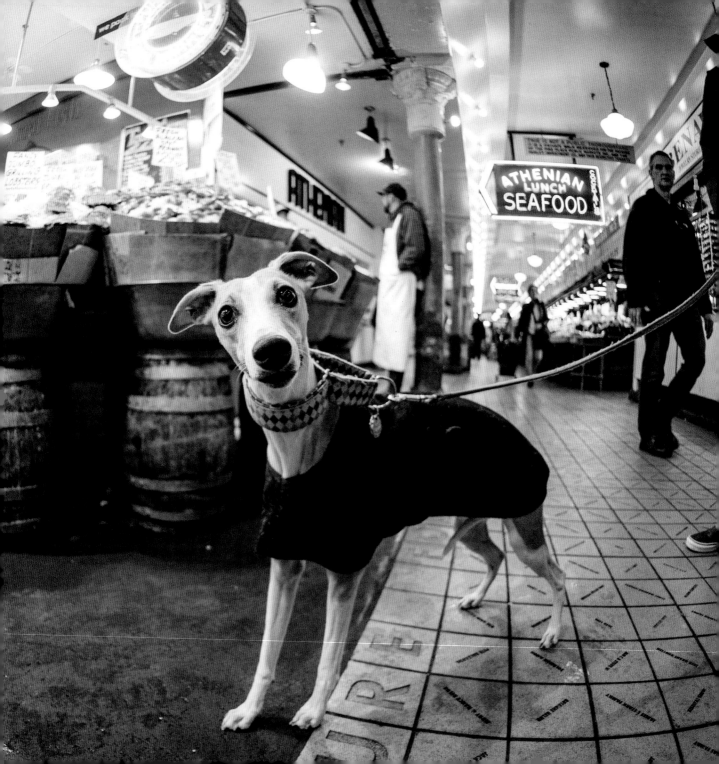

« **Sammy,** *Whippet, 18 months old, Pike Place Market, Seattle, Washington*

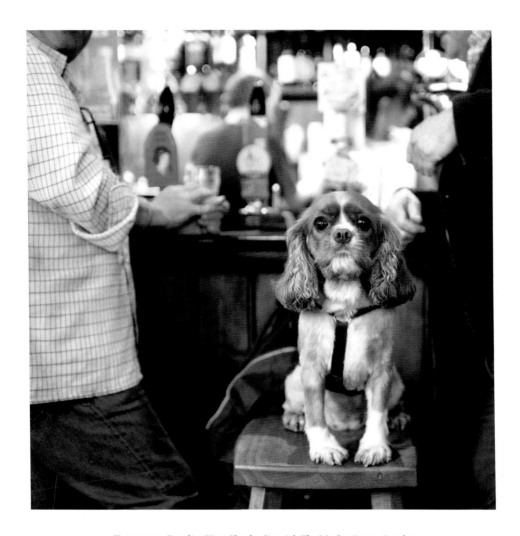

Tuppence, *Cavalier King Charles Spaniel, The Market Porter, London*

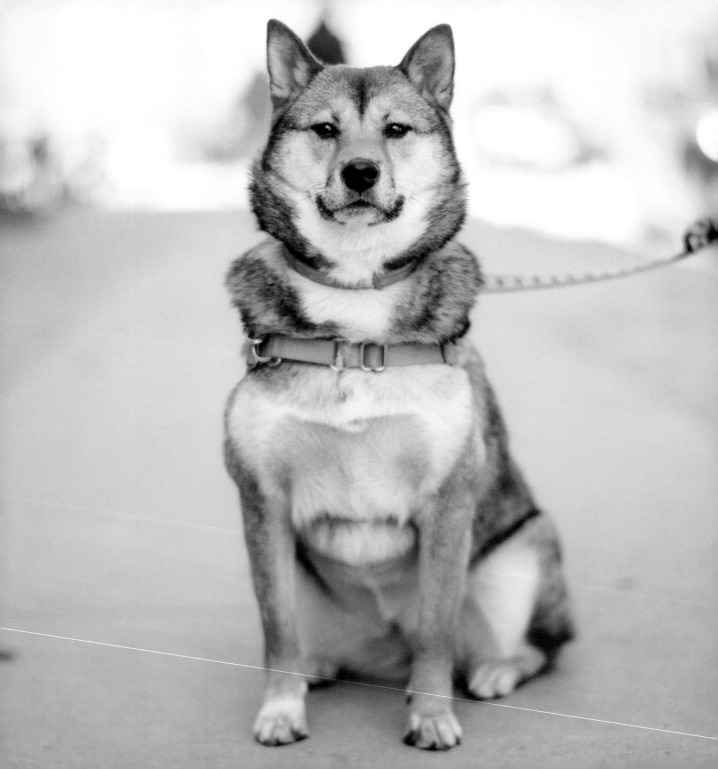

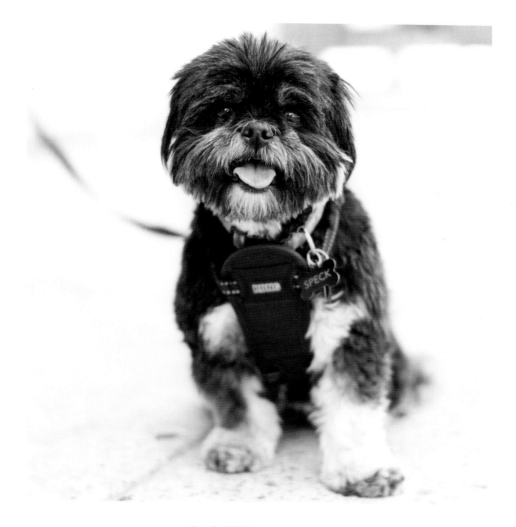

Speck, *Shih Tzu mix, 5 years old*

TOP ROW, LEFT TO RIGHT

Lady, *Standard Poodle*

Mómo, *Miniature Poodle*

Jolie, *Standard Poodle*

Simba, *Labradoodle*

Singe, *Lhasa Apso*

Amos, *Pomeranian mix*

BOTTOM ROW, LEFT TO RIGHT

Viking, *Standard Poodle*

Samson, *Goldendoodle, 1 year old*

Monkey, *Standard Poodle, 5 years old*

Hamlet, *Irish Water Spaniel*

Hawkeye, *Goldendoodle*

Arthur, *Irish Water Spaniel*

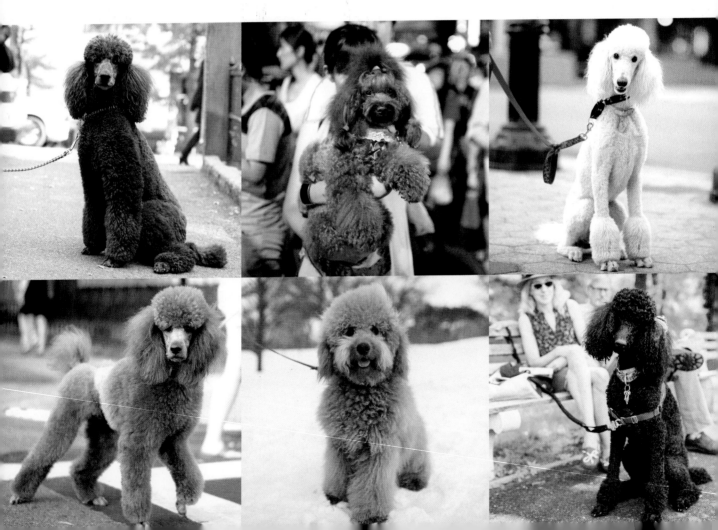

Haircuts

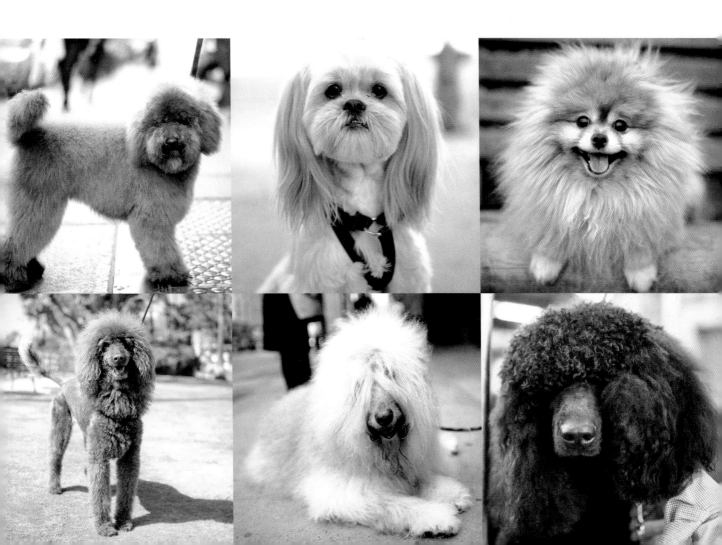

Sassy

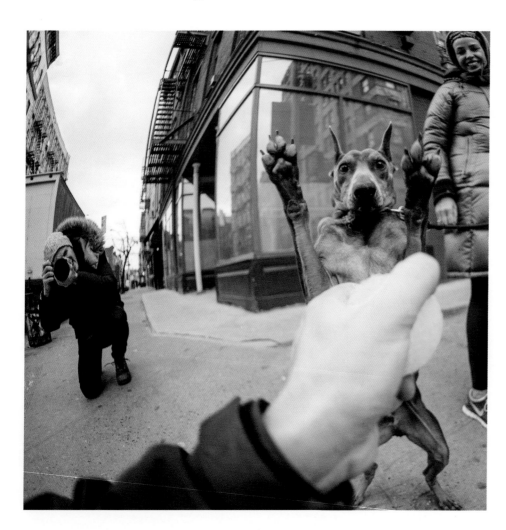

TOP ROW,
LEFT TO RIGHT

Chibi, *Pembroke*
Welsh Corgi,
6 months old

Dixie, *Pomeranian,*
5 months old

Nacho,
Chihuahua mix

CENTER ROW,
LEFT TO RIGHT

Goose,
Siberian Husky

Elle, *French Bulldog,*
5 years old

Cliff, *Whippet,*
3 years old

BOTTOM ROW,
LEFT TO RIGHT

Vivienne,
French Bulldog

Gary, *Eastern*
Gray Squirrel,
9 months old

Chloe, *Staffordshire*
Bull Terrier,
1 year old

« **Kal-El,** *German Pinscher,*
4 years old

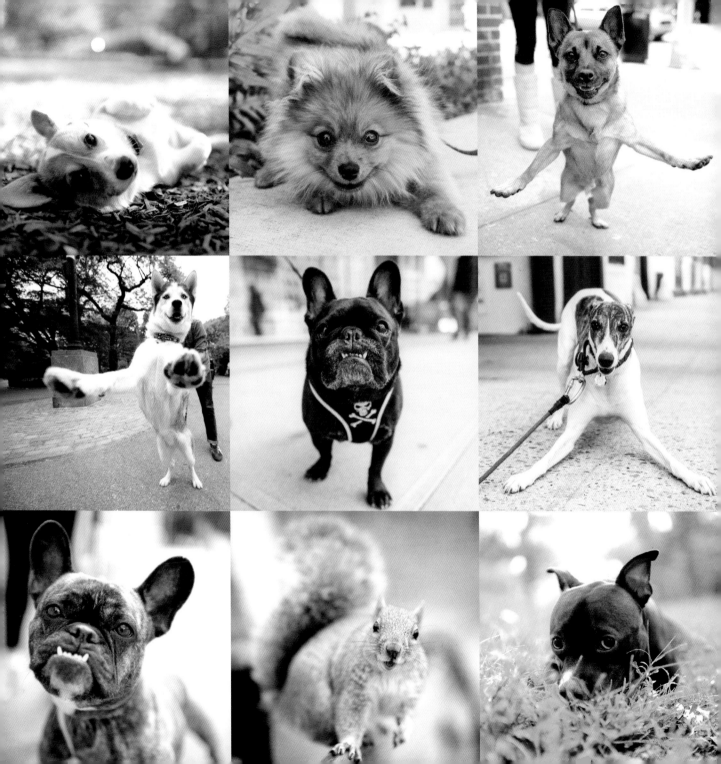

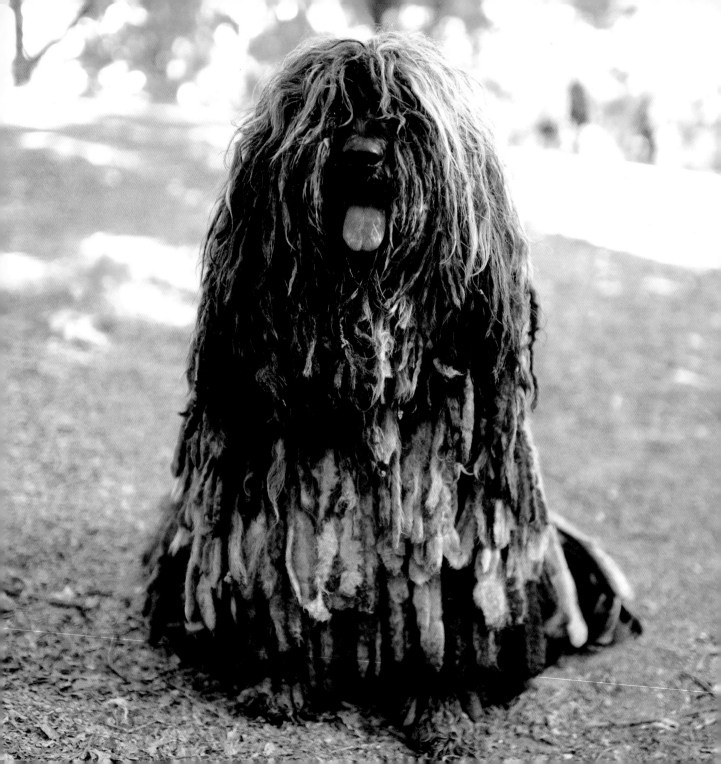

« Lola, *Bergamasco*

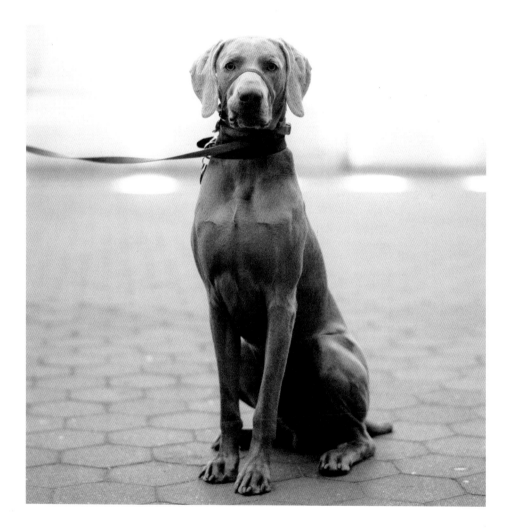

Nova, *Weimaraner, 22 months old*

Pairs

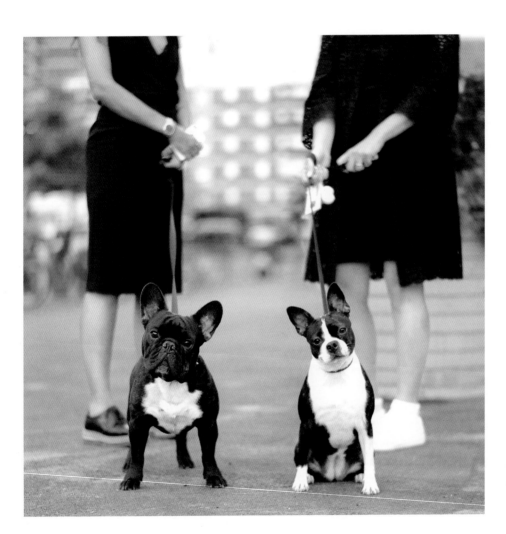

CLOCKWISE,
FROM TOP LEFT

Gordon and
Mister Peabody,
English Bulldogs

Aloe and **Elijah,**
*Labrador Retrievers,
2 and 10 years old*

Eloise and **Watson,**
*Miniature
Schnauzers*

Maggie and
Murphy, *Shih Tzus,
6 years and 1 year old*

« **Mario** and **Gina,**
*French Bulldog and
Boston Terrier*

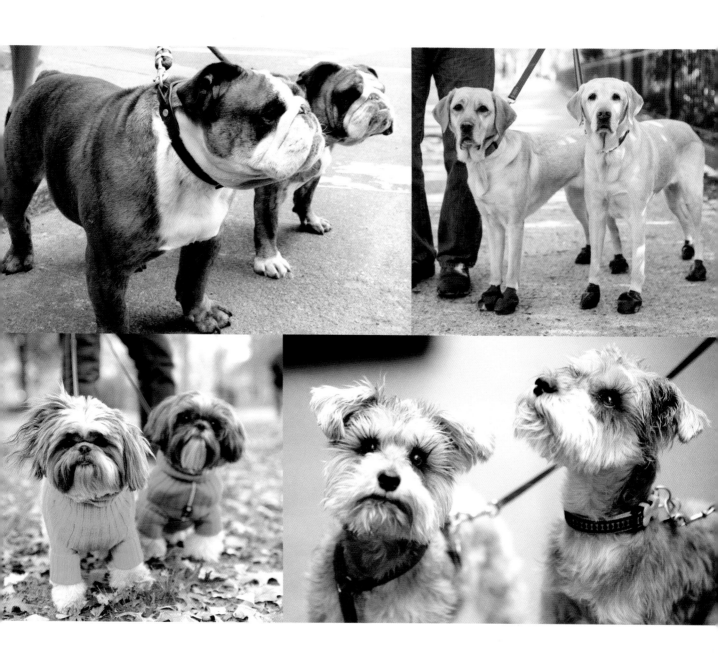

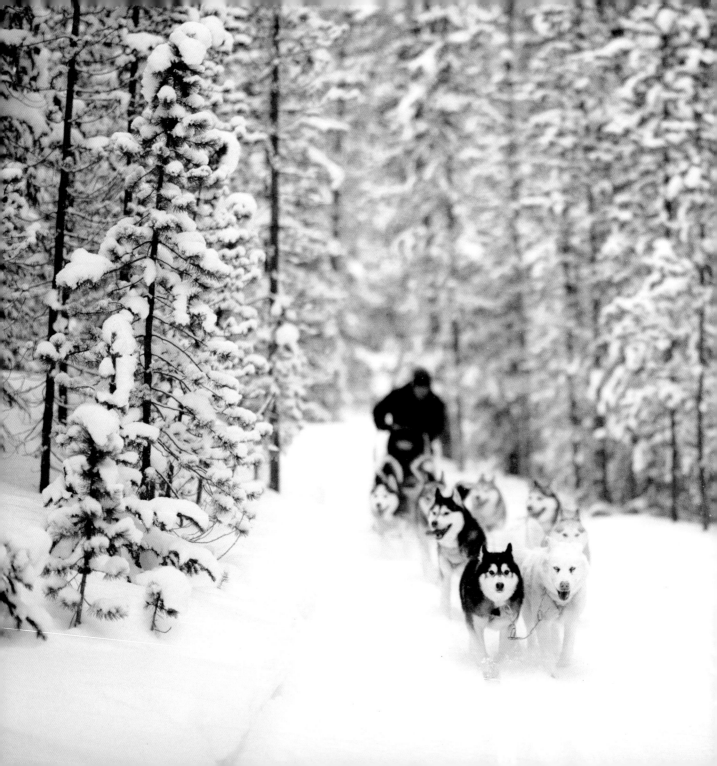

« Logan, Yeti, CJ, Pepper, Chug
Water, Dragon, Butterfingers,
and **Ozzie,** *Siberian Huskies,*
Breckenridge, Colorado

Sled Dogs

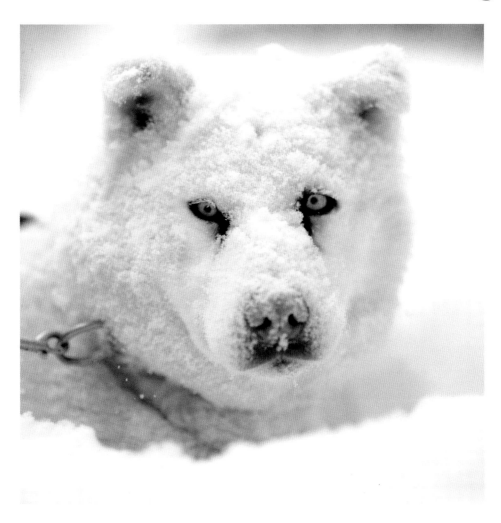

Yeti, *Siberian Husky*

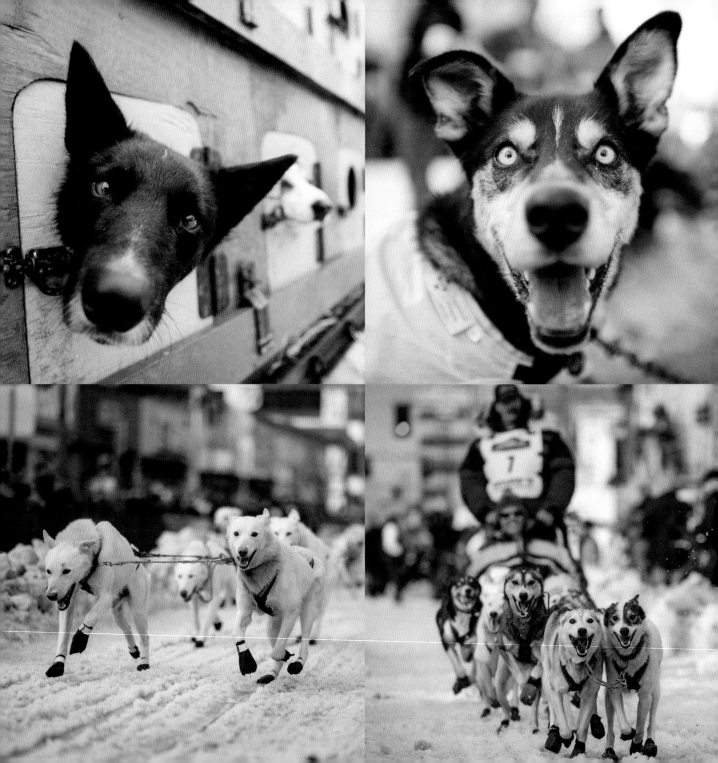

TOP ROW, LEFT TO RIGHT

Ruler and **Eraser,**
Alaskan Huskies

Stout, *Alaskan Husky*

BOTTOM ROW

Mushers and sled
dog teams prepare
to travel 979 miles
from Anchorage to
Nome, Alaska.

Iditarod

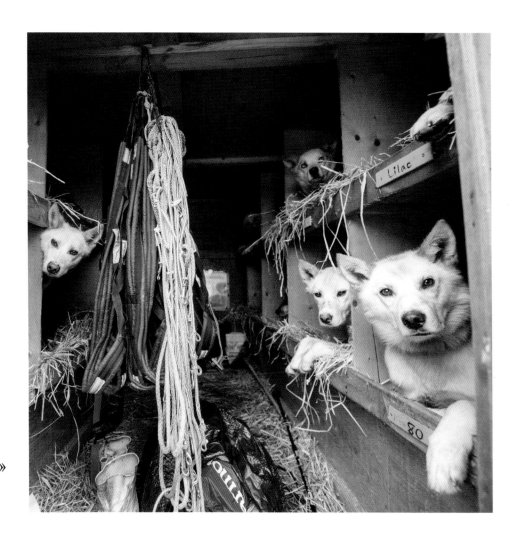

Lilac, 80, Tulip, and »
others, *Alaskan Huskies,*
2015 Iditarod Ceremonial
Start, Anchorage, Alaska

Fetch

CLOCKWISE,
FROM TOP LEFT

Hercules,
*Golden Retriever/
Hovawart mix*

Chapel, *Australian
Cattle Dog,
9 months old*

Hudson,
*Labrador Retriever,
6 years old*

Mowgli,
*Golden Retriever,
5 years old*

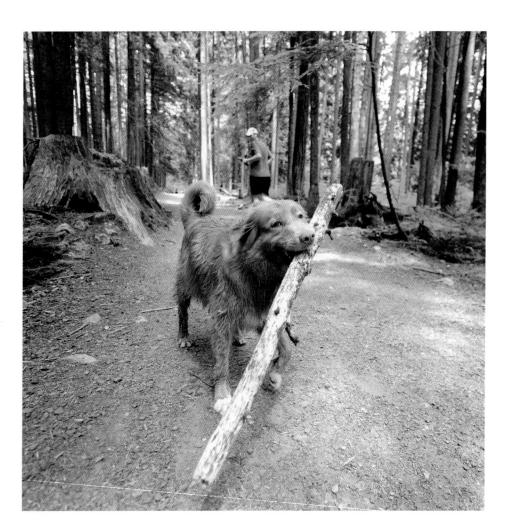

《 Angus, *Nova Scotia
Duck Tolling Retriever*

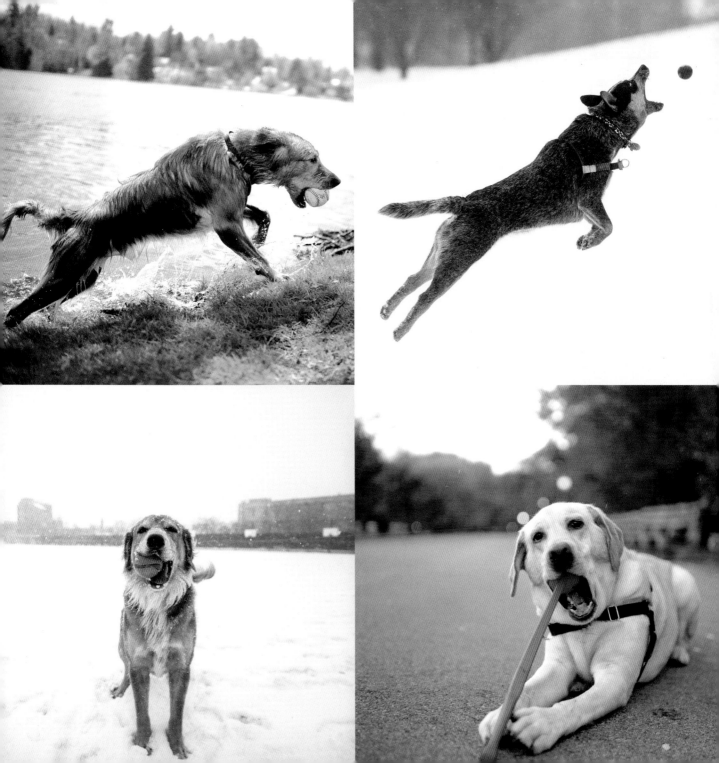

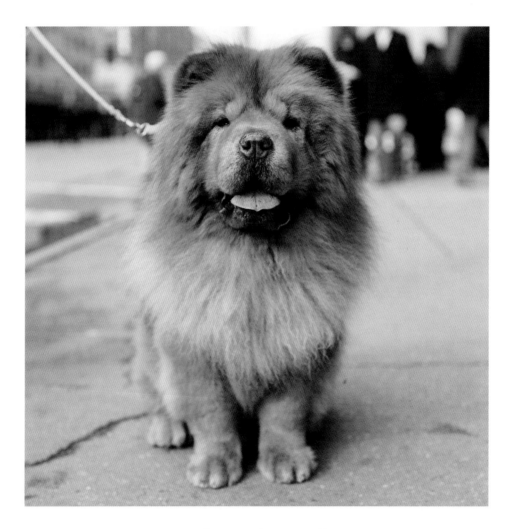

Bamboo, *Chow Chow, 7 years old*

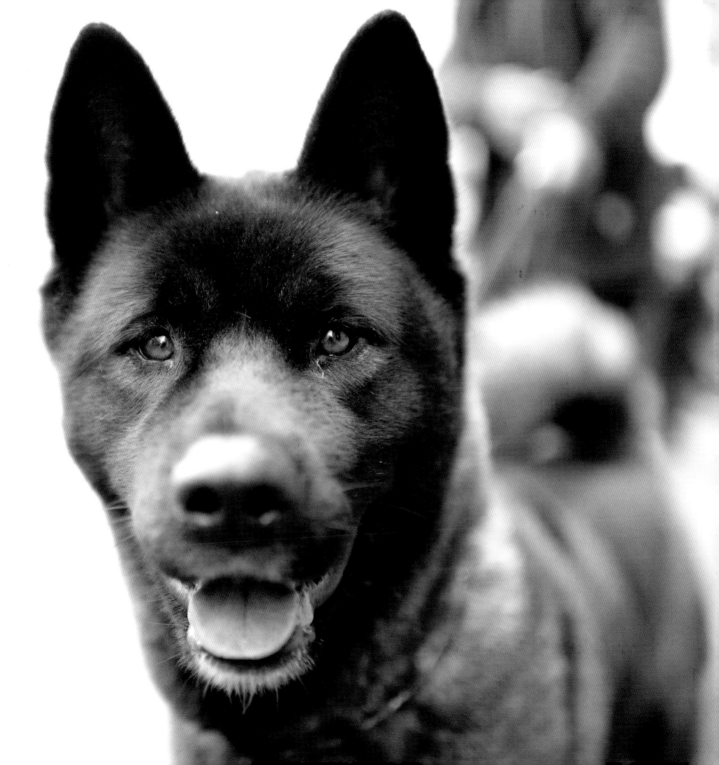

Shaking Paws

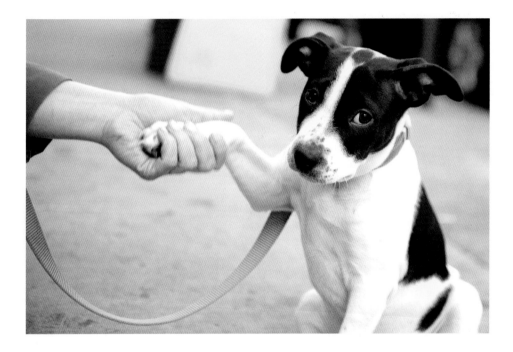

Starsky, *mix, 2 months old*

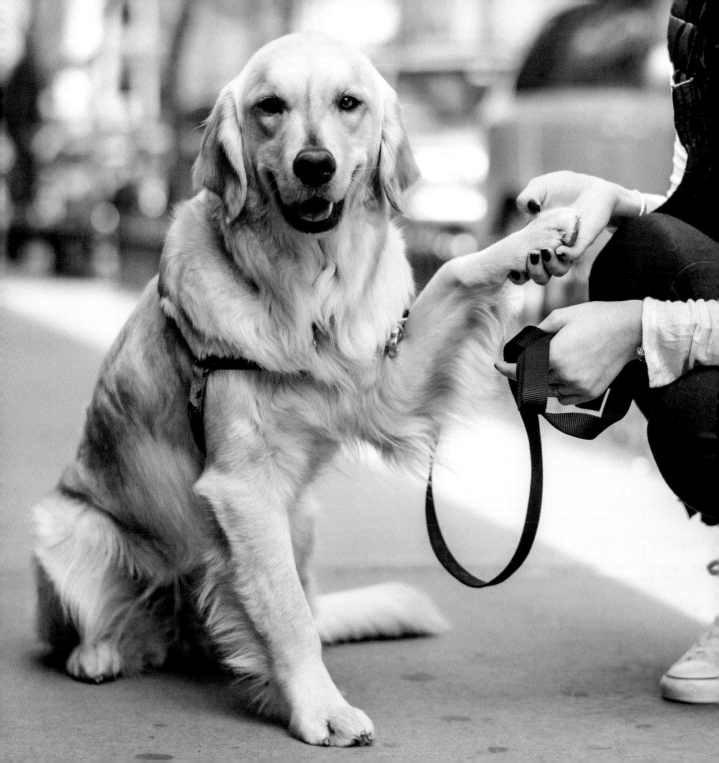

Head Tilts

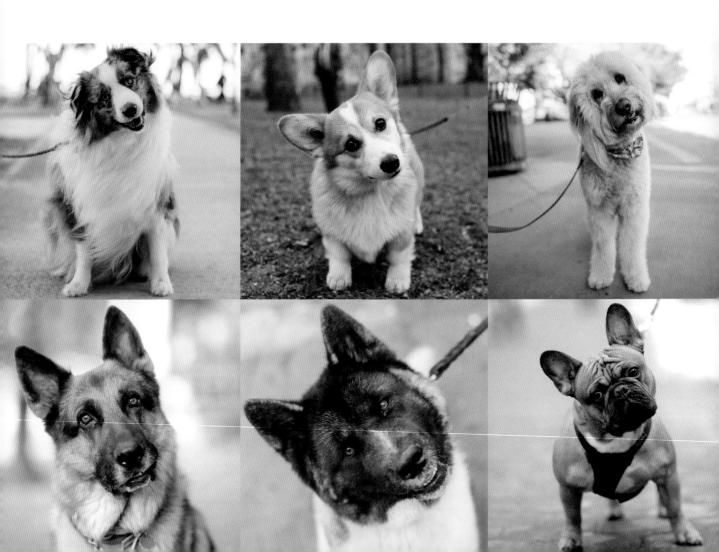

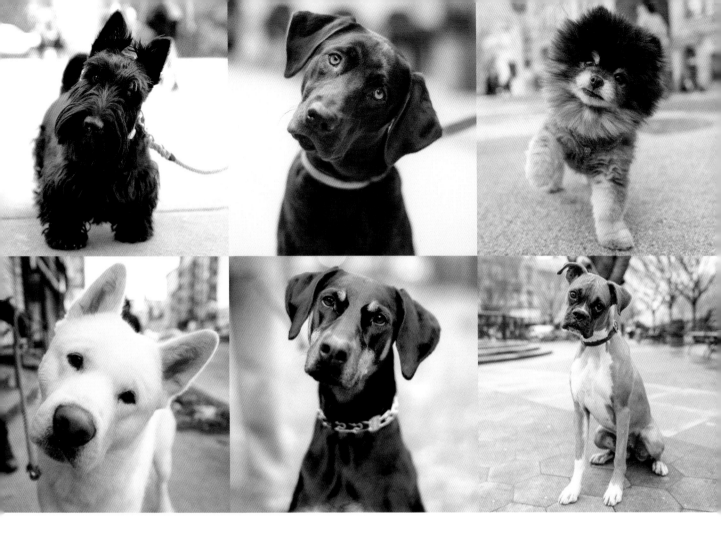

TOP ROW, LEFT TO RIGHT

Wallace, *Scottish Terrier*

Luna, *Labrador Retriever, 8 months old*

Pebbles, *Pomeranian, 14 years old*

CENTER ROW, LEFT TO RIGHT

Wyatt, *Australian Shepherd, 4 years old*

Hastings, *Pembroke Welsh Corgi, 6 months old*

Marti, *Labradoodle, 4 years old*

Reggie, *Akita, 2 years old*

Rita, *Doberman Pinscher, 8 years old*

Wallice, *Boxer, 9 months old*

BOTTOM ROW, LEFT TO RIGHT

Denker, *German Shepherd*

Charlie, *Akita, 3 years old*

Bobby, *French Bulldog*

"Black Malinois don't really exist, so she's a unicorn (and a rescue)."

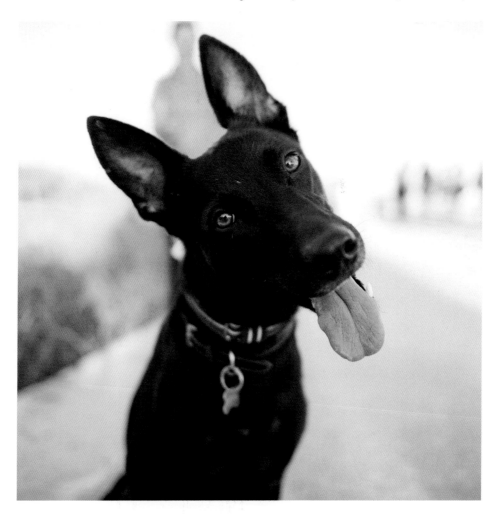

Baci, *Belgian Malinois, 4 years old*

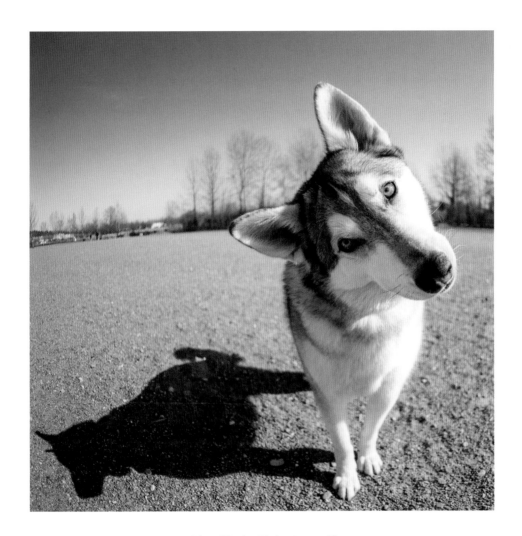

Blue, *Siberian Husky, 4 years old*

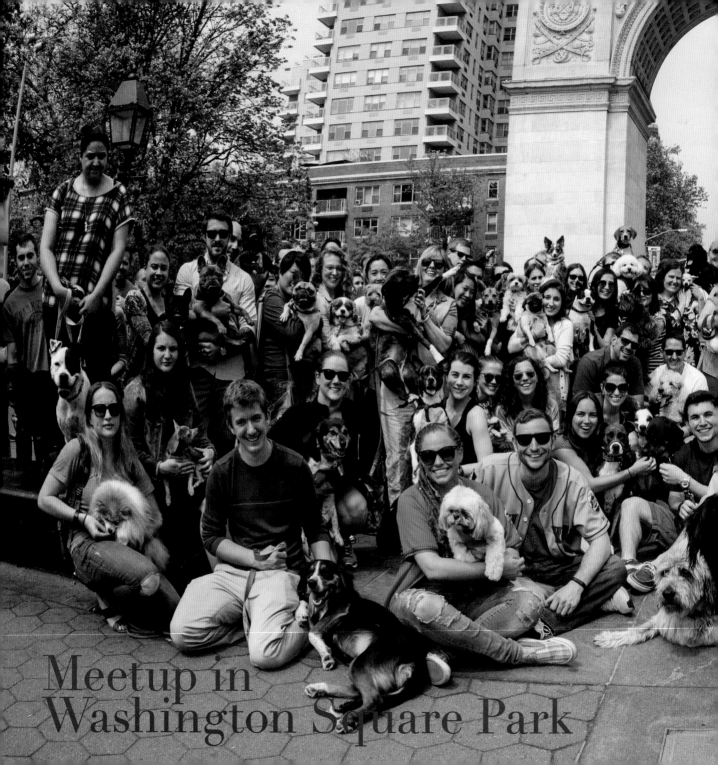

Meetup in
Washington Square Park

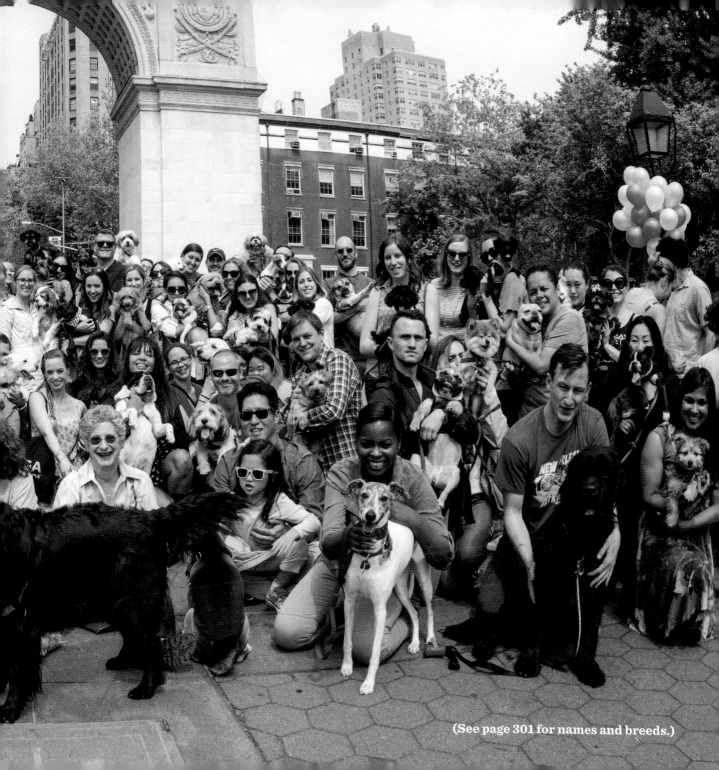

(See page 301 for names and breeds.)

Rare Breeds

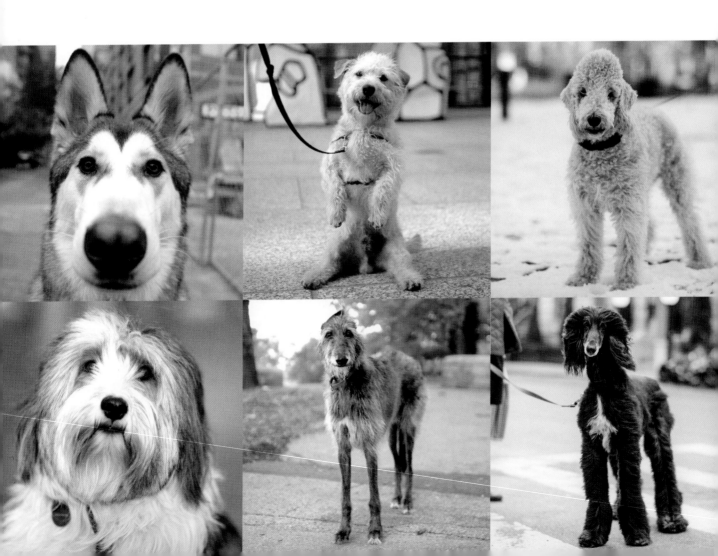

TOP ROW, LEFT TO RIGHT

Oscar, *Sealyham Terrier, 5 months old;* **Curry,** *Thai Ridgeback, 5 years old*

CENTER ROW, LEFT TO RIGHT

Rikku, *Tamaskan;* **Ronan,** *Glen of Imaal Terrier, 1 year old;* **Ki,** *Bedlington Terrier, 7 years old;* **Theo,** *Berger Picard, 10 months old;* **Liuli,** *Formosan Mountain Dog, 2 years old*

BOTTOM ROW, LEFT TO RIGHT

Sadie, *Polish Lowland Sheepdog;* **Hamlet,** *Scottish Deerhound, 8 years old;* **Beauty,** *Afghan Hound, 6 years old;* **Baloo,** *Hovawart;* **Carmen,** *Peruvian Inca Orchid, 4 years old;* **Kicsi,** *Puli, 4 years old*

Ninja (aka The Fart Assassin), *French Bulldog, 2 years old*

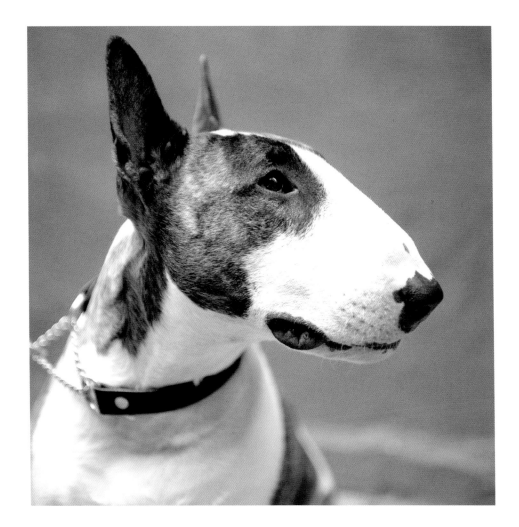

Neville, *Bull Terrier*

Hunting

TOP ROW

Dux, *Kleine Münsterländer,* »
Willowemoc Wild Forest,
Sullivan County, New York

BOTTOM ROW, LEFT TO RIGHT

Ea and **Dux,** *Kleine*
Münsterländers

This versatile hunting breed, Kleine Münsterländer, learns exercises like retrieving a fox over water and pointing, flushing, and retrieving chukars.

Leica and **Dux,** *Kleine Münsterländers, Bethel, New York*

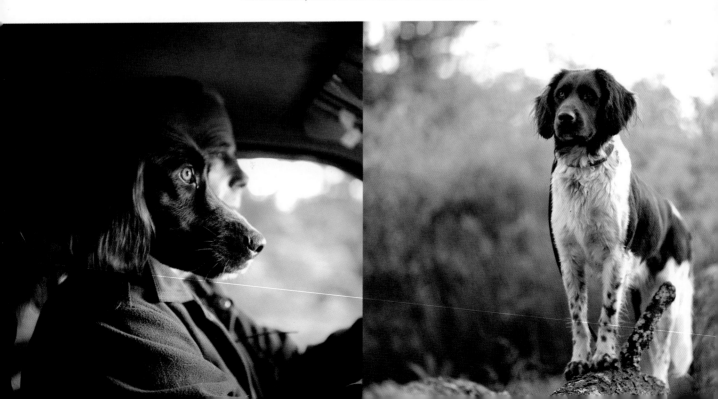

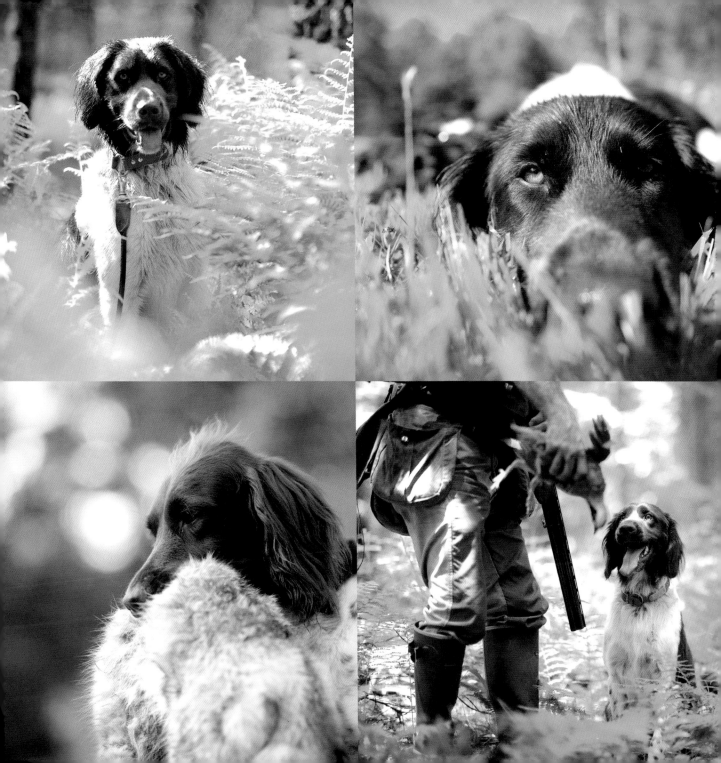

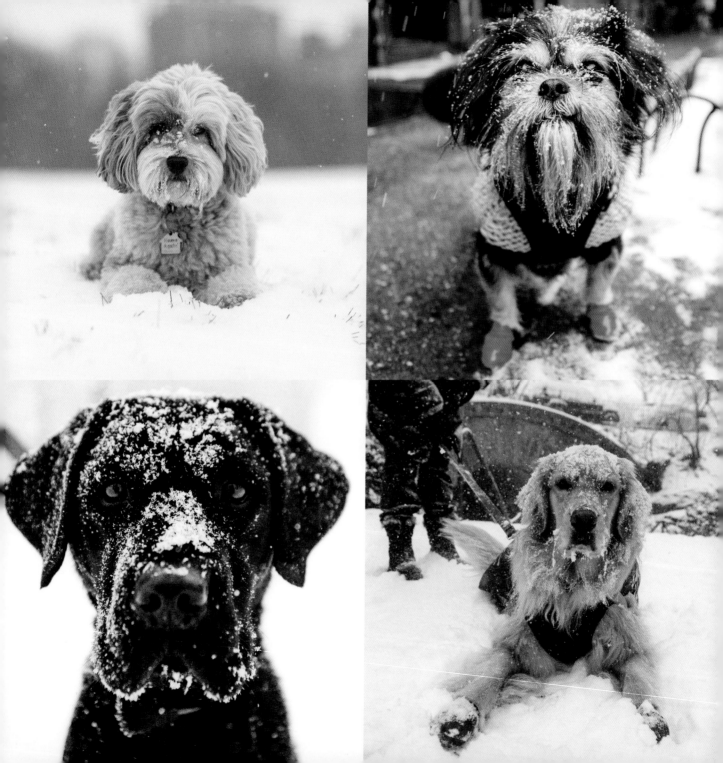

Thayer,
Miniature Labradoodle,
3 years old

Momo,
Shih Tzu/Yorkshire
Terrier mix,
8 years old

Shelby,
Golden Retriever,
3 years old

Truffle,
Labrador Retriever,
3 years old

Snow

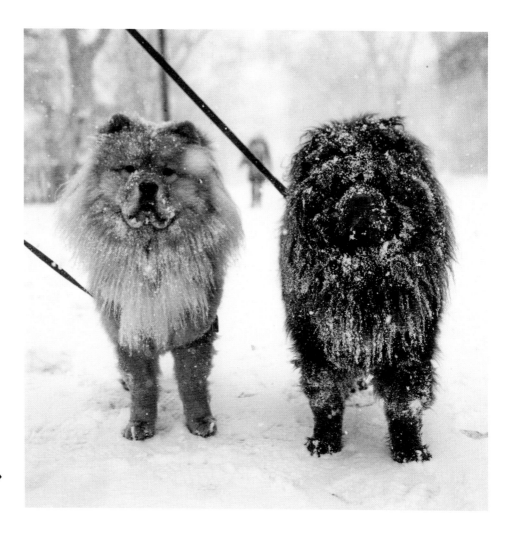

Rojo and **Rio,** »
Chow Chows,
1 and 6 years old

Pampered Pooches

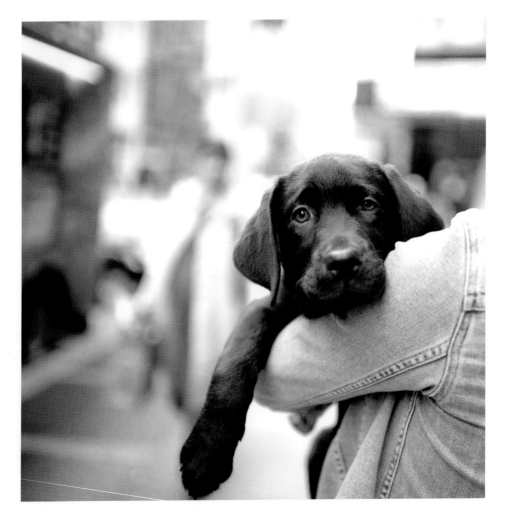

Mason, *Labrador Retriever, 3 months old*

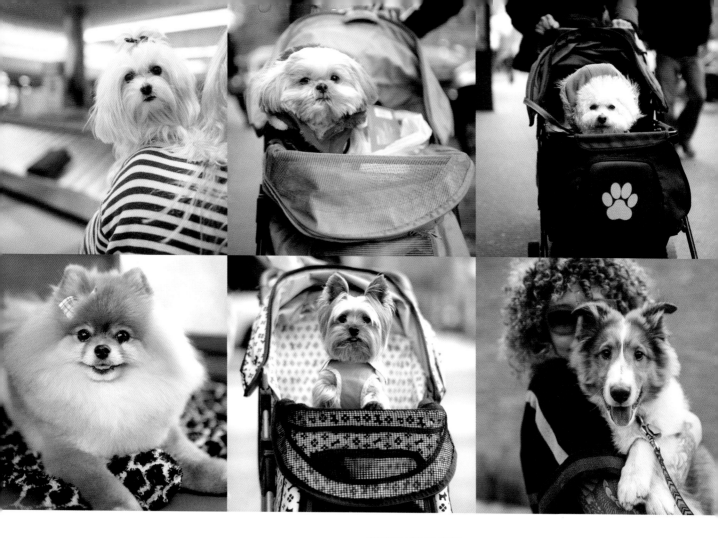

TOP ROW, LEFT TO RIGHT

Trip, *Maltese, 1 year old*

Chloe, *Shih Tzu, 7 years old*

Shana, *Bichon Frise*

BOTTOM ROW, LEFT TO RIGHT

Jasmine, *Pomeranian*

Bentley, *Yorkshire Terrier, 6 years old*

Bochy, *Shetland Sheepdog, 4 months old*

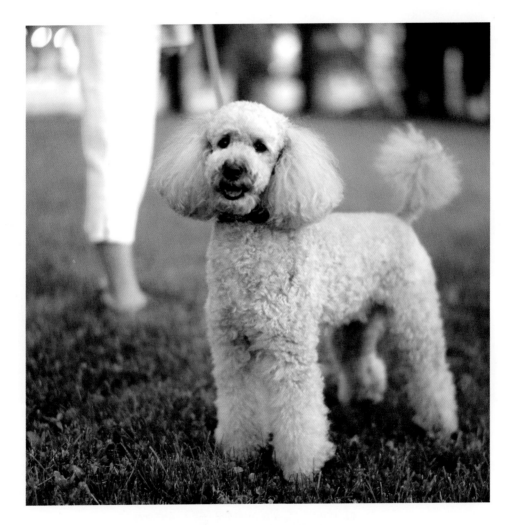

Peppermint, *Miniature Poodle*

"She likes to climb trees."

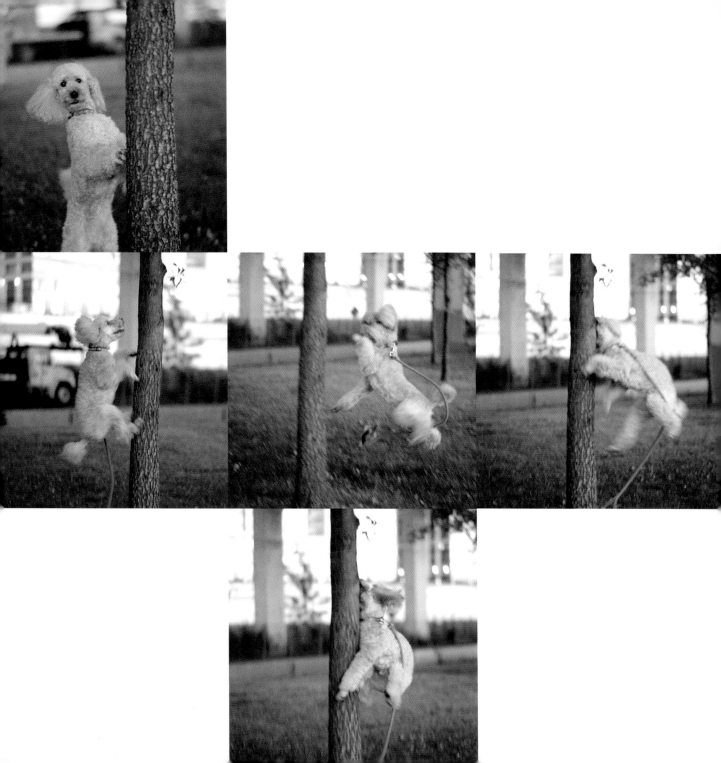

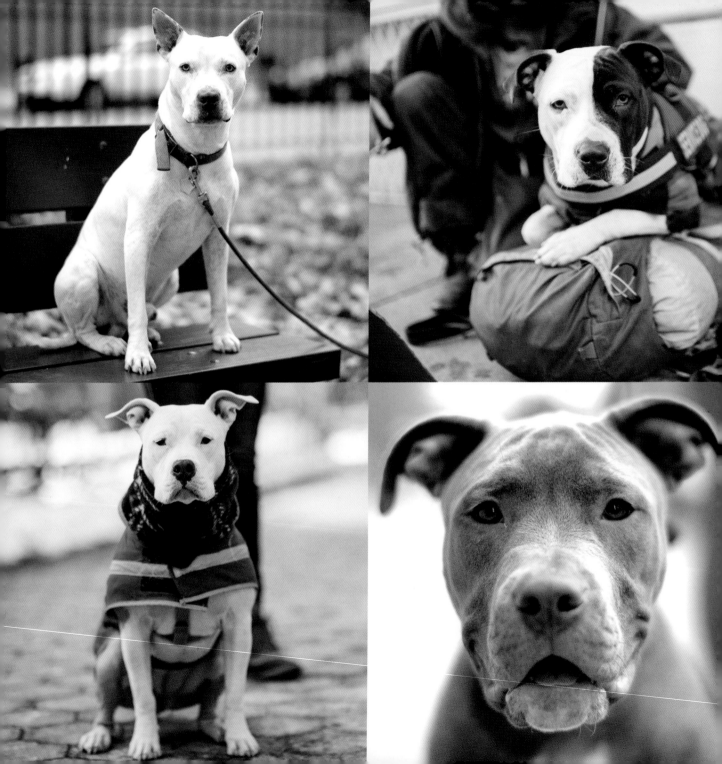

CLOCKWISE,
FROM TOP LEFT

Luke

Athena, *1 year old*

King

Stella, *1 year old*

Pit Bulls

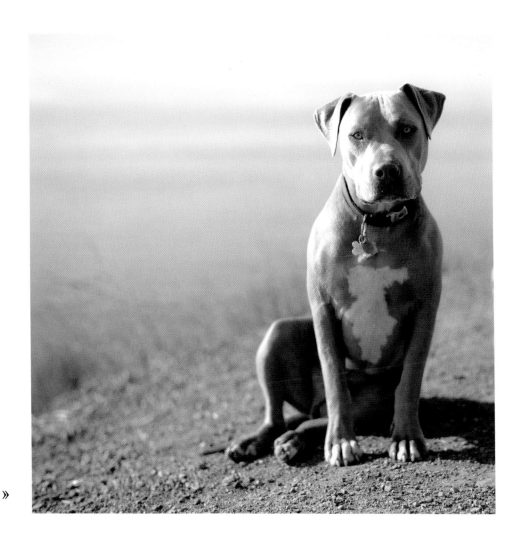

Bane, *9 months old,* »
Big Sur, California

Therapy Dogs

These certified therapy dogs from The Good Dog Foundation visit students at elementary schools to listen patiently while the children practice their reading skills.

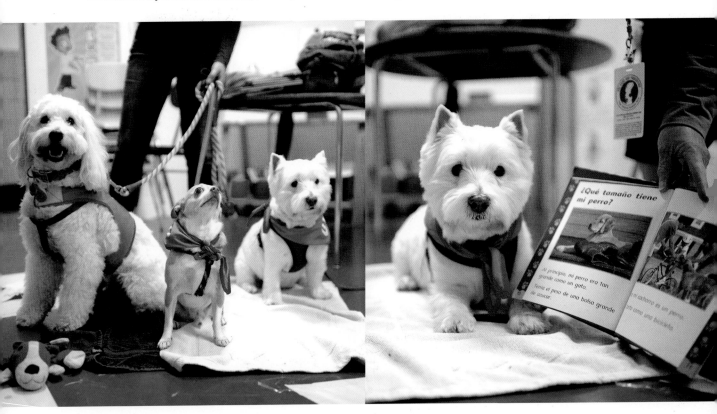

Sparky, Lucky, *and* **Snowball,** *Miniature Goldendoodle, Chihuahua, and West Highland White Terrier, P.S. 75, New York City*

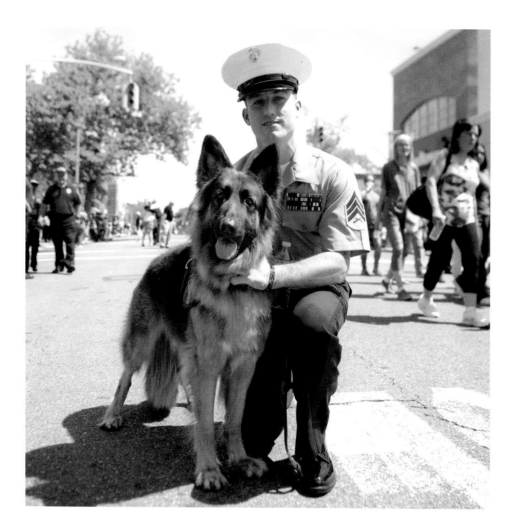

Diesel, *German Shepherd, Bay Ridge, Brooklyn, New York*

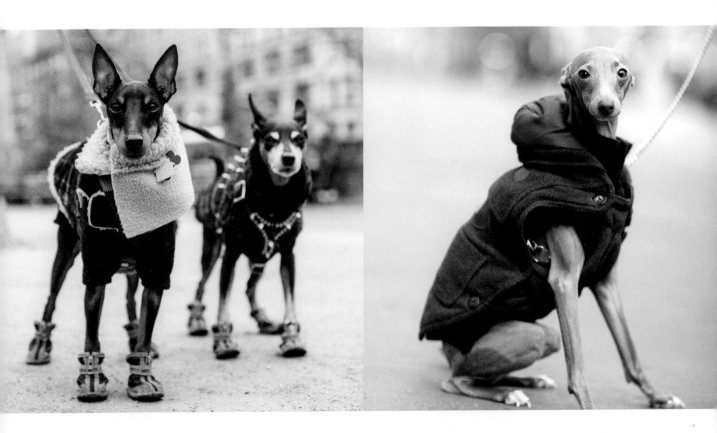

Seeker and **Cliff,** *Manchester Terrier and*
Miniature Pinscher, 3 and 13 years old

Cleo, *Italian Greyhound*

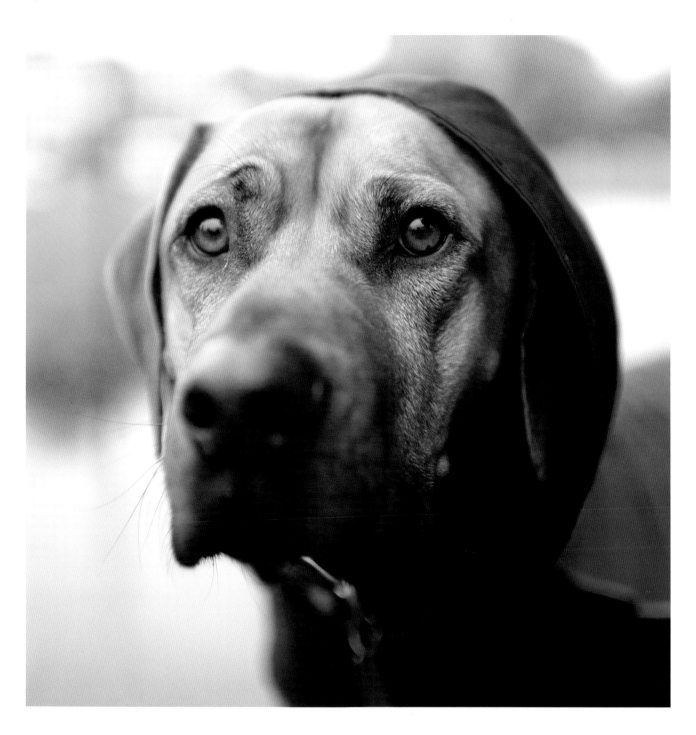

Sharp Dressers

TOP ROW, LEFT TO RIGHT

Saarinen, *Beagle mix, 1 year old;* **Calypso,** *Pug;* **Lady,** *Weimaraner, 10 years old*

CENTER ROW, LEFT TO RIGHT

Nathan, *Yorkshire Terrier;* **Brody,** *Dachshund, 4 years old;* **Bobby,** *Maltese, 6 months old;* **Cobi,** *Schnorkie (Miniature Schnauzer/ Yorkshire Terrier mix), 2 years old;* **Bonnie,** *Boston Terrier, 7 years old;* **Wayne,** *Boston Terrier*

BOTTOM ROW, LEFT TO RIGHT

Desi, *Yorkshire Terrier, 5 years old;* **Larry,** *Whippet, 4 months old;* **Bacon,** *Miniature Pinscher;* **Lulu,** *Boxer, 5 months old;* **Linus,** *Toy Poodle;* **Romeo,** *Pit Bull*

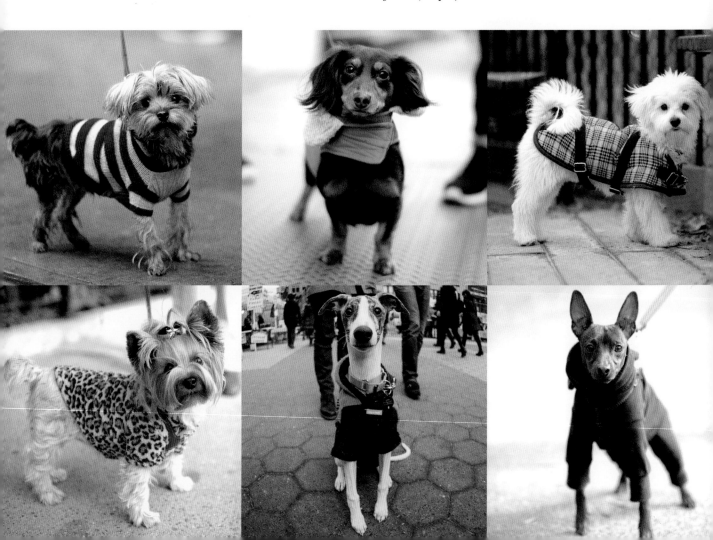

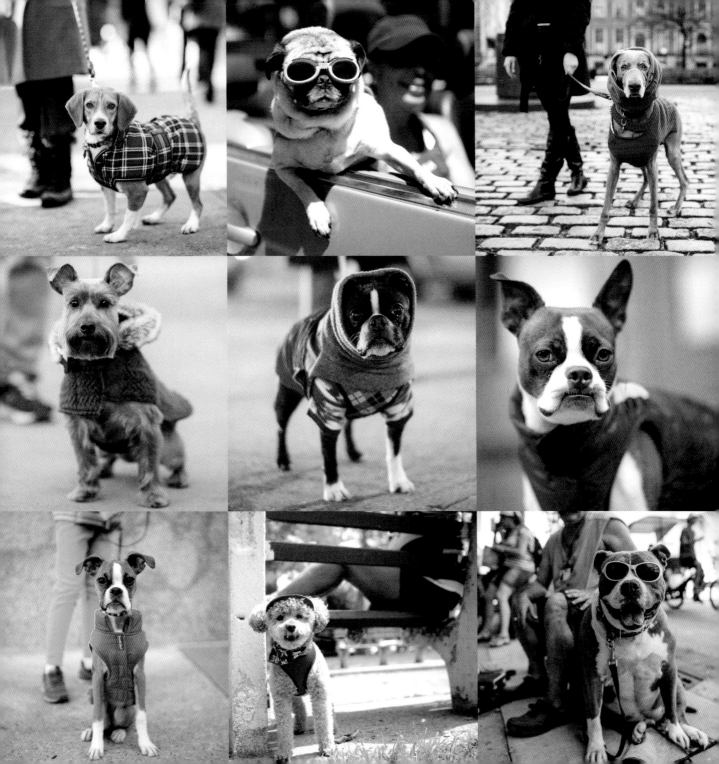

Close-up

Travis, *German Shorthaired Pointer,*
12 years old, Vancouver, British Columbia

TOP ROW, FROM LEFT

Crom, *Cane Corso, 2 years
old;* **Franklin,** *Pit Bull;*
Augustus Gloop, *Siberian
Husky, 3 years old*

CENTER ROW, FROM LEFT

Oliver, *Siberian Husky,
2 years old;* **Maya,** *Labrador
Retriever mix, 6 months old;*
Sofie, *Miniature
Australian Shepherd*

BOTTOM ROW, FROM LEFT

Stella, *Pit Bull/
Labrador Retriever mix;*
Noodle, *Shiba Inu, 6 months
old;* **Danger,** *Boston Terrier*

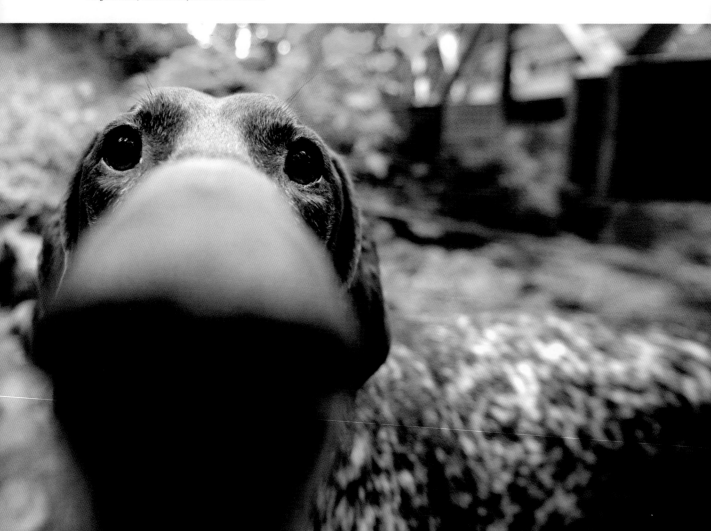

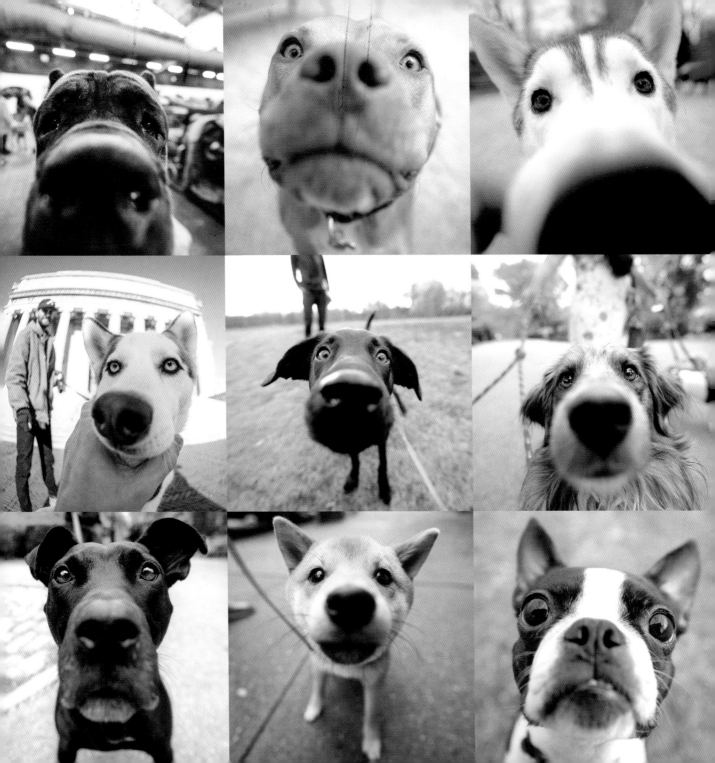

Puppies

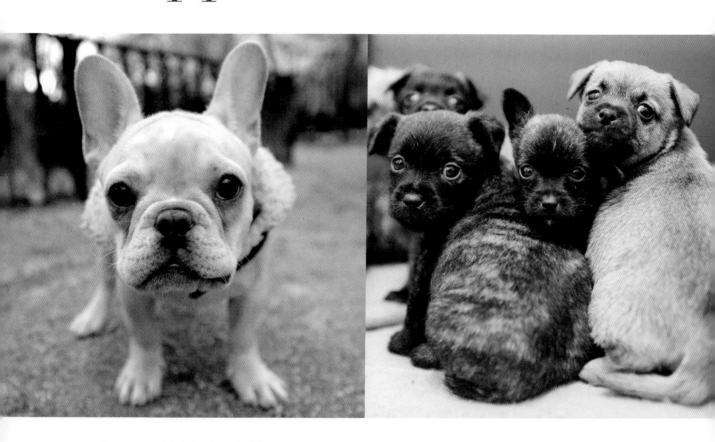

Peanut, *French Bulldog, 4 months old*

Terrier mix puppies, 2 weeks old

Buttercup, *Pit Bull/Terrier mix, 8 weeks old*

Dot, *Australian Cattle Dog, 4 months old*

Tri-pawed

《 Mogwai, *French Bulldog*

Rio, *Spitz/Pomeranian mix*

"He eats his liver with fava beans and a nice Chianti."

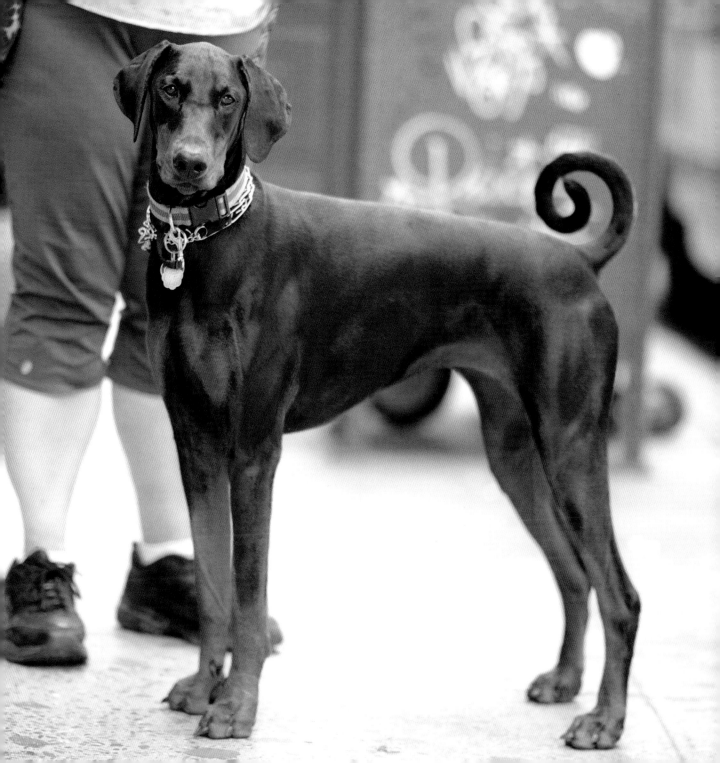

Bulldogs

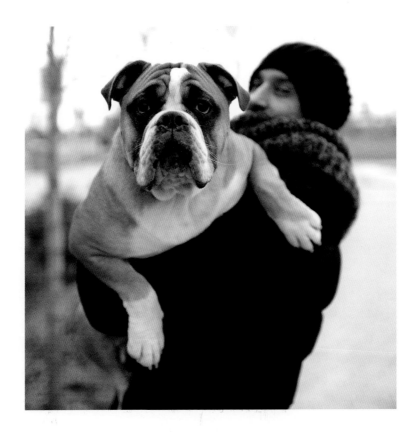

Max, *English Bulldog, 7 months old*

"He wants to go back to the park."

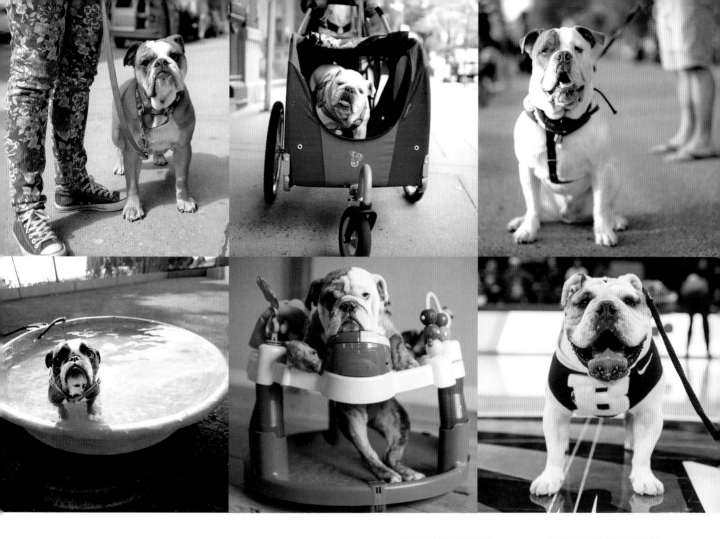

TOP ROW, LEFT TO RIGHT

Gracie

Lady, *11 years old*

Maxwell

BOTTOM ROW, LEFT TO RIGHT

Matilda

Francis

Butler Blue the Third
(aka Trip)

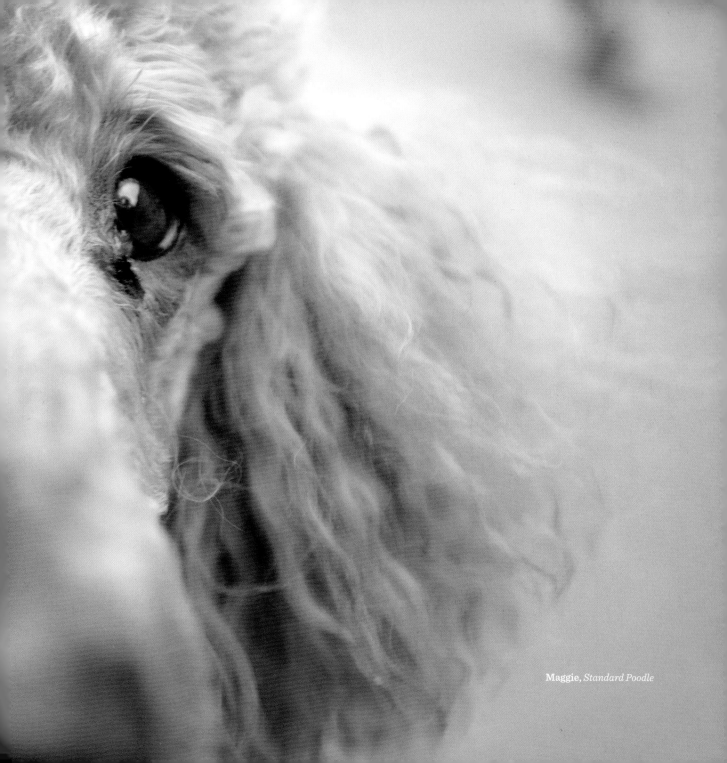

Maggie, *Standard Poodle*

Sweaters

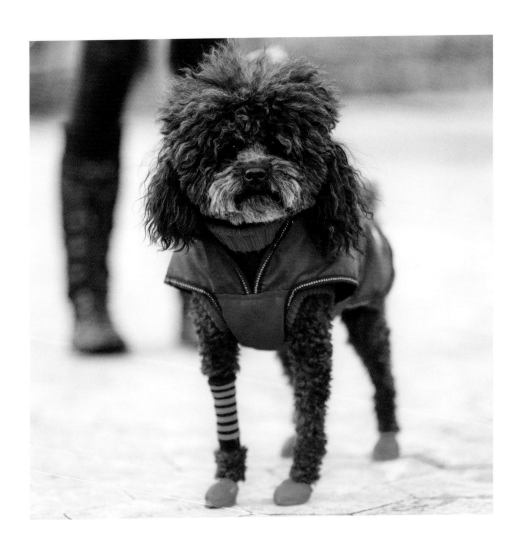

TOP ROW,
LEFT TO RIGHT

Khalessi,
Dachshund

Cinnamon, *Morkie
(Maltese/Yorkshire
Terrier mix),
2 years old*

Aldo, *Yorkshire
Terrier*

CENTER ROW,
LEFT TO RIGHT

Augusta, *Rhodesian
Ridgeback, 1 year old*

Koji, *Japanese Chin*

Jelly Bean, *Shar Pei,
7 years old*

BOTTOM ROW,
LEFT TO RIGHT

Dri, *German
Pinscher, 12 years old*

Zoey, *Dachshund,
2 years old*

Mina, *Italian
Greyhound*

《 **BB,** *Miniature Poodle,
4 years old*

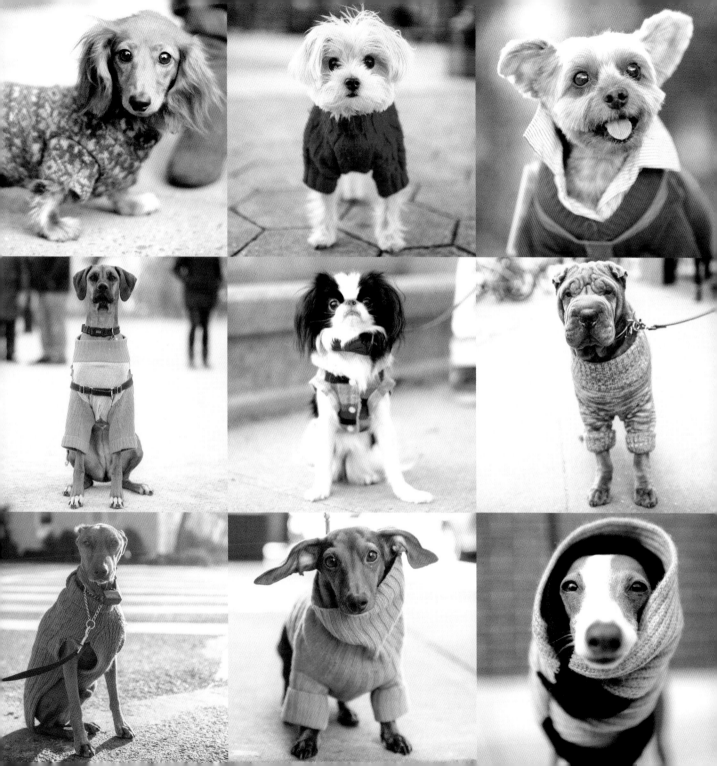

Doodles

TOP ROW, LEFT TO RIGHT

Noah, *Miniature Goldendoodle, 4 months old;* **Harry,** *Goldendoodle, 4 months old;* **Boo Radley,** *Australian Labradoodle*

CENTER ROW, LEFT TO RIGHT

Opal, *Sheepadoodle, 5 months old;* **Otto,** *Bernedoodle, 17 months old;* **Max,** *Labradoodle, 4 months old;* **Bentley,** *Labradoodle, 7 years old;* **Teddy,** *Goldendoodle;* **Bojangles,** *Goldendoodle*

BOTTOM ROW, LEFT TO RIGHT

Parker, *Miniature Labradoodle, 5 months old;* **Hula,** *Miniature St. Berdoodle;* **Roscoe,** *Goldendoodle, 3 years old;* **Pinot,** *Labradoodle, 5 years old;* **Cassius,** *Boxerdoodle, 1 year old;* **Baker,** *Labradoodle*

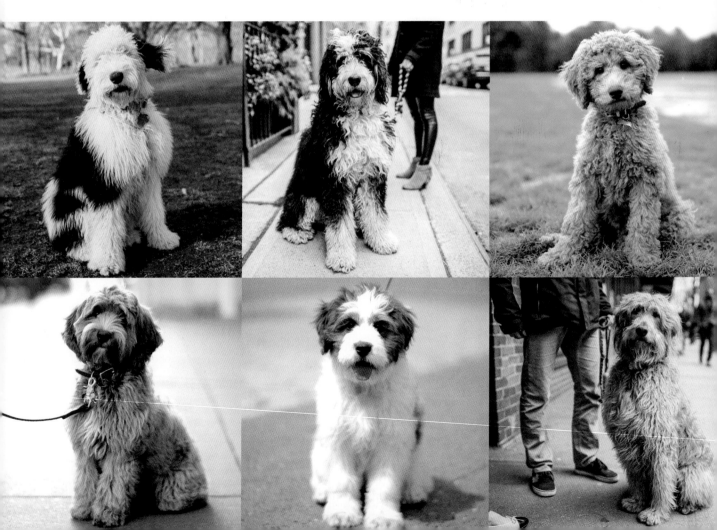

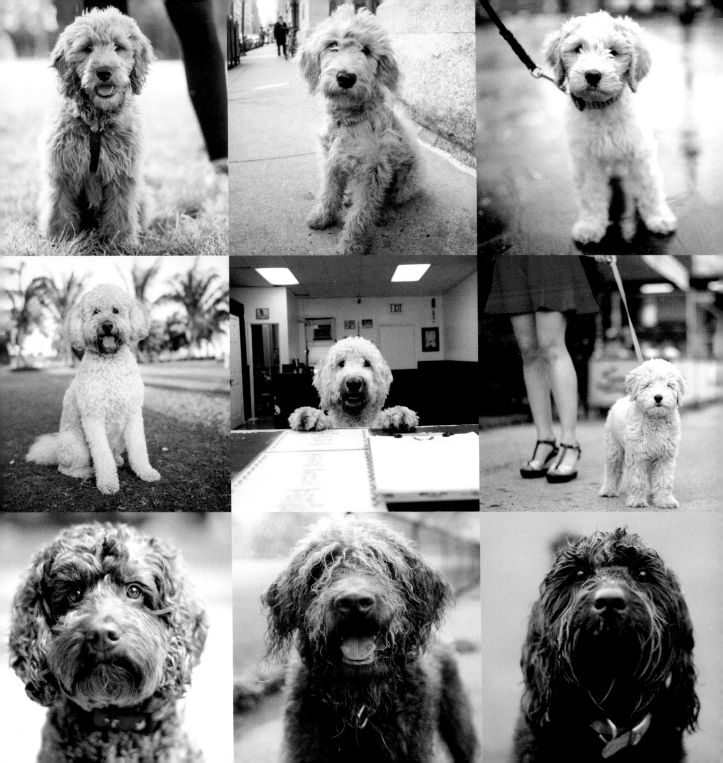

Bionic

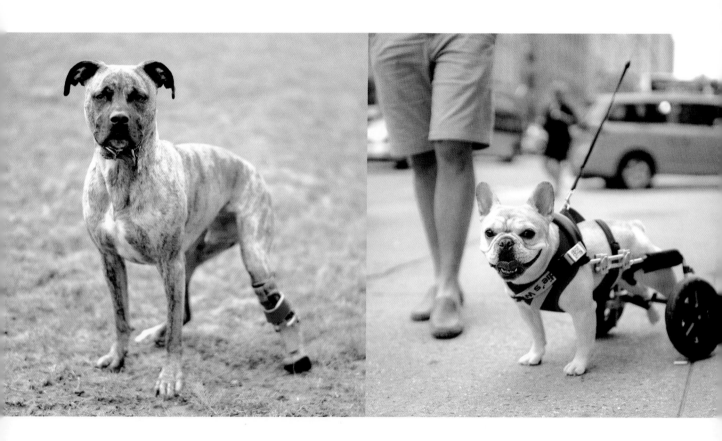

Farley, *Pit Bull/Boxer mix*

Connie, *French Bulldog*

"People look at her and think she's disabled.

We consider her 'specially abled.'"

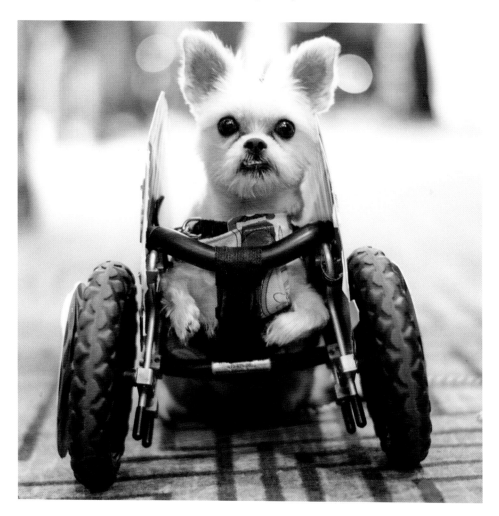

Lexi, *mix, 1 year old*

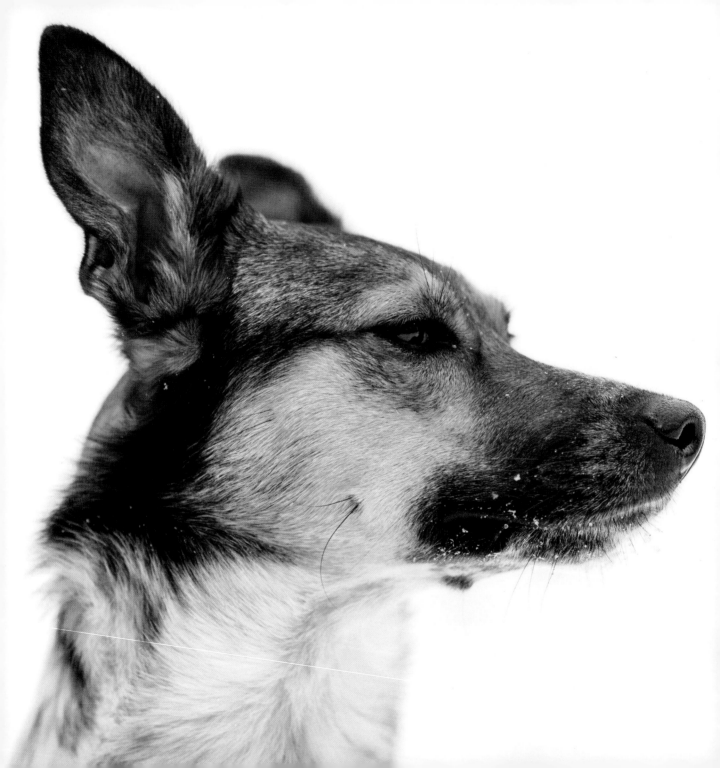

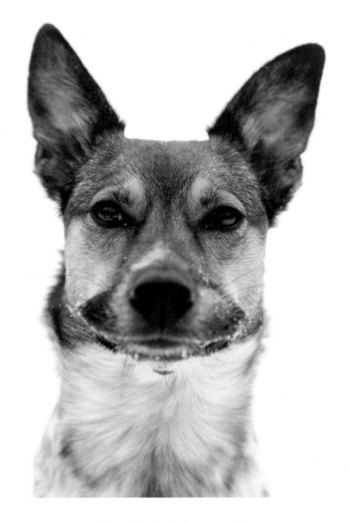

Greta, *Shepherd mix, 3 years old*

Puppies

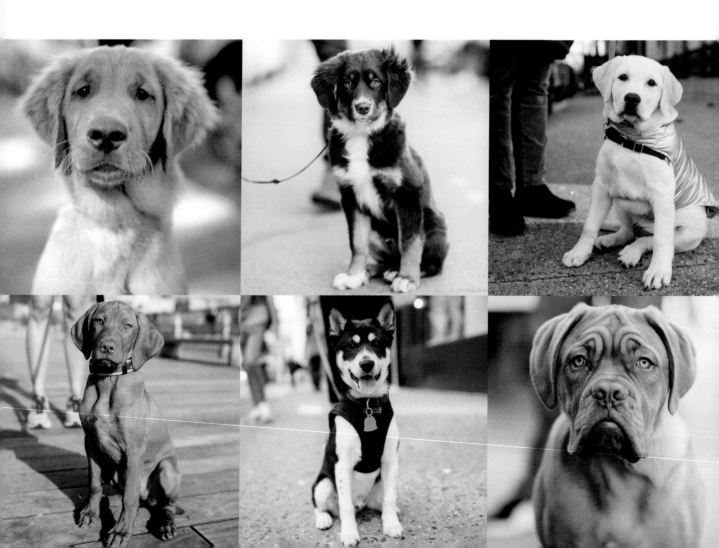

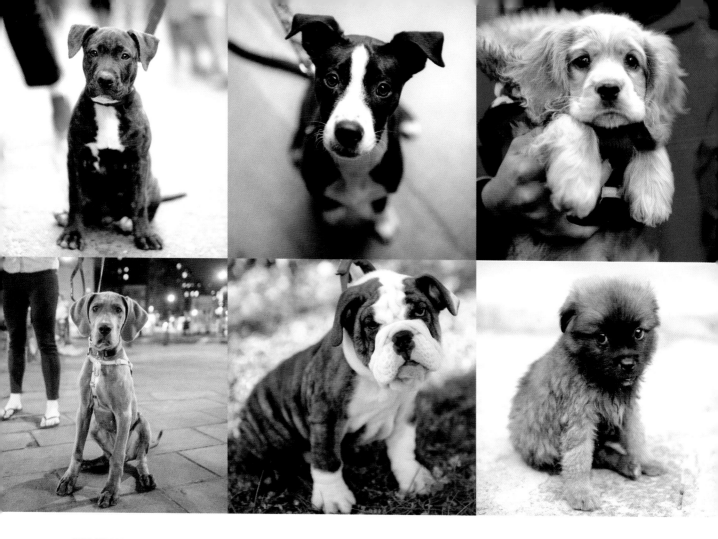

TOP ROW, LEFT TO RIGHT

Pek, *Pit Bull, 3 months old*

Olive, *Pit Bull/Labrador Retriever/ Boston Terrier mix, 6 months old*

Tokey, *Cocker Spaniel, 9 weeks old*

CENTER ROW, LEFT TO RIGHT

August, *Golden Retriever, 5 months old*

Marlow, *Miniature Australian Shepherd, 4 months old*

Nico, *Labrador Retriever, 3 months old*

Frankie, *Great Dane, 4 months old*

MJ, *English Bulldog, 2 months old*

Stray dog, *from Yangshuo, China*

BOTTOM ROW, LEFT TO RIGHT

Finn, *Vizsla, 3 months old*

Spence, *Shiba Inu, 16 weeks old*

Carl, *Dogue de Bordeaux, 4 months old*

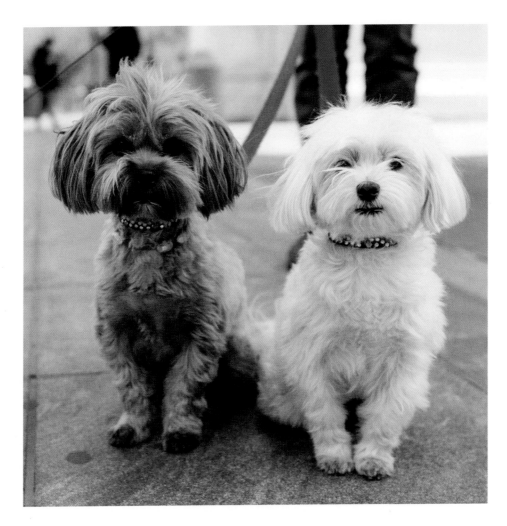

Gitana and **Dama**, *Yorkshire Terrier/Shih Tzu mix and Maltese, 2 and 3 years old*

"She reminds me of a model.

She has long slender legs and likes to strike poses."

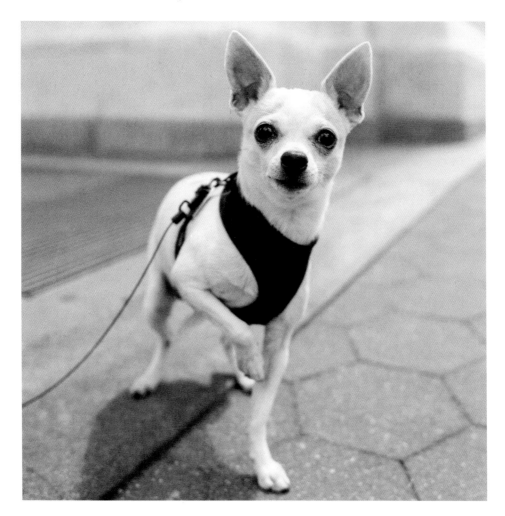

Penny Lane, *Chihuahua, 4 years old*

Glasses

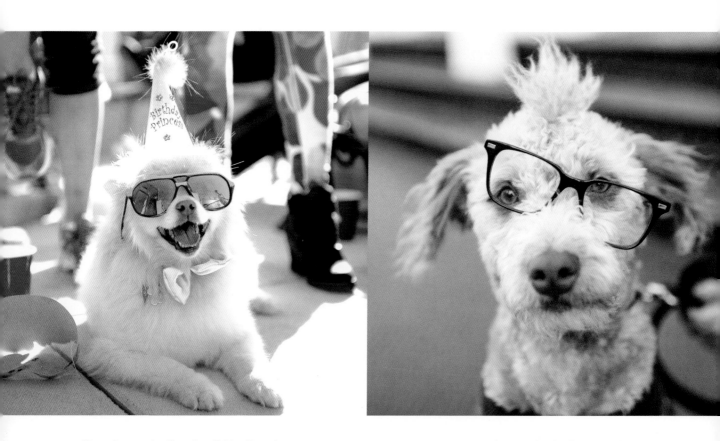

Singa, *Pomeranian/American Eskimo Dog mix*

Mingus, *Labradoodle, 1 year old*

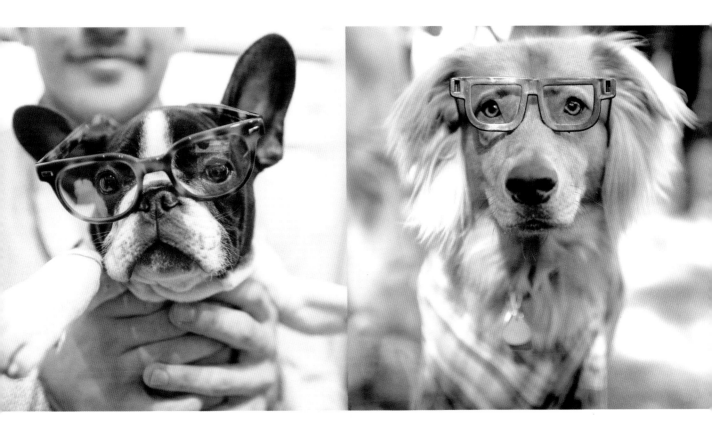

Sir William, *French Bulldog, 5 months old*

Roxy, *Golden Retriever mix*

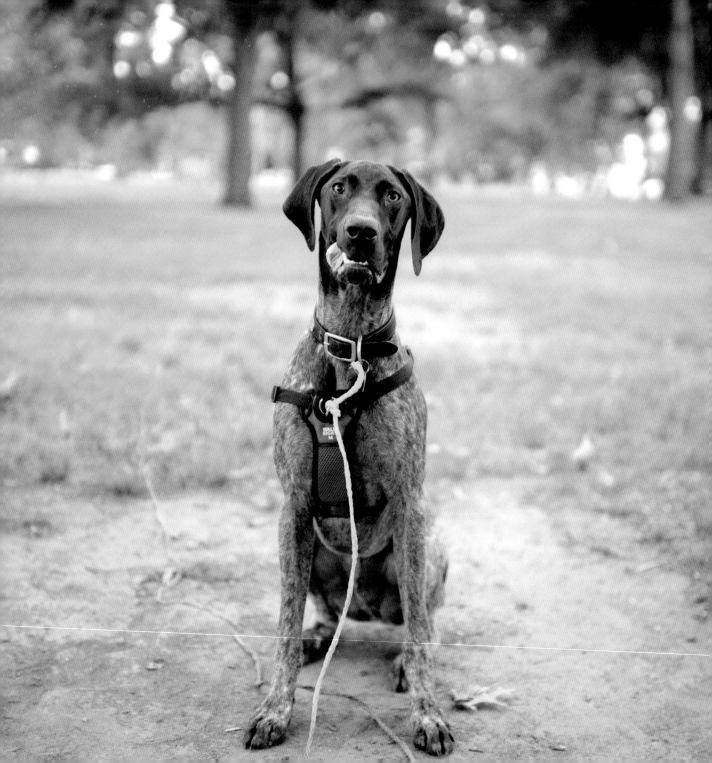

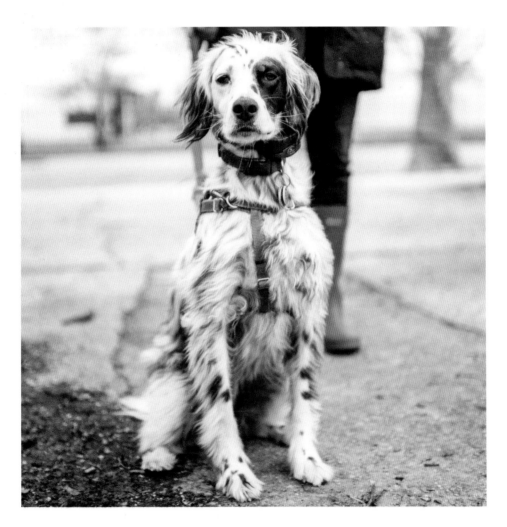

Willow, *English Setter, 2 years old*

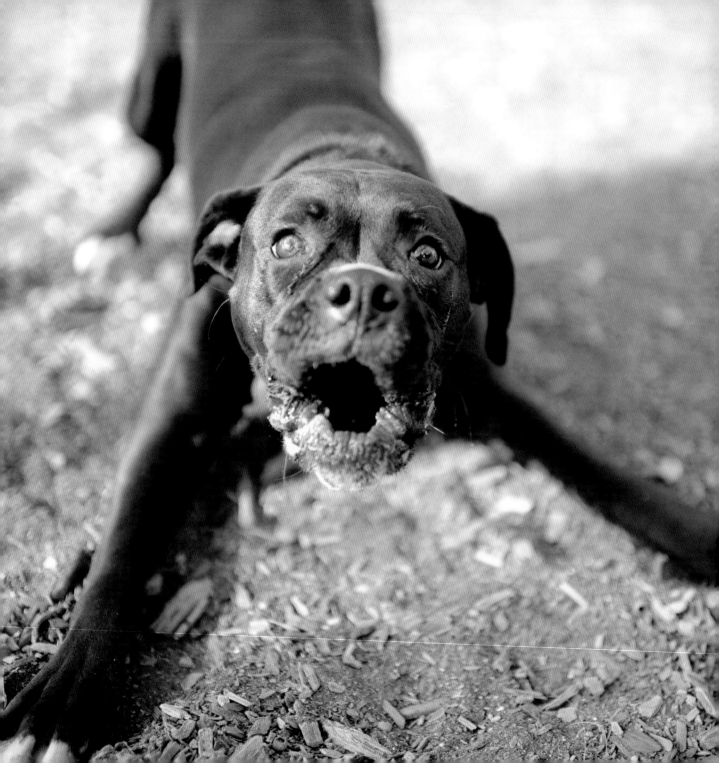

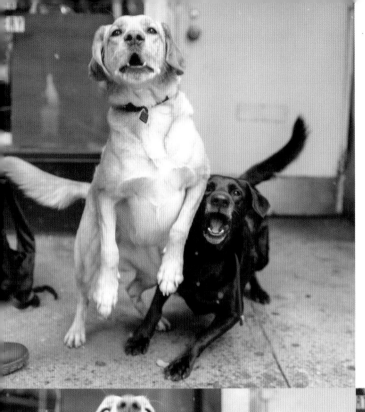

Barkers

OPPOSITE

Marlow, *Boxer*

THIS PAGE

Molly and **Nemo,**
Labrador Retrievers, 3 years old

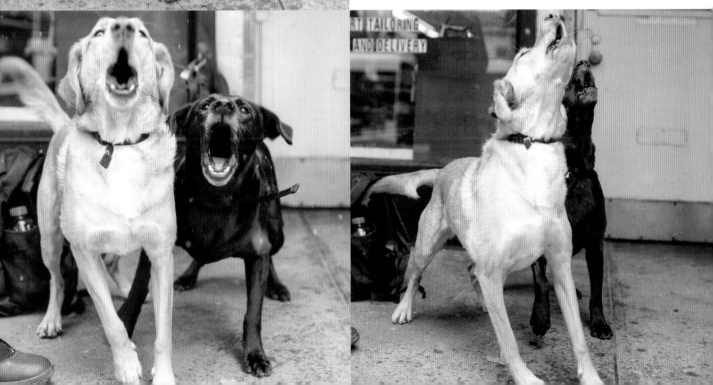

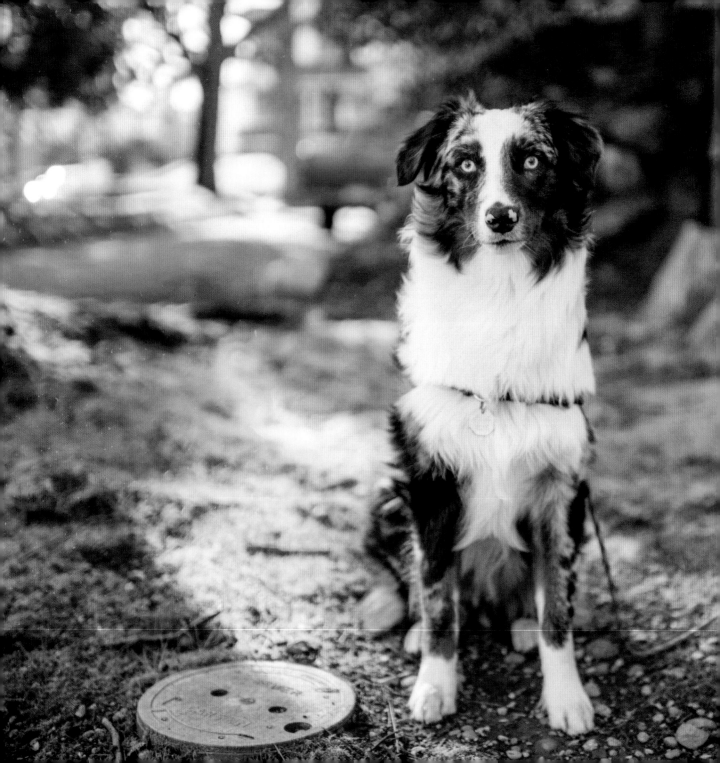

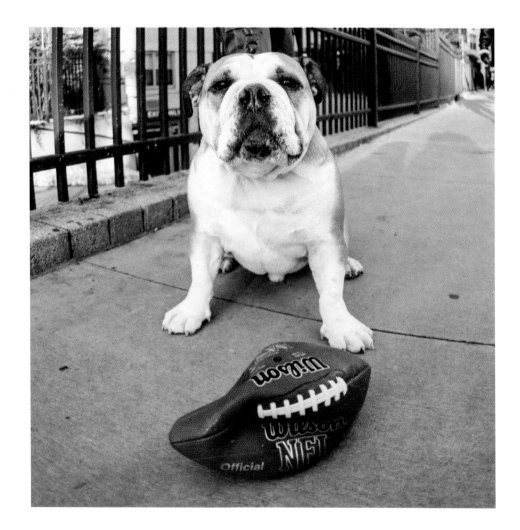

Dexter, *English Bulldog, 3 years old*

"This explains Deflategate!"

Ears

TOP ROW, LEFT TO RIGHT

Rascal, *German Shepherd*

Biggie, *Basenji*

Tank, *French Bulldog*

BOTTOM ROW, LEFT TO RIGHT

Eddie, *Pembroke Welsh Corgi, 10 years old*

Ophelia, *Basset Hound, 2 years old*

Mila, *Doberman Pinscher, 5 years old*

Roxanne, *Papillon*

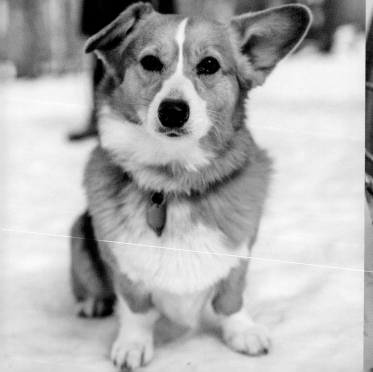

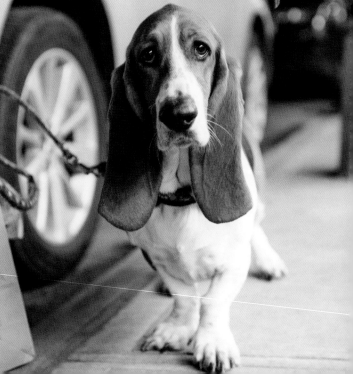

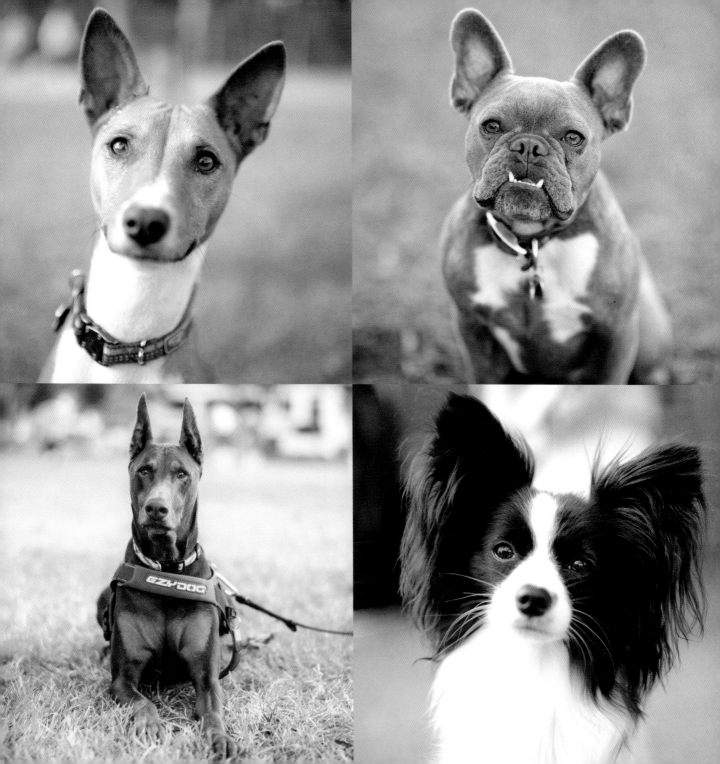

Packs

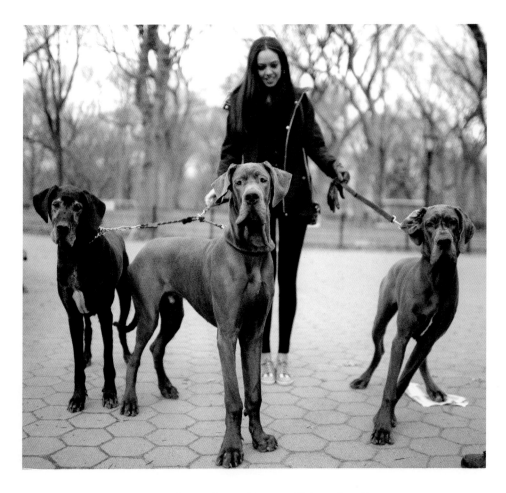

LEFT TO RIGHT: **Bamm-Bamm, Homer,** and **Marge,** *Great Danes*

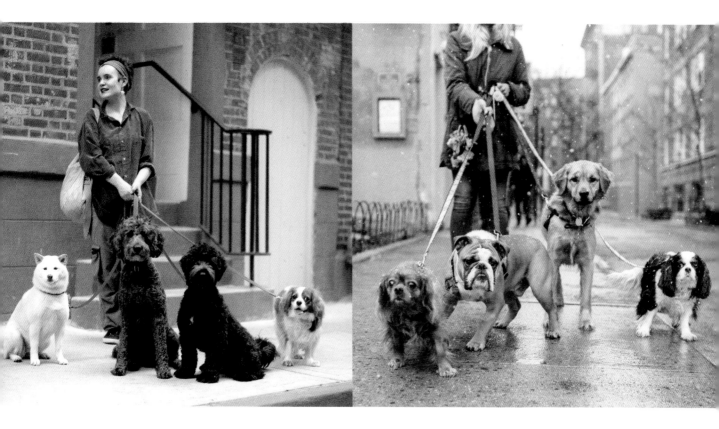

LEFT TO RIGHT: **Olivia, Freddy, Zach,** and **Milo,**
Shiba Inu, Goldendoodle, Miniature Goldendoodle,
and Cavalier King Charles Spaniel

LEFT TO RIGHT: **Peppercorn, Gordon, Jagger,** and **Chloe,**
Cavalier King Charles Spaniel, English Bulldog, mix,
and Cavalier King Charles Spaniel

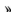

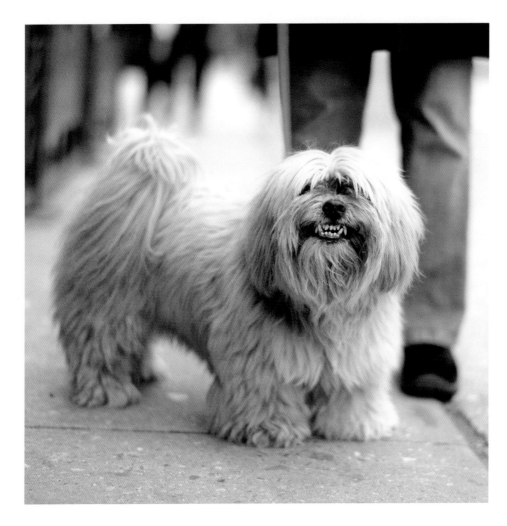

Harry, *Lhasa Apso*

He's not actually smiling.

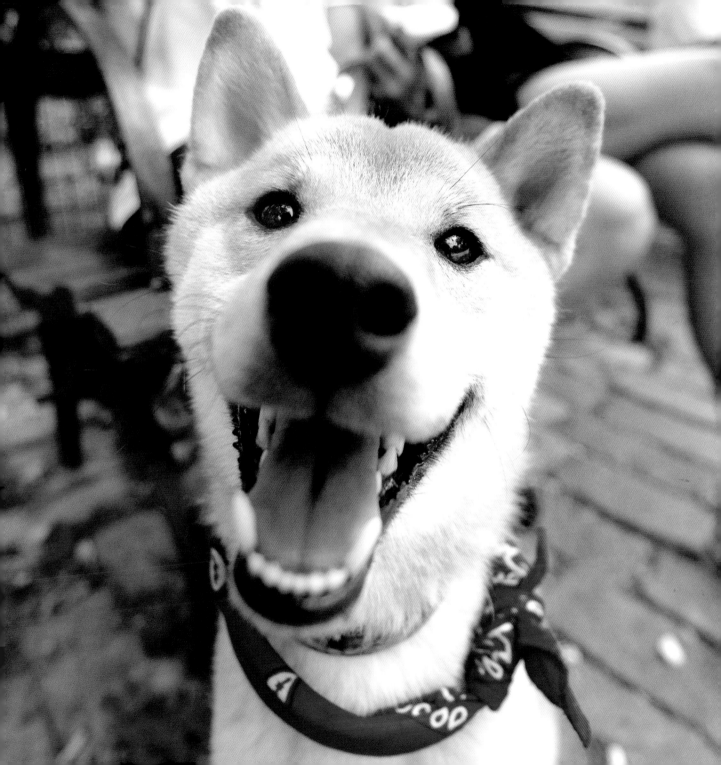

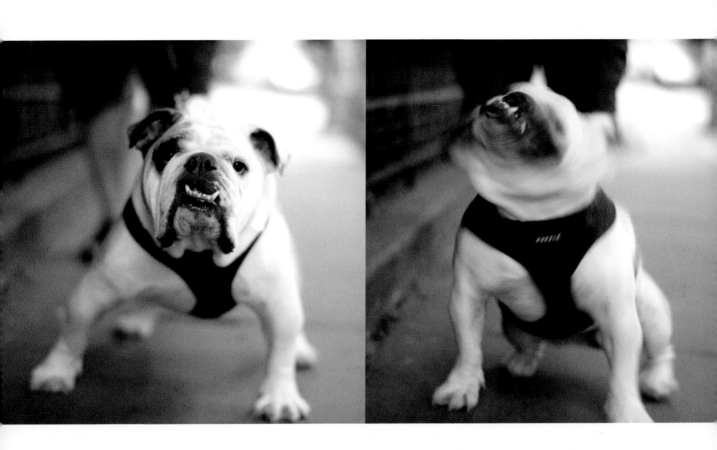

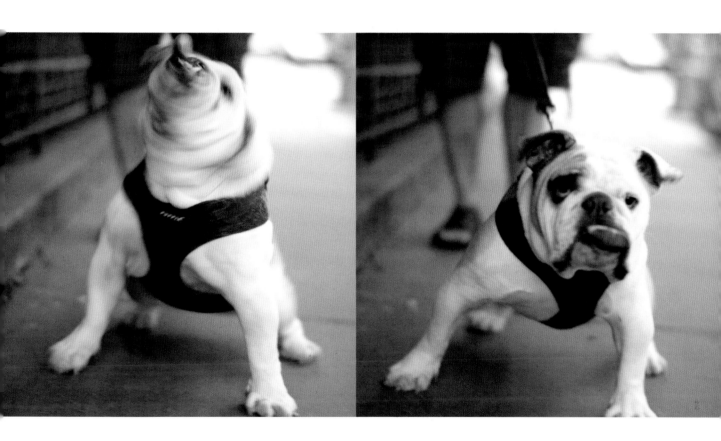

Armando,
English Bulldog

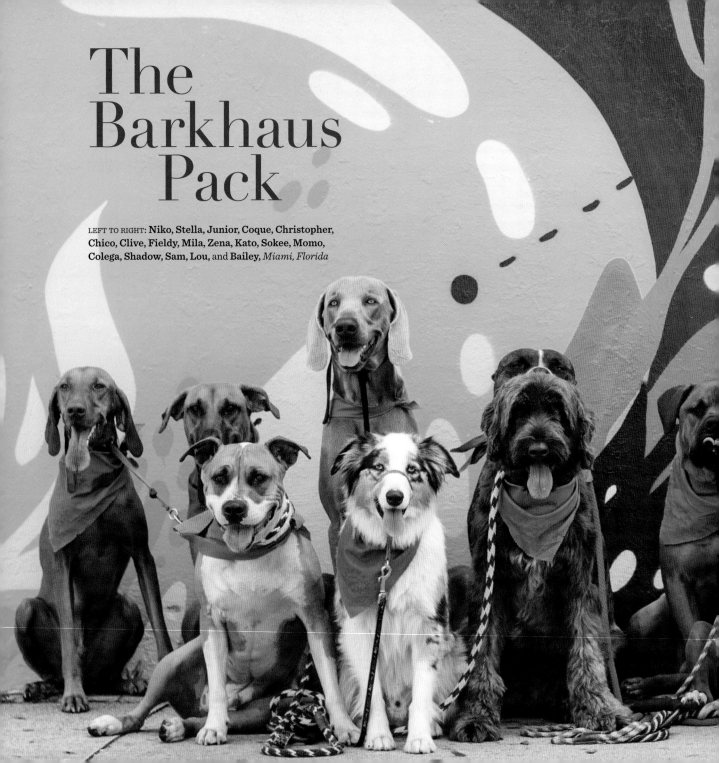

The Barkhaus Pack

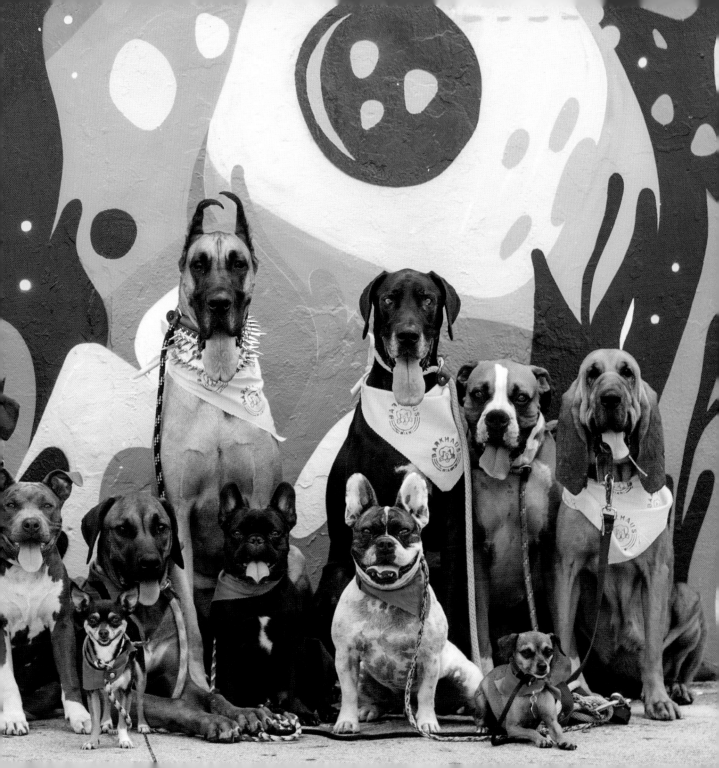

This is the closest I've ever come to being bitten by a dog.

This capture was taken a moment before the dog took a snarling lunge towards me (and my crotch) as I jumped up. I haven't shot a Malinois with a wide-angle lens since; they're beautiful but territorial.

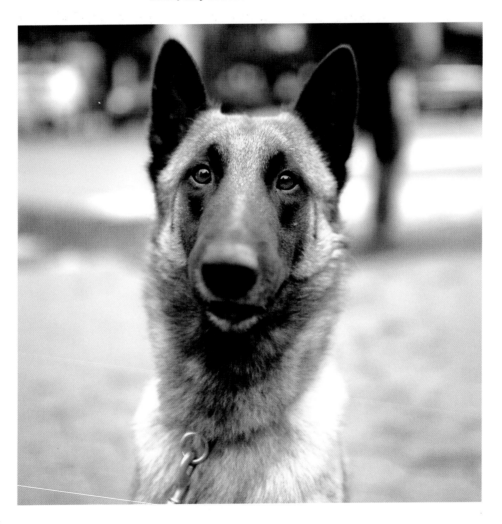

Luciano, *Belgian Malinois*

"Fieldy is a protective Boerboel and a nervous dog, too.
I've been working with him for almost a year, exposing him to various situations, new people, new dogs, and new scenarios, and he has come a long way, but the work never stops. This is a breed that needs a very knowledgeable and assertive handler."

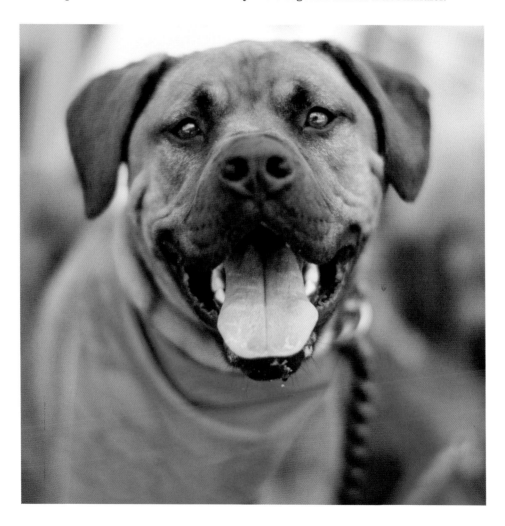

Fieldy, *Boerboel*

Žuti (Croatian for "yellow") is one of several town dogs that can be seen strolling around the Hvar harbor unleashed. These dogs have a unique sense of independence and their playful antics add to the lively spirit of the town.

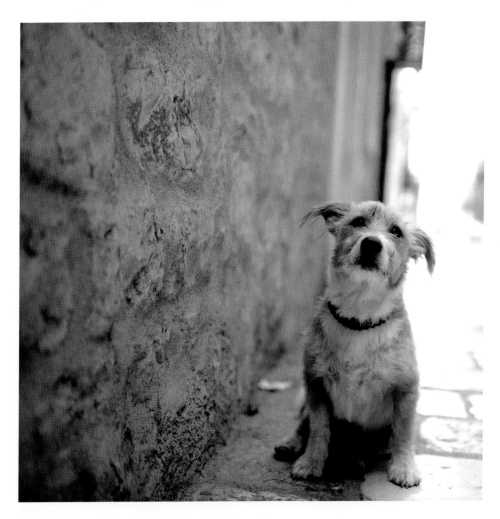

Žuti, *mix, Hvar, Croatia*

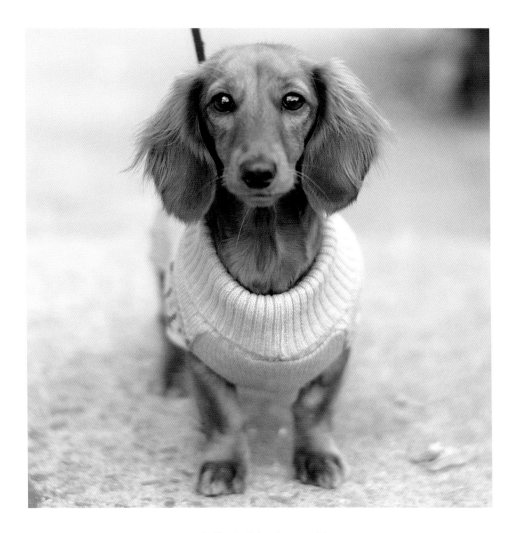

Bella, *Dachshund, 1 year old*

"The Jennifer Aniston of dogs."

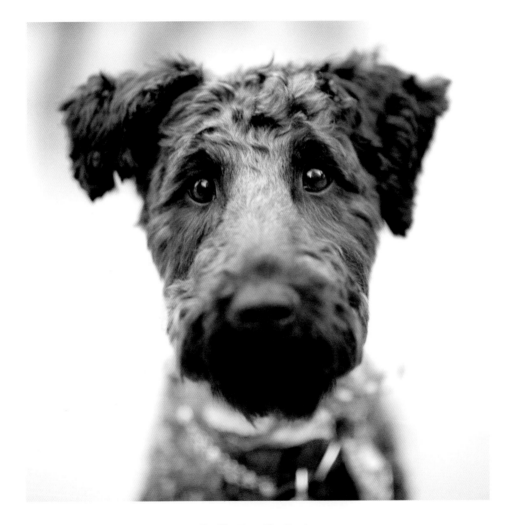

Charlie, *Kerry Blue Terrier*

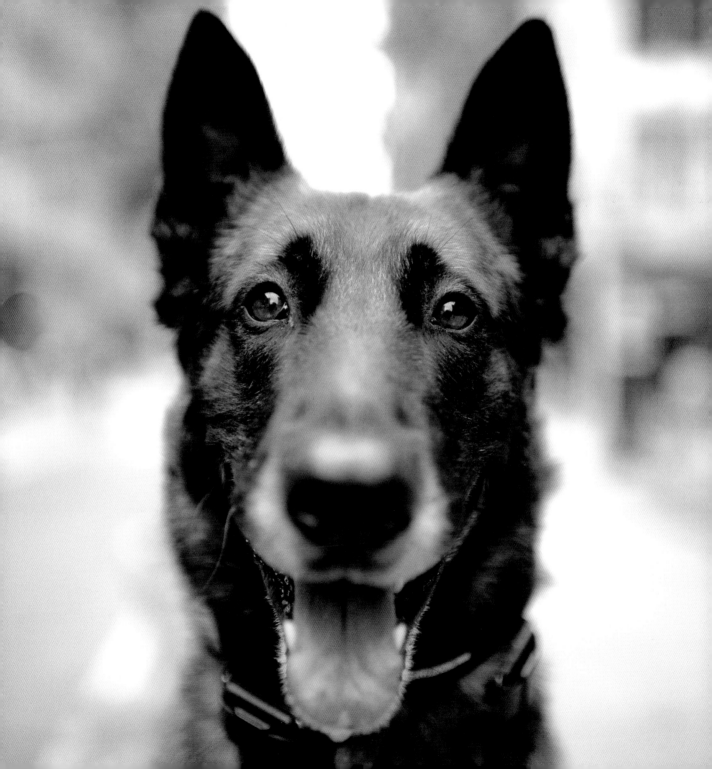

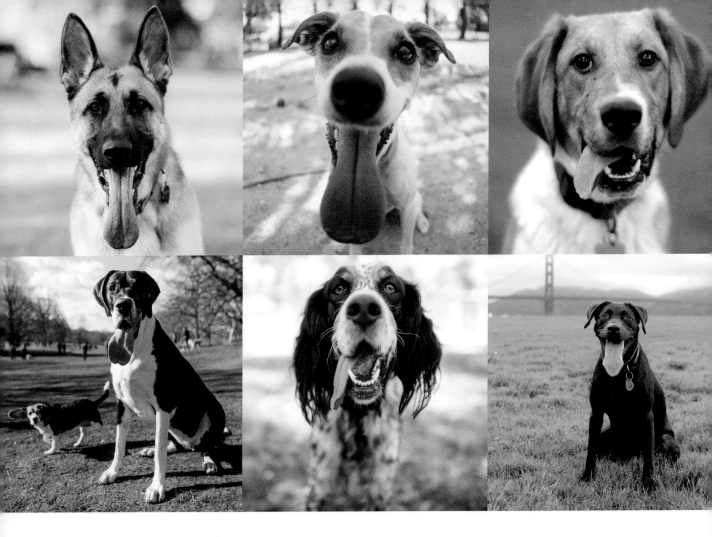

TOP ROW, LEFT TO RIGHT

Luke, *German Shepherd, 1 year old*

Rosie, *Jack Russell Terrier, 3 years old*

Scooby, *Hound mix*

Zeus, *Newfoundland, 1 year old*

CENTER ROW, LEFT TO RIGHT

Mia and **Chloe,** *Beagle and Great Dane, 5 years old*

Penny, *English Setter, 3 years old*

Frankie, *Labrador Retriever, 1 year old*

Trixie, *Australian Shepherd, 7 years old*

George, *English Bulldog*

Nēgro, *Spanish Shepherd/Labrador Retriever mix, 5 months old*

BOTTOM ROW, LEFT TO RIGHT

Trigger, *Redbone Coonhound, 9 months old*

Harvey, *Basset Hound, 3 years old*

River, *Australian Shepherd, 18 months old*

Tongues

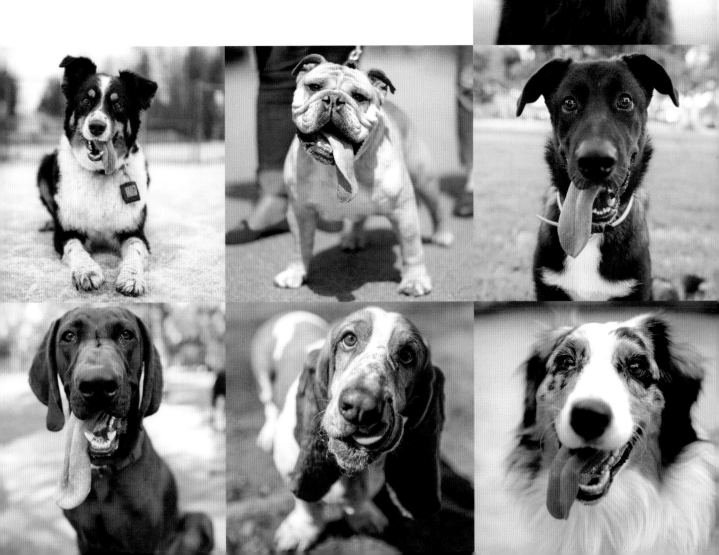

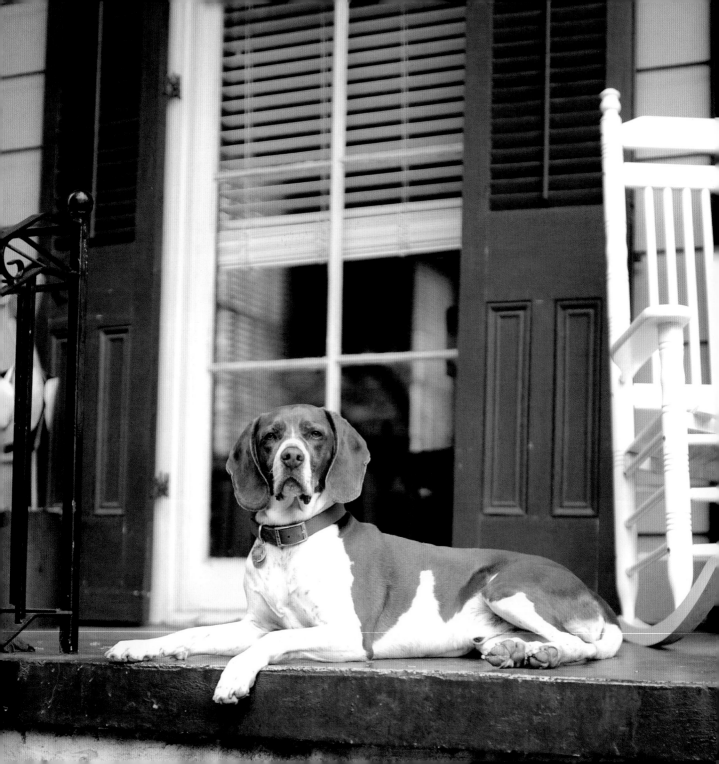

Daisy, *Treeing Walker Coonhound, 3 years old*

"She likes squirrels, too."

Fan Favorites

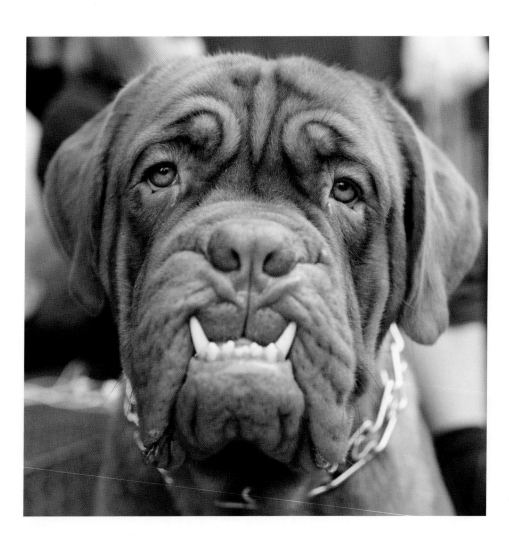

« **Moses,** *Dogue de Bordeaux, 15 months old*

Bow Ties

Lester, *Poodle mix, 10 years old*

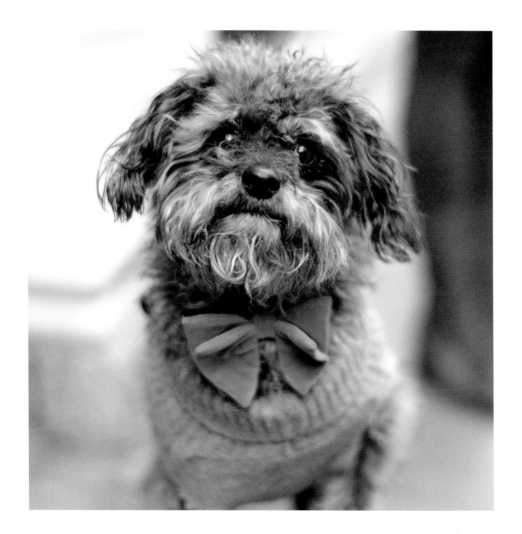

Comet, *Poodle mix*

Vicktory Dogs

"Tug was seized during the Michael Vick dogfighting raid. Pit Bulls weren't bred for aggression, but they are fiercely loyal to their owners. When put in the ring, they fought for their owners. It's a very sick practice. Tug is likely to spend the rest of his life at the sanctuary."

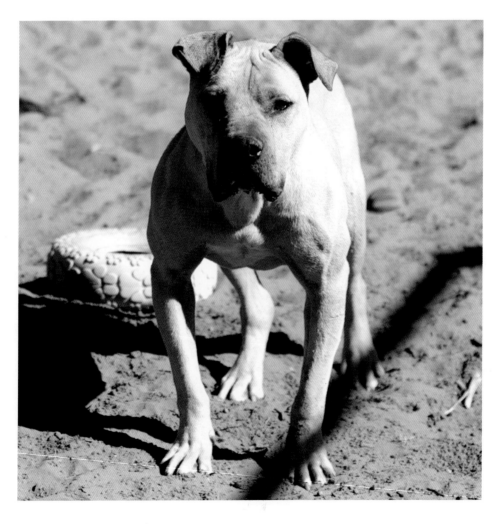

Tug, *Pit Bull mix, Best Friends Animal Sanctuary, Kanab, Utah*

"Ray is another dog from the Michael Vick dogfighting ring. He's come a long way—it took him six years to pass the American Kennel Club Canine Good Citizen program. He's now one of the sweetest animals at the sanctuary and serves as a symbol of what we do every day."

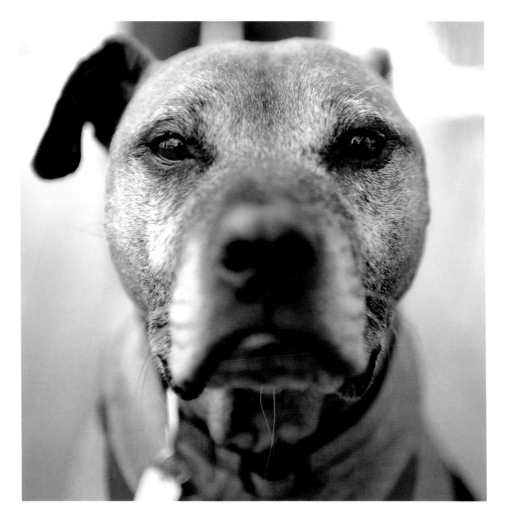

Ray, *Pit Bull, 9 years old*

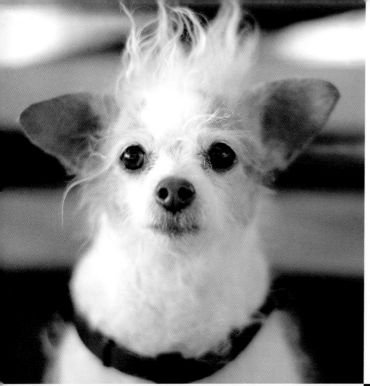

Seniors

THIS PAGE, ABOVE

Susie, *Chihuahua mix,*
14 years old

THIS PAGE, RIGHT

Simon, *Chihuahua mix,*
15 years old

OPPOSITE, TOP ROW,
LEFT TO RIGHT

Urlacher, *Border Collie mix,*
12 years old; **Lola,** *Great*
Pyrenees, 11 years old; **Misty,**
Wheaten Terrier, 11 years old

OPPOSITE, CENTER ROW,
LEFT TO RIGHT

Sebastian, *Afghan Hound,*
12 years old; **Elliott,** *Great*
Dane, 8 years old; **Jimmy,**
Chihuahua, 13 years old

OPPOSITE, BOTTOM ROW,
LEFT TO RIGHT

Maya, *Labrador Retriever,*
13 years old; **Tristan,**
Basset Hound; **Flash,**
Greyhound, 11 years old

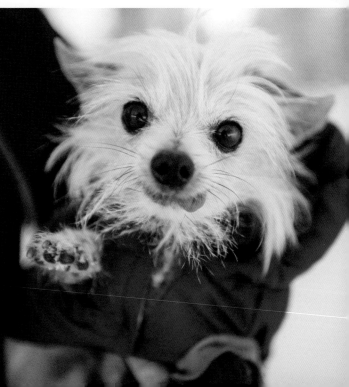

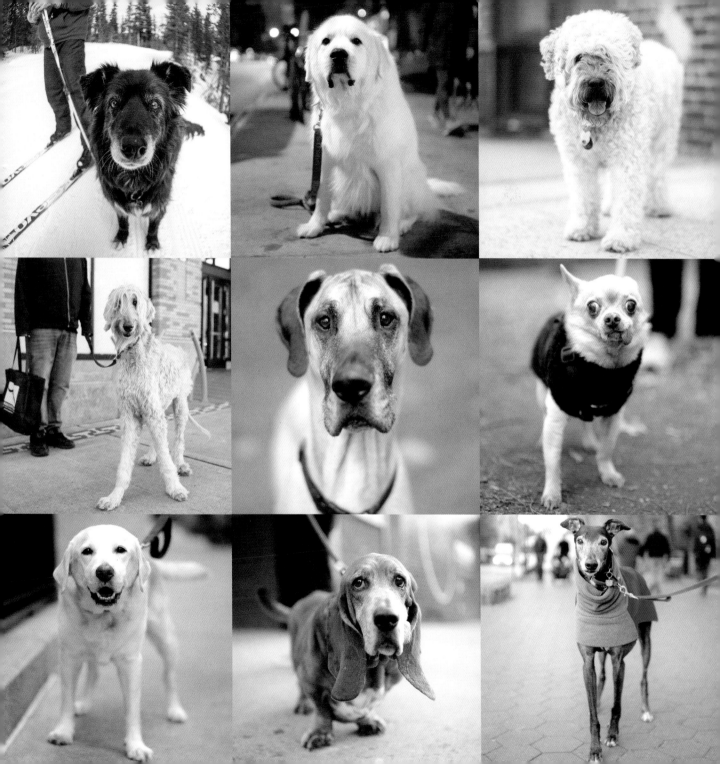

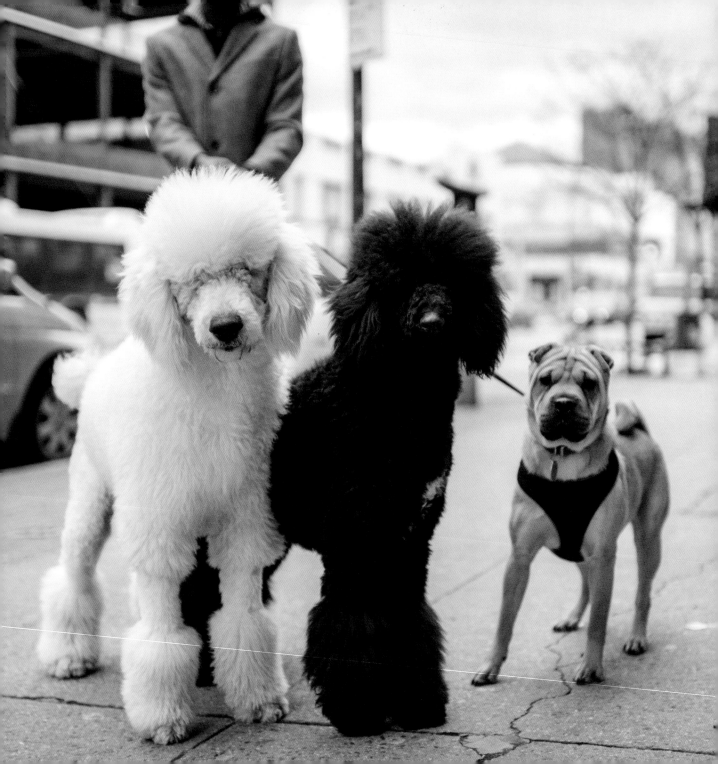

I took this shot on Martin Luther King Jr. Day on Martin Luther King Jr. Boulevard in Harlem. This trio is a fitting combination for the day.

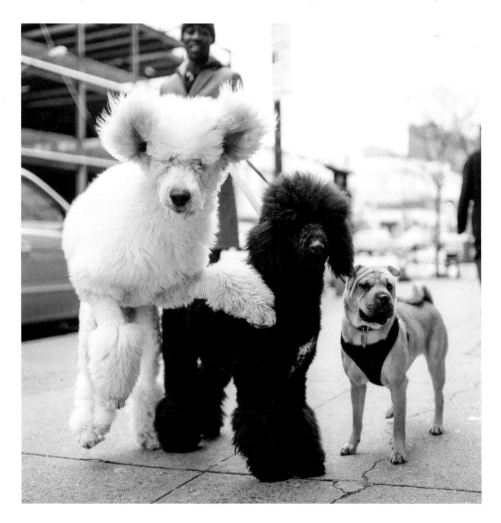

Apollo, Piper, and **Kris,** *Standard Poodles and Shar Pei, all 1 year old*

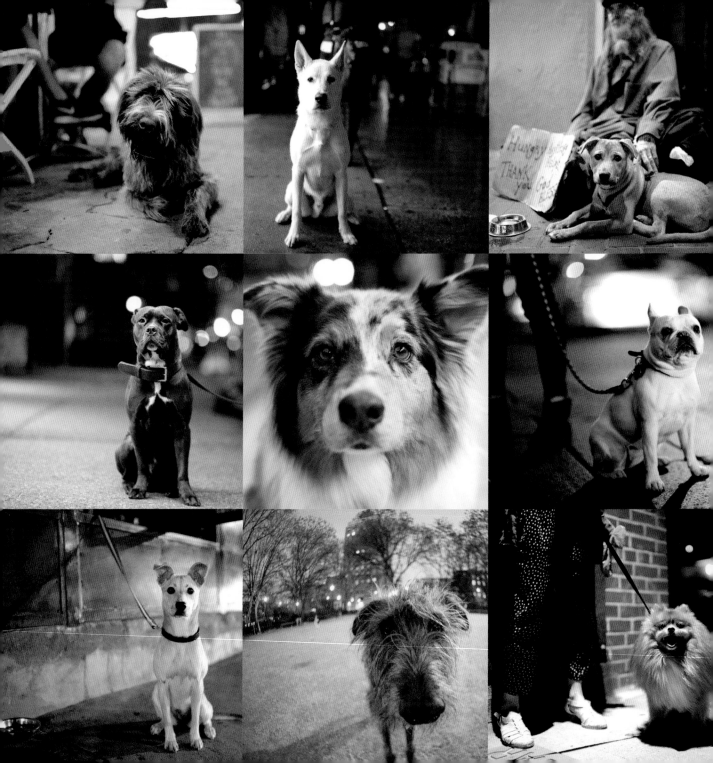

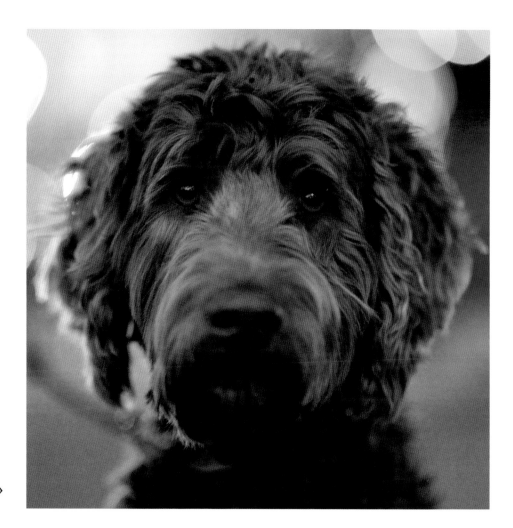

Nighttime

TOP ROW,
LEFT TO RIGHT

Barley, *Wirehaired Pointing Griffon, 11 months old*

Luna, *Siberian Husky, 1 year old*

Free, *Pit Bull/ Golden Retriever mix, New Orleans, Louisiana*

CENTER ROW,
LEFT TO RIGHT

Gatti, *Pit Bull*

Hudson, *Australian Shepherd, 9 years old*

Noelle, *French Bulldog*

BOTTOM ROW,
LEFT TO RIGHT

Milo, *Dingo mix*

Brooks, *Scottish Deerhound, 6 years old*

Bear, *Pomeranian*

Laffy, »
Labradoodle

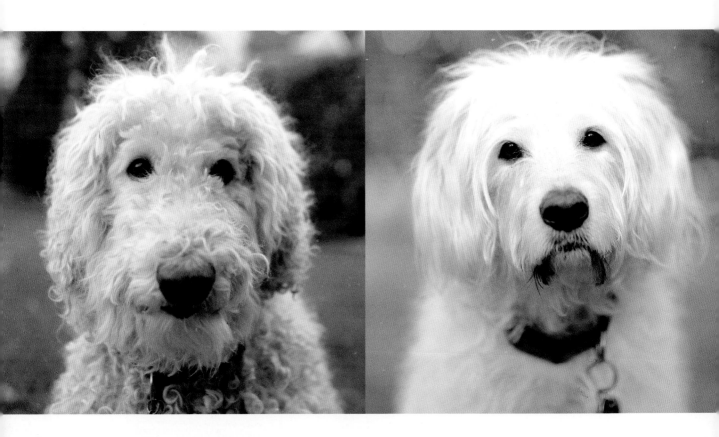

Bialy, *Standard Poodle*

Willy, *Labradoodle*

Bialy and Willy are father and son.

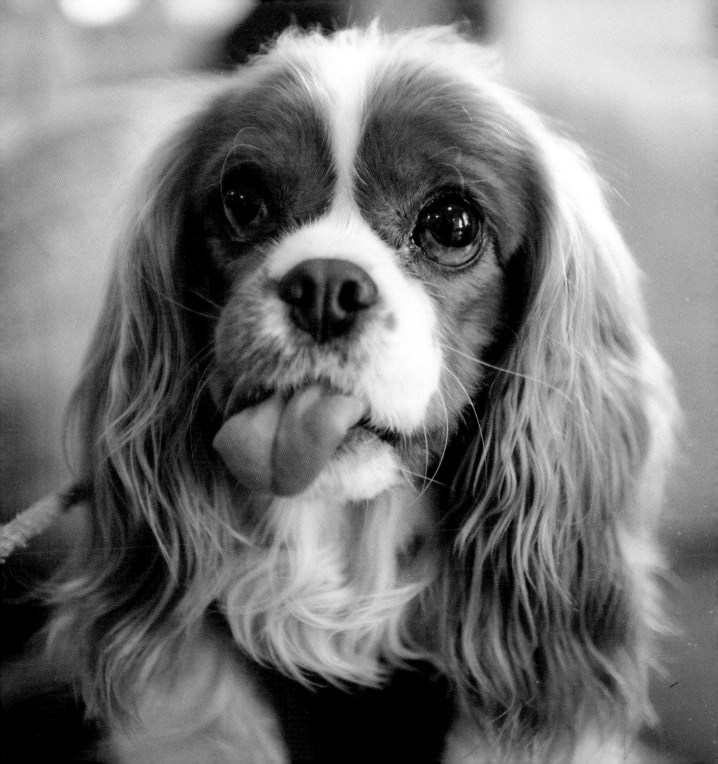

Oliver, *Labrador Retriever* »

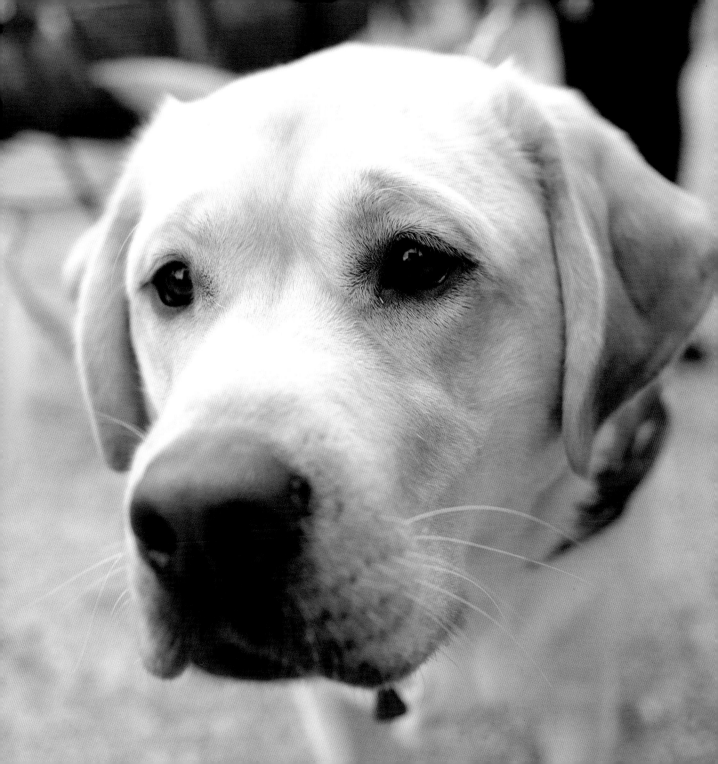

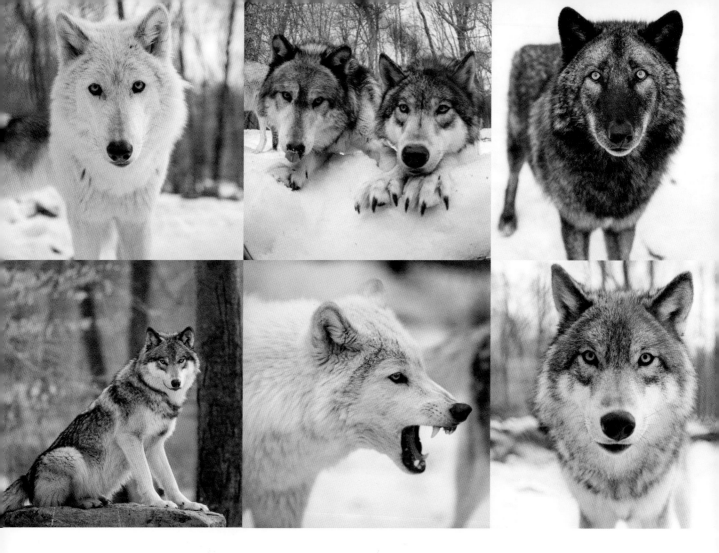

"Dogs need a master.
Wolves want to be the master."

TOP ROW,
LEFT TO RIGHT

River, *Timber Wolf,*
6 years old

Nightsong and
Khaleesi, *Timber*
Wolves, 13 and
2 years old

Tikanni, *British*
Columbian Wolf,
4 years old

BOTTOM ROW,
LEFT TO RIGHT

Teton, *Timber Wolf,*
2 years old

River, *Timber Wolf,*
6 years old

Rain, *Timber Wolf,*
2 years old

Wolves

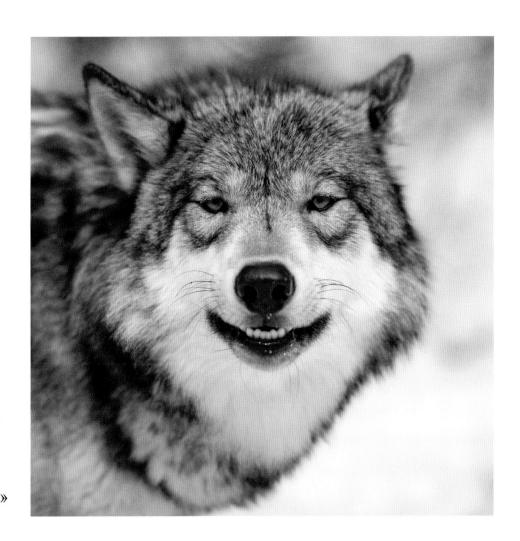

Khaleesi, *Timber Wolf,* »
2 years old

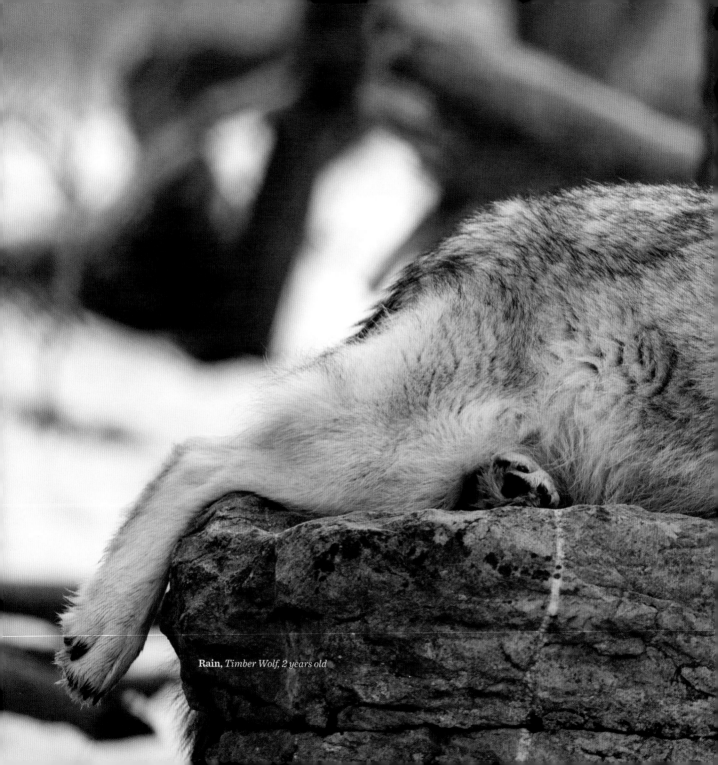

Rain, *Timber Wolf, 2 years old*

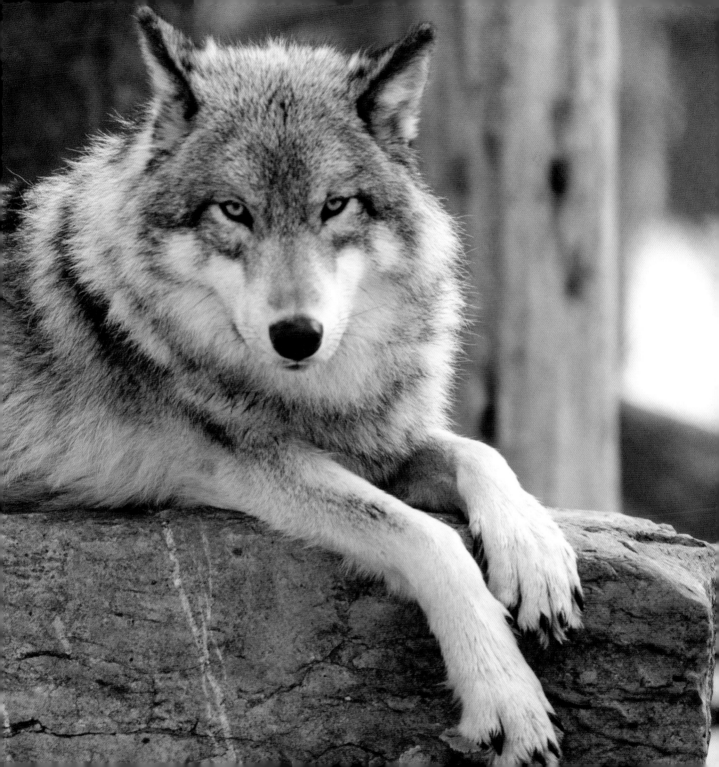

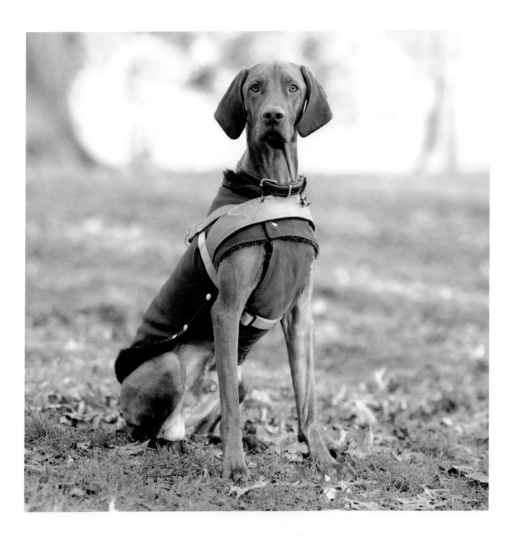

Pauli, *Vizsla, 1 year old*

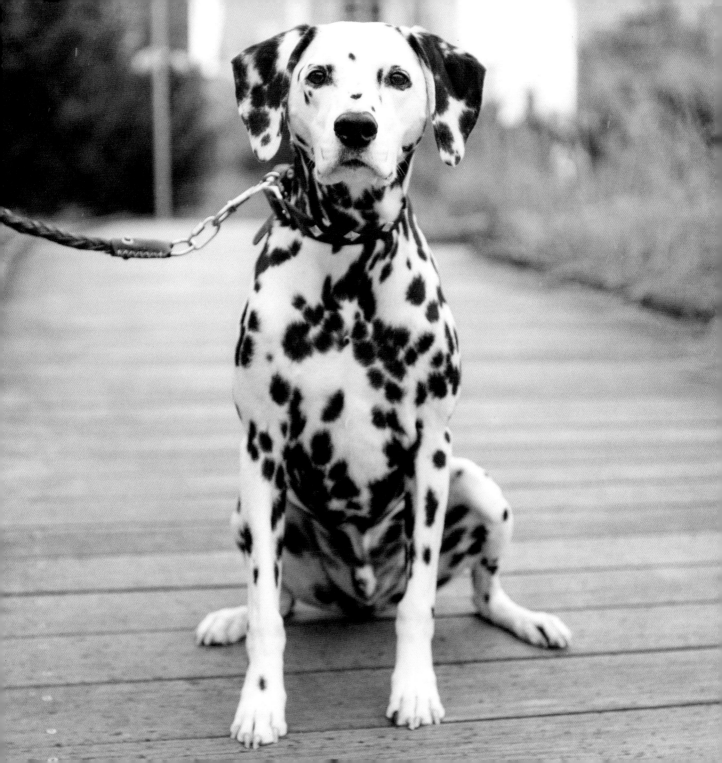

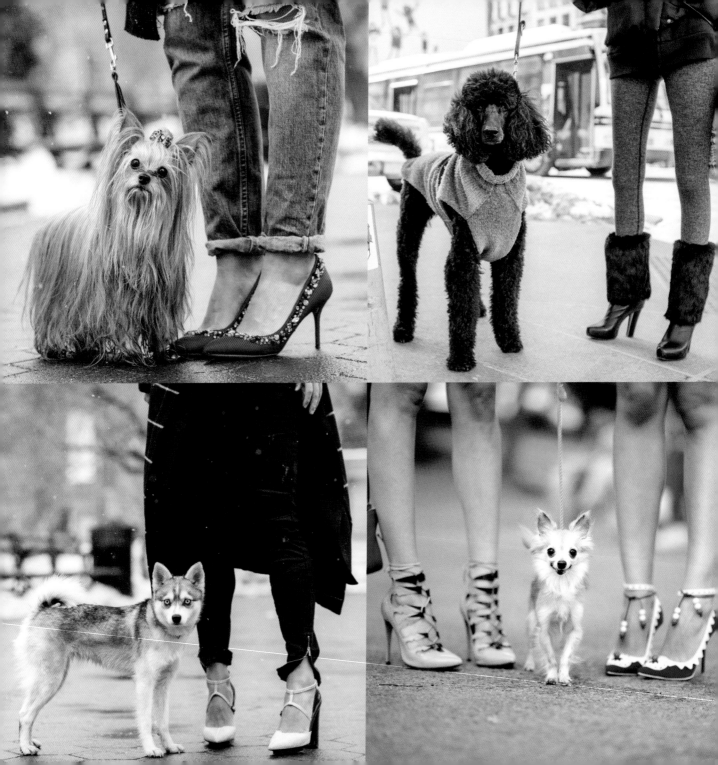

Only in New York City

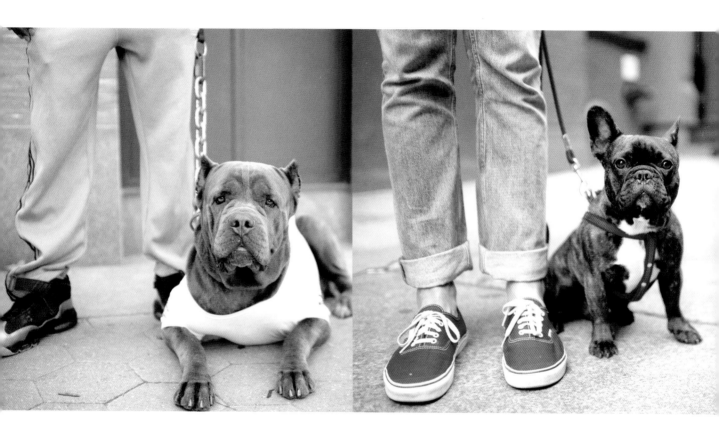

OPPOSITE, CLOCKWISE FROM TOP LEFT

Lola, *Yorkshire Terrier, 9 years old*

Po, *Standard Poodle, 13 years old*

Beatrice, *Longhaired Chihuahua, 9 years old*

Luna, *Alaskan Klee Kai, 1 year old*

THIS PAGE, LEFT TO RIGHT

Ra Ra, *Cane Corso*

Charlie, *French Bulldog*

"He was found digging around a hotel parking lot in Newark, New Jersey. A lady brought him to Union Square, asking if anyone could at least take him overnight. I said I would and we exchanged numbers. That was eight years ago.**"**

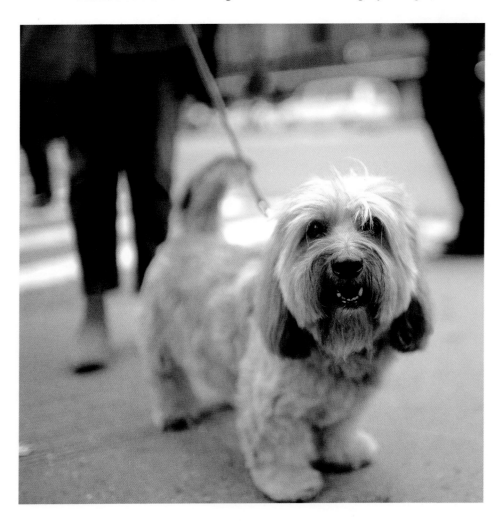

Jerzy, *Terrier mix*

"When I met him at the shelter, he had gotten a zero on his behavioral test. He's now a certified therapy dog."

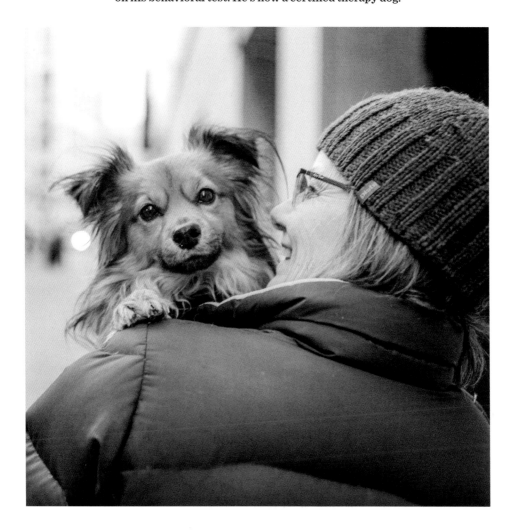

Bellino, *mix, 3 years old*

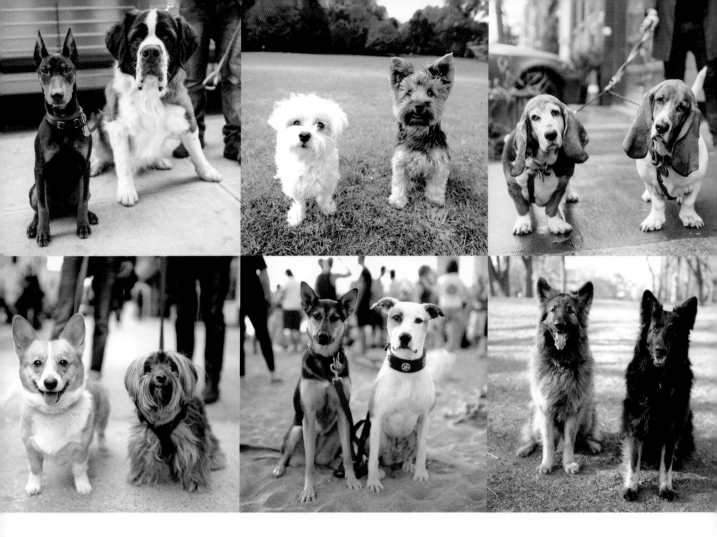

TOP ROW, LEFT TO RIGHT

Buddy and **Clyde**, *German Pinscher and St. Bernard, 6 months and 3 years old;* **Maximus** and **Alice**, *Maltese and Yorkshire Terrier, 6 years and 1 year old;* **Joni** and **Jerry**, *Basset Hounds, 10 and 8 years old*

CENTER ROW, LEFT TO RIGHT

Emma and **Squirrels**, *Pembroke Welsh Corgi and Biewer Terrier;* **Maric** and **Ava**, *German Shepherd mix and Pit Bull/ American Bulldog/Whippet mix;* **Sam** and **Lucy**, *Shiloh Shepherds;* **Zizou** and **Messi**, *mix and Catahoula Leopard Dog;* **Zoe** and **Parker**, *Vizslas, 7 and 9 years old;* **Gus** and **Travis**, *German Shorthaired Pointers, 5 and 12 years old*

BOTTOM ROW, LEFT TO RIGHT

Woody and **Nova**, *Pit Bull/Heeler mix and Rhodesian Ridgeback mix;* **Sabrina** and **Porter**, *Boxer and Labrador Retriever;* **Seamus** and **Ollie**, *Goldendoodle and Pit Bull/Boxer mix*

Pairs

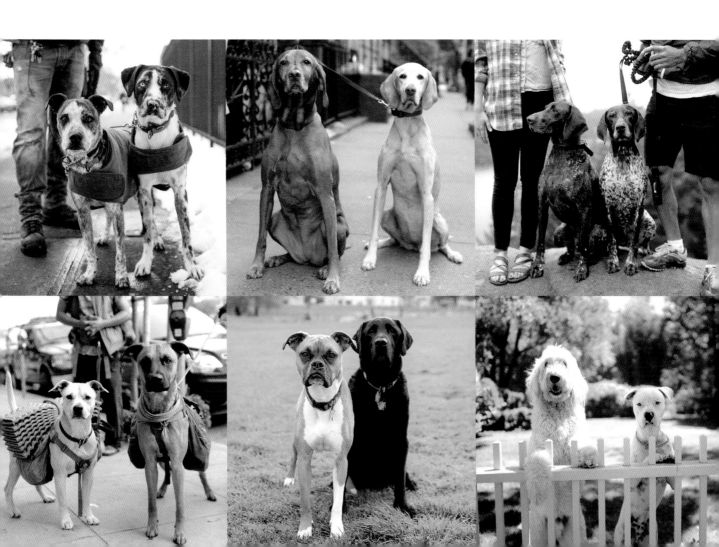

One-Eyed

Tiger, *mix, 6 years old*

Harvey, *French Bulldog*

Popeye, *mix*

Tilly, *Basset Hound*

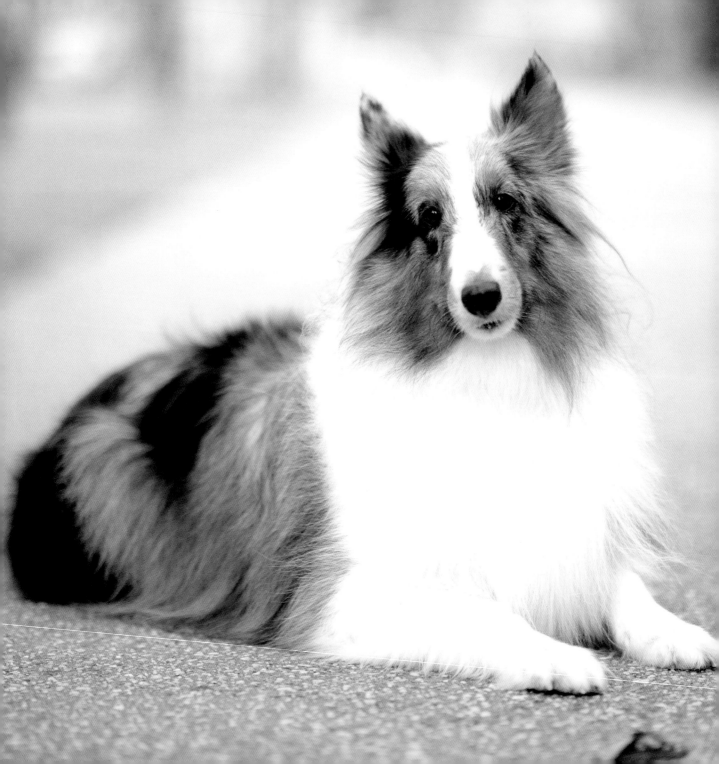

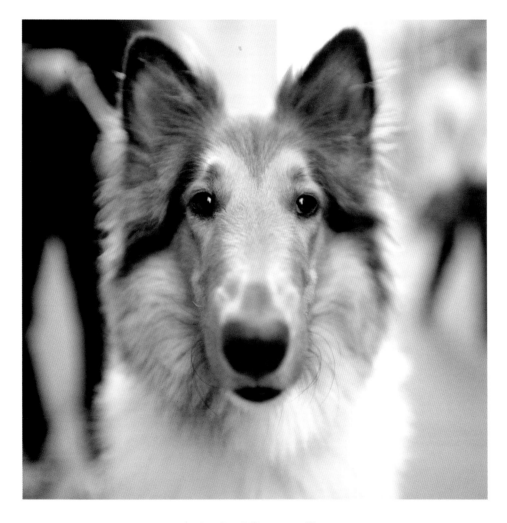

Bentley, *Collie, 3 years old*

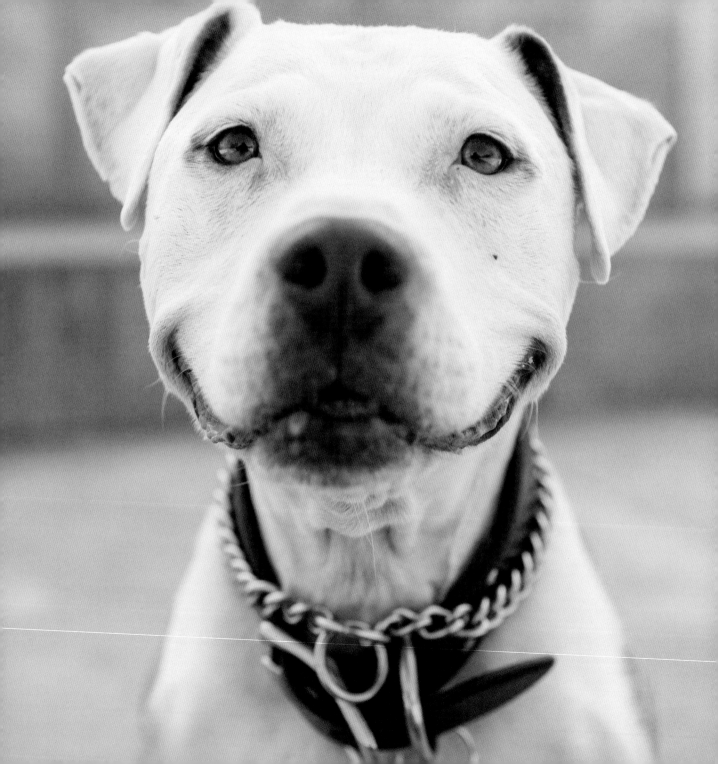

« **Brinks,** *Pit Bull, 11 years old*

Smiles

TOP ROW, LEFT TO RIGHT

Osa, *Rottweiler, 1 year old*

Clara, *Samoyed, 7 years old*

Hudson, *Australian Shepherd*

BOTTOM ROW, LEFT TO RIGHT

Chloe, *French Bulldog*

Ziggy Stardust Marley Stern,
Alaskan Malamute mix

Butch, *American Bulldog/Boxer mix*

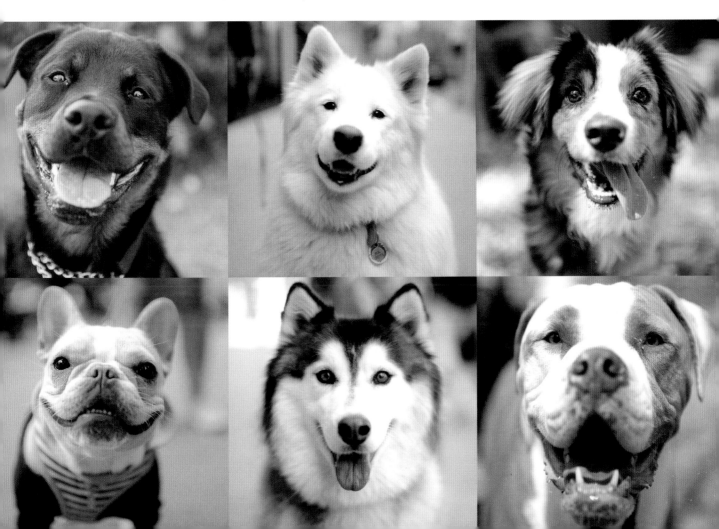

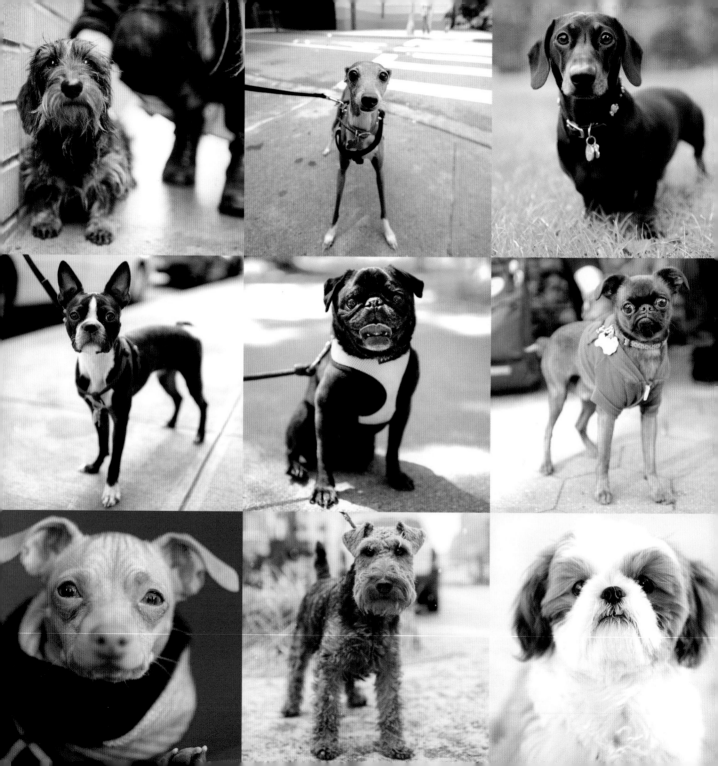

Small Breeds

TOP ROW, LEFT TO RIGHT: **Mina,** *Dachshund, 3 years old;* **Pixel,** *Italian Greyhound;* **Herman le Grande,** *Dachshund, 3 years old;* **Betty,** *Boston Terrier;* CENTER ROW, LEFT TO RIGHT: **Dr. Indiana Bones,** *Boston Terrier;* **Hamilton,** *Pug;* **Taco,** *Brussels Griffon, 1 year old;* **LeBron James,** *Papillon, 2 years old;* **Chorizo,** *Dachshund, 10 months old;* **Lola,** *Scottish Terrier;* BOTTOM ROW, LEFT TO RIGHT: **Tuna,** *Chiweenie (Chihuahua/Dachshund mix), 4 years old;* **Daphne,** *Welsh Terrier, 1 year old;* **Chip,** *Shih Tzu;* **Muppet** and **Toast,** *Cavalier King Charles Spaniels;* **Goya,** *West Highland White Terrier;* **Dash,** *Dachshund, 18 months old*

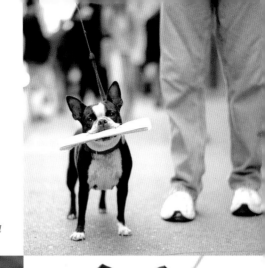

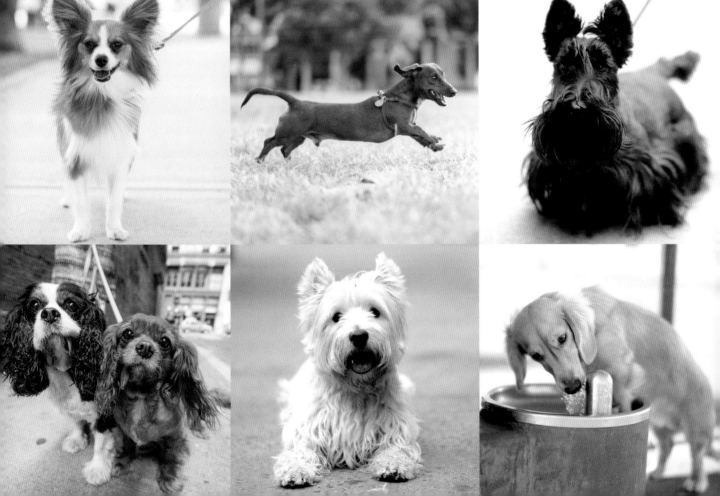

Retrievers

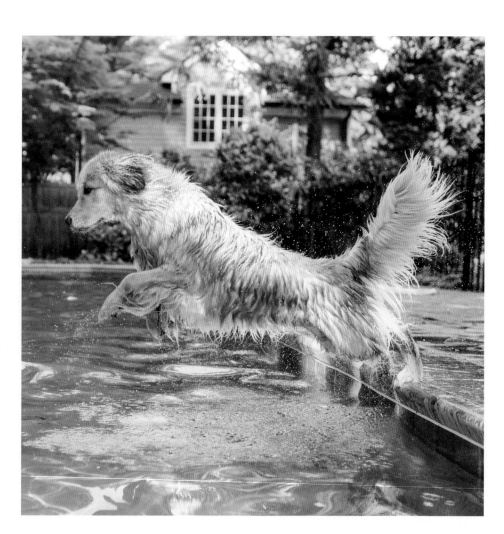

TOP ROW,
LEFT TO RIGHT

Zac, *Nova Scotia
Duck Tolling
Retriever*

Chloe, *Golden
Retriever*

Cody, *Labrador
Retriever, 5 years old*

CENTER ROW,
LEFT TO RIGHT

Carl, *Golden
Retriever, 8 years old*

Jasper, *Golden
Retriever*

Yoda, *Golden
Retriever, 6 years old*

BOTTOM ROW,
LEFT TO RIGHT

Buddy, *Golden
Retriever,
17 months old*

Boris, *Silver Lab
(Labrador Retriever/
Weimaraner mix)*

Keeley, *Golden
Retriever*

《 **Sundae,** *Golden Retriever,
2 years old*

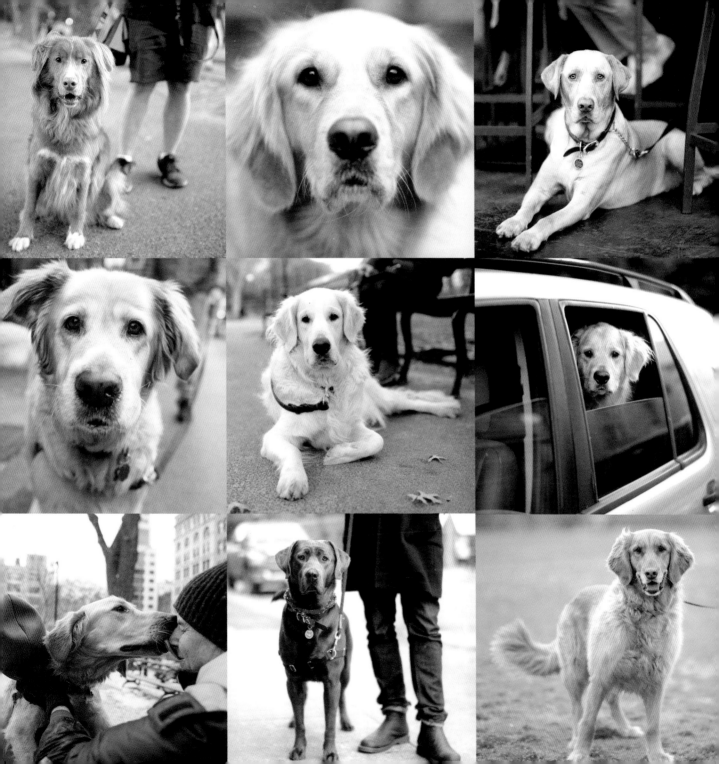

I met Cooper in Santa Monica, California, as he was being walked by his owner. This was one of the last photos taken of Cooper—his owner e-mailed me a few days later to tell me Cooper had passed away unexpectedly, and she wanted to thank me for the comfort the photo had provided. For me, it was a touching reminder of how important a single image can be.

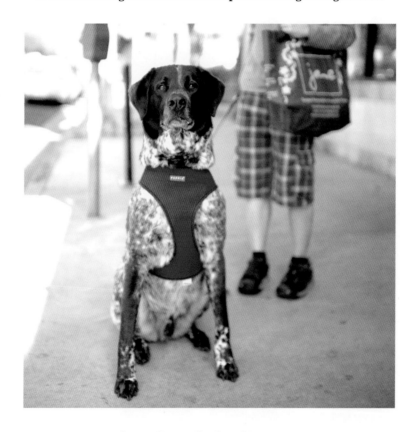

Cooper, *German Shorthaired Pointer mix*

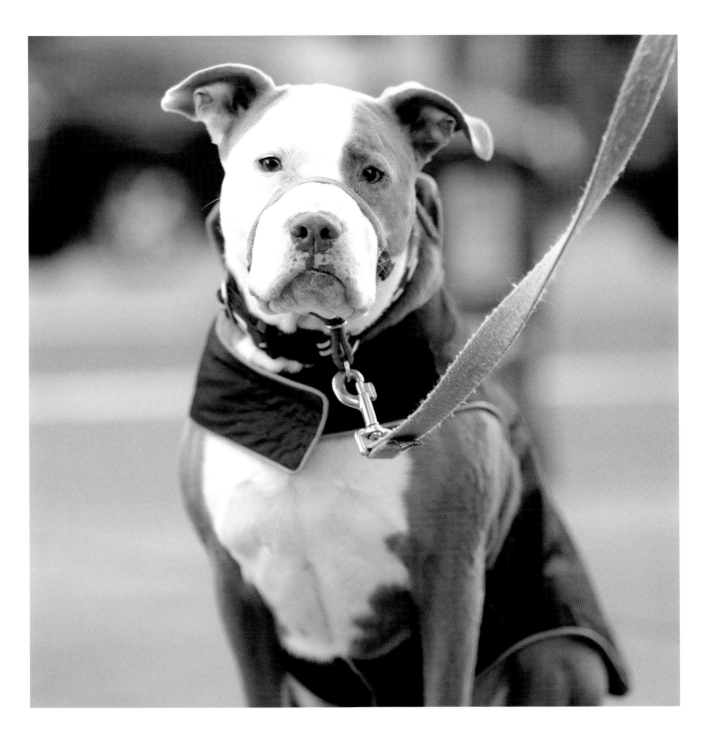

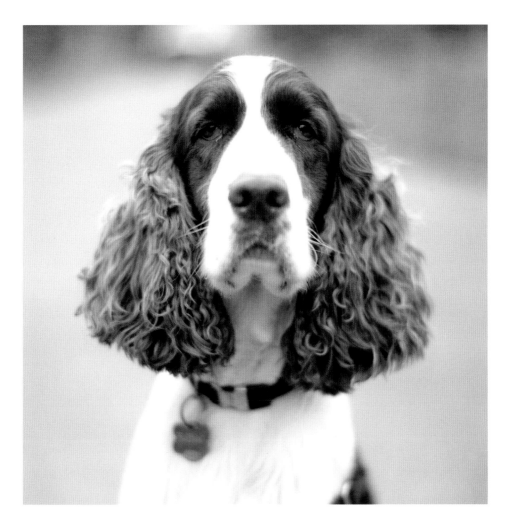

Whistler, *English Springer Spaniel*

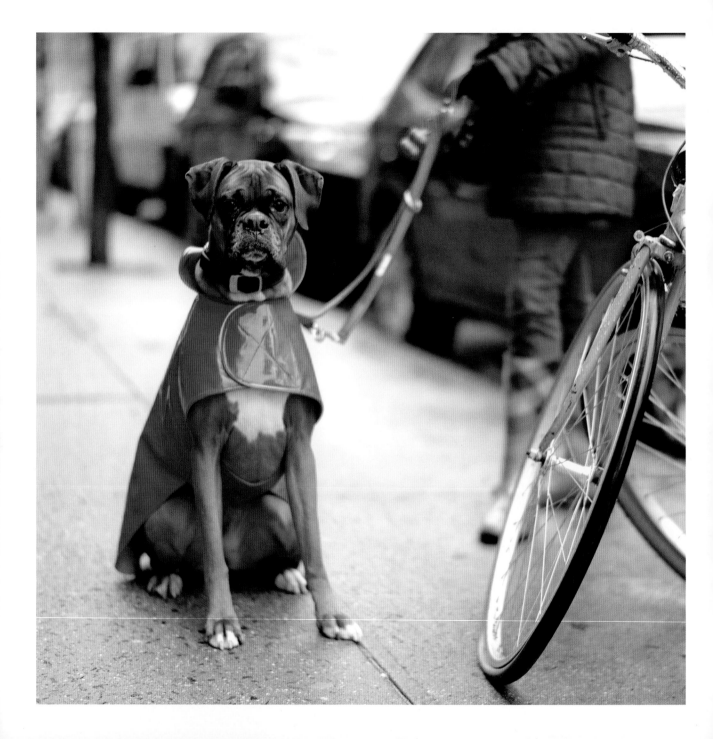

Raincoats

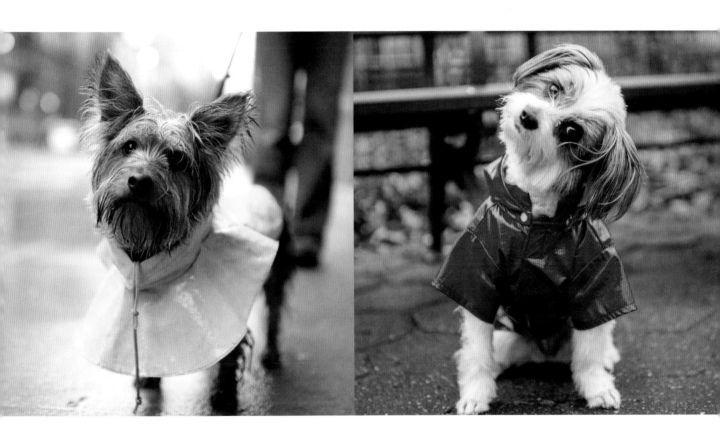

Henry, *Yorkshire Terrier*

Chelsea, *Terrier/Poodle mix, 5 years old*

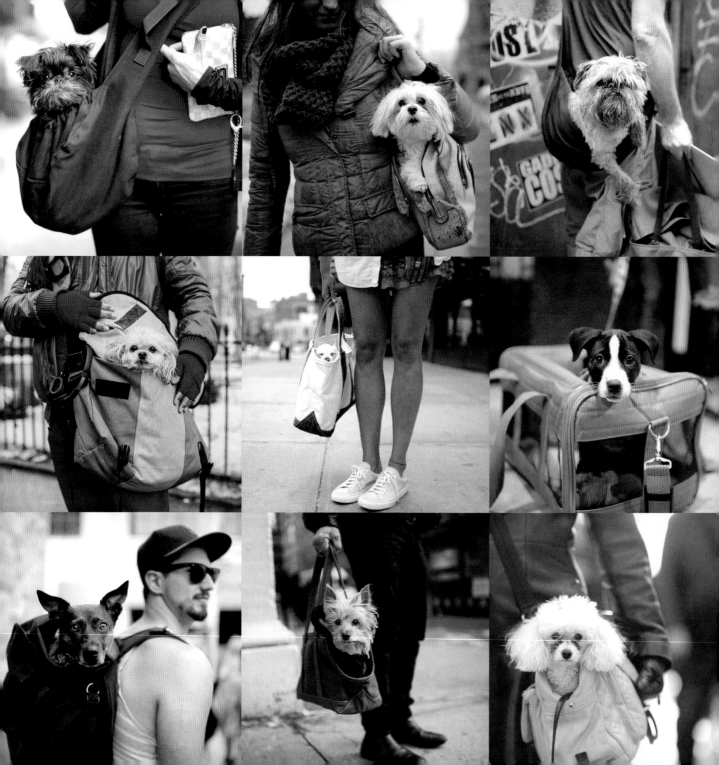

TOP ROW,
LEFT TO RIGHT

Billy Bob,
Affenpinscher

Gizmo, *Maltese*

Phineus,
Brussels Griffon

CENTER ROW,
LEFT TO RIGHT

Matthew, *Poodle/
Lhasa Apso mix,
11 years old*

Renard, *Chihuahua
mix, 14 years old*

Olive, *Pit Bull/
Labrador Retriever/
Boston Terrier mix,
3 months old*

BOTTOM ROW,
LEFT TO RIGHT

Watson, *mix*

Mick, *Yorkshire
Terrier, 13 years old*

Bella, *Toy Poodle*

Portable Pooches

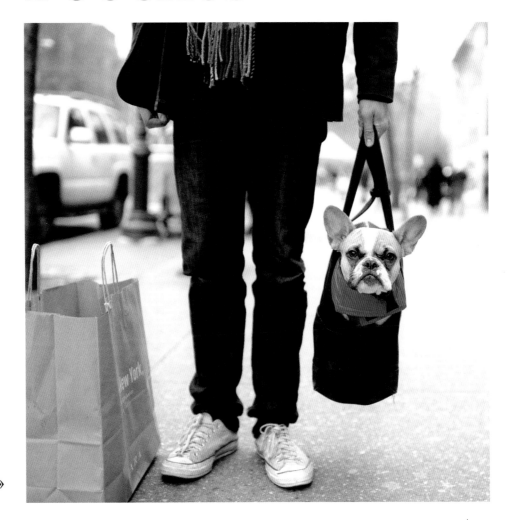

Frances Bacon, *French* »
Bulldog, 1 year old

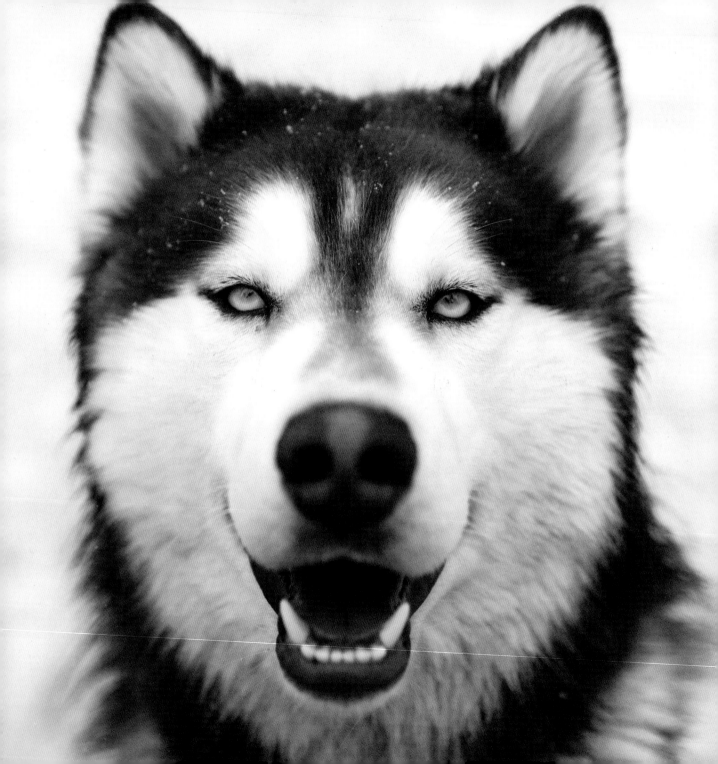

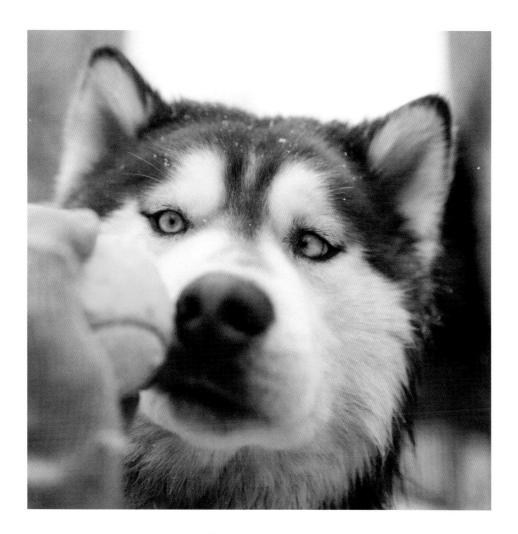

Mochi, *Siberian Husky, 1 year old*

Favorite Toys

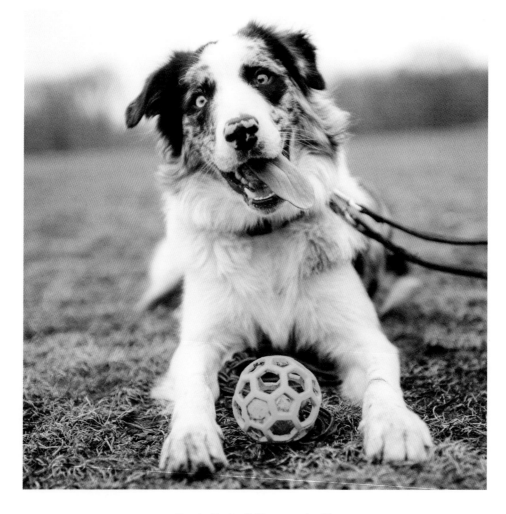

Razzle, *Border Collie, 11 months old*

TOP ROW, LEFT TO RIGHT

Buster,
German Shepherd

Charlie,
Australian Cattle Dog,
8 months old

CENTER ROW, LEFT TO RIGHT

Delirium,
Pit Bull mix

Callie,
Australian Shepherd,
5 years old

BOTTOM ROW, LEFT TO RIGHT

Hank,
English Bulldog

Eight,
Whippet,
4 years old

Laika,
Boston Terrier,
1 year old

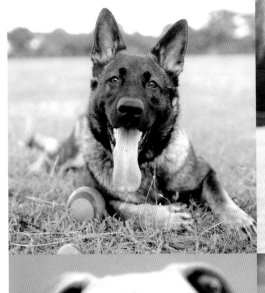
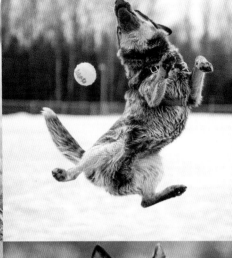
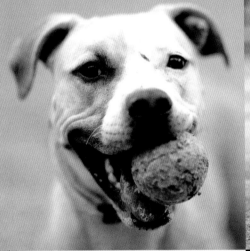
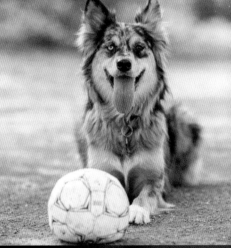
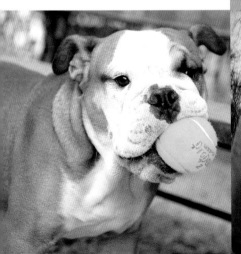
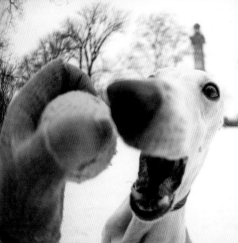
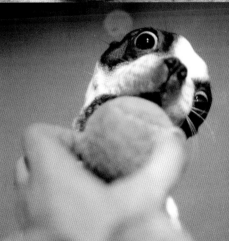

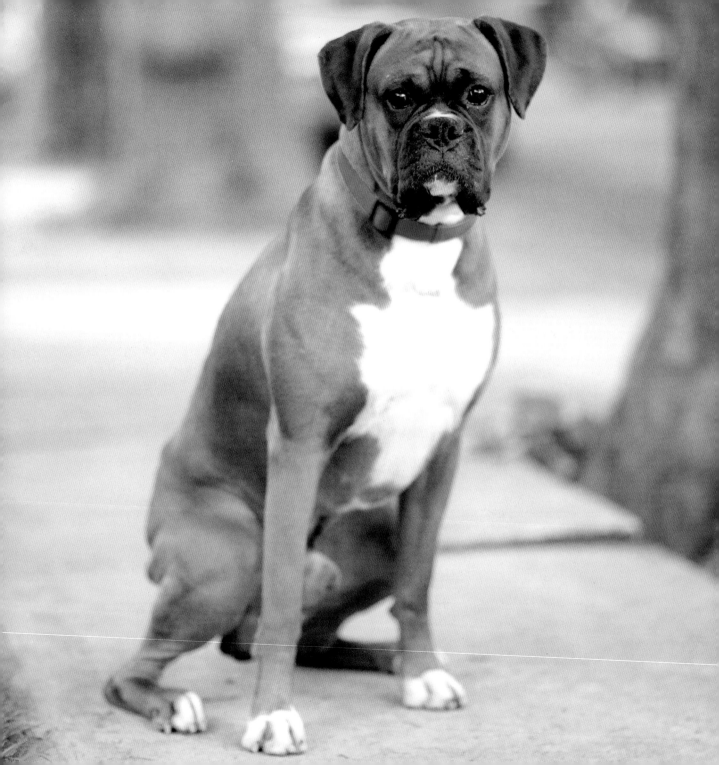

« Bagel, *Boxer*

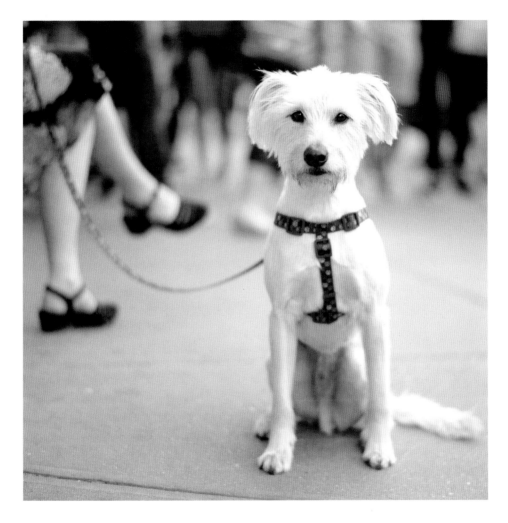

Jasper, *mix*

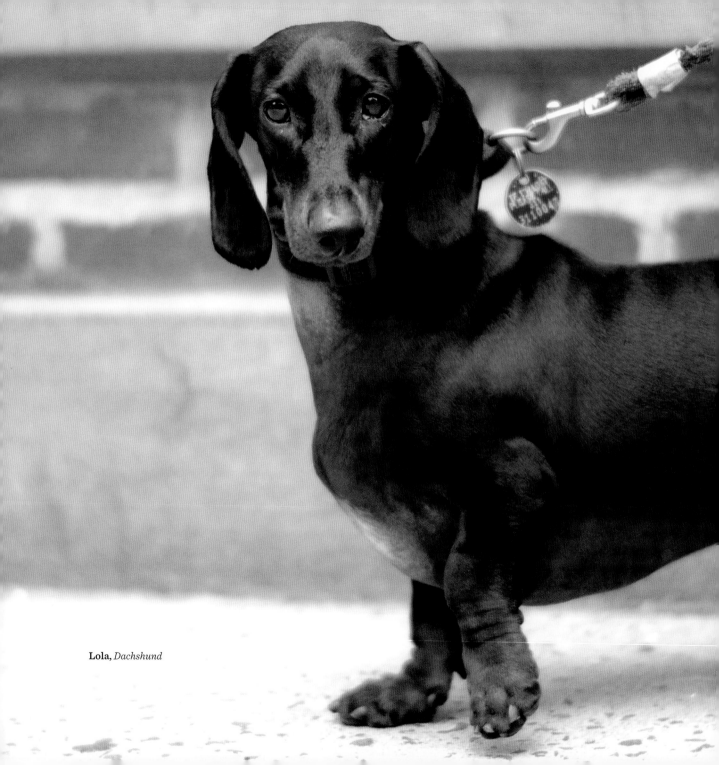

Lola, *Dachshund*

Dorji is a very lucky stray dog. The porch on which he's lying is his home. The man behind him gave him a name, a place to eat and sleep, haircuts in the summer, and an overall sense of belonging. Having seen many stray dogs in China thus far, it was moving to see a special case like this. Dorji has scars on his snout and body from rocks thrown at him by locals. Dorji is also the prototypical type of dog that's seen in cages and sold for food in the Guangxi region of China. I've never met a dog with a stronger air of grateful humility than I have in Dorji. I wish him and his human continued happiness.

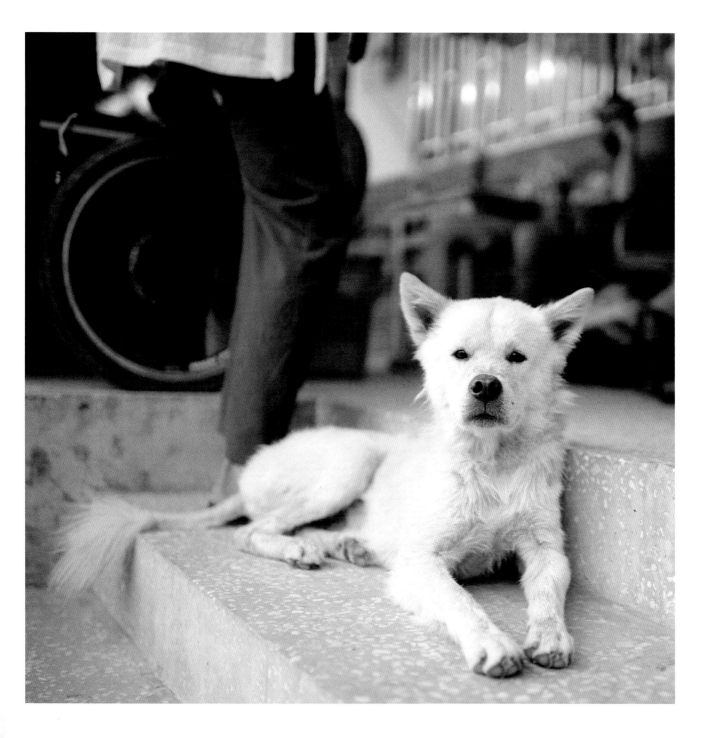

Small Breeds

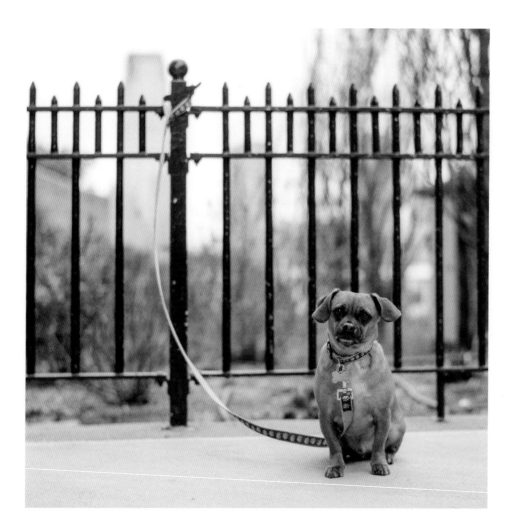

« **Elvis,** *mix*

TOP ROW, LEFT TO RIGHT

Ellie Mae, *Scottish Terrier, 8 months old;* **Chloe Kardoggian,** *Chihuahua;* **Biboune,** *Cairn Terrier, 2 years old;* **Sam,** *Pembroke Welsh Corgi, 9 months old*

SECOND ROW, LEFT TO RIGHT

Max, *Toy Poodle;* **Snowball,** *Maltese, 2 years old;* **Pepper,** *Boston Terrier, 2 years old;* **Sasha,** *Miniature Schnauzer, 2 years old*

THIRD ROW, LEFT TO RIGHT

Duke, *Pekingese, 6 years old;* **Lola,** *French Bulldog;* **Licorice,** *Dachshund;* **Quincy,** *Miniature Australian Shepherd, 18 months old*

BOTTOM ROW, LEFT TO RIGHT

Sandy, *Pomeranian;* **Blue,** *Yorkshire Terrier;* **Domino,** *Toy Poodle, 2 years old;* **Peaches,** *Pug, 2 years old*

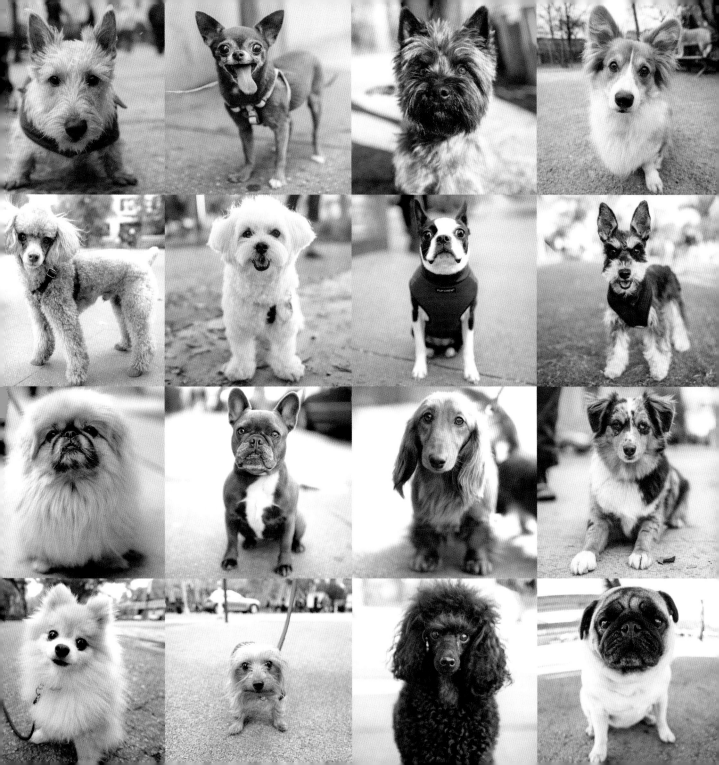

Snow

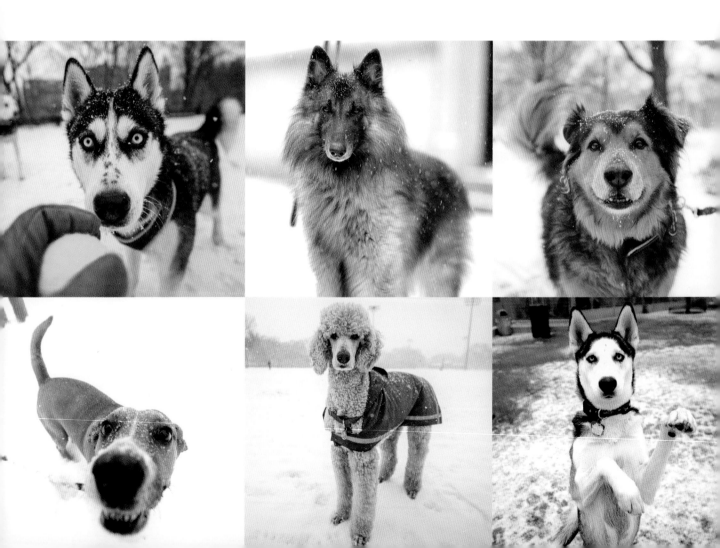

TOP ROW, LEFT TO RIGHT

Yume, *Siberian Husky, 10 months old*

Parker, *Belgian Tervuren*

Beck, *Chow Chow mix, 3 years old*

Lick, *Cavapoo*

Koukla, *Pembroke Welsh Corgi, 1 year old*

Chapel, *Australian Cattle Dog, 9 months old*

BOTTOM ROW, LEFT TO RIGHT

Argos, *Pit Bull/Basset Hound/ Beagle mix, 4 years old*

Rufus, *Standard Poodle, 5 years old*

Squirrel, *Siberian Husky*

Lille, *Bouvier des Flandres, 5 years old*

Grace, *Vizsla, 6 months old*

Rain, *Boxer*

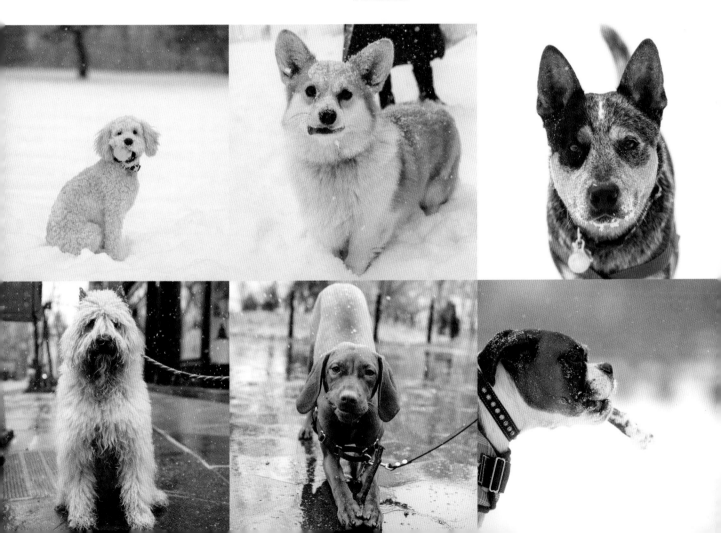

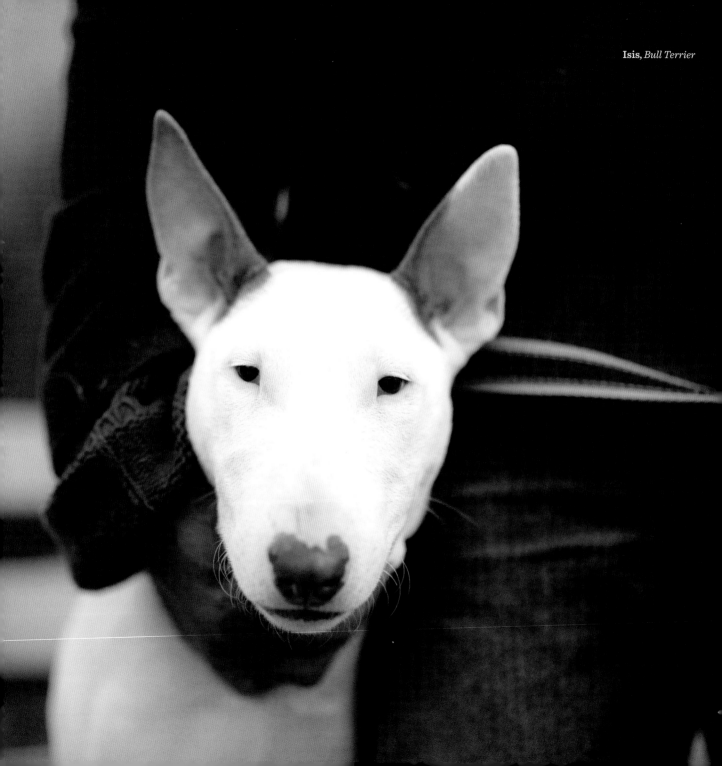

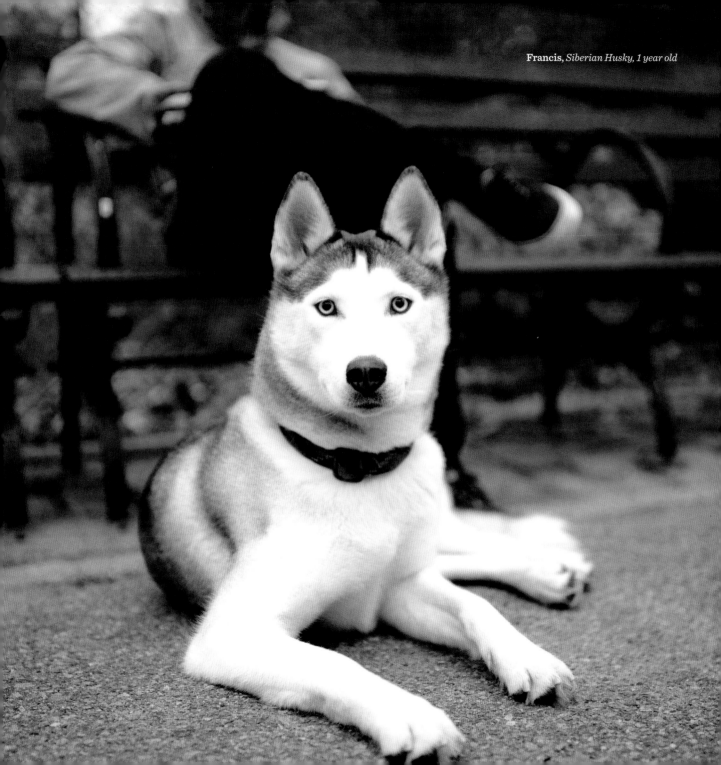

Francis, *Siberian Husky, 1 year old*

Shoes

TOP ROW, LEFT TO RIGHT

Mugs, *Boxer, 8 years old*

Ophelia, *Pit Bull/Shepherd mix*

Leo, *Pomeranian, 2 years old*

Sabrina, *Papillon, 6 years old*

Tally, *Toy Poodle, 4 years old*

BOTTOM ROW, LEFT TO RIGHT

Helo, *Berger Picard*

Archie, *Brittany, 9 years old*

Bowdie and **Clyde,** *Labrador Retrievers, 6 years old*

Lucy, *Wheaten Terrier, 4 years old*

Etta, *Greyhound*

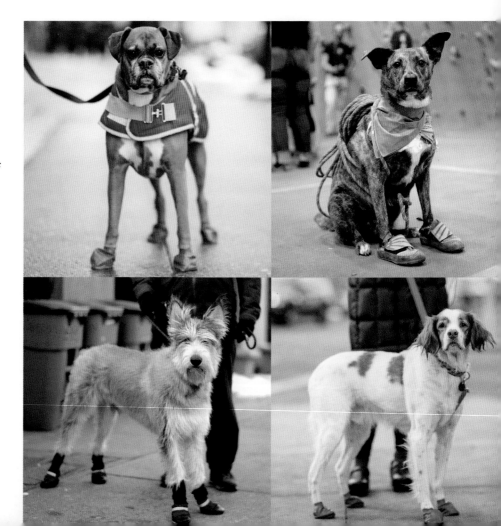

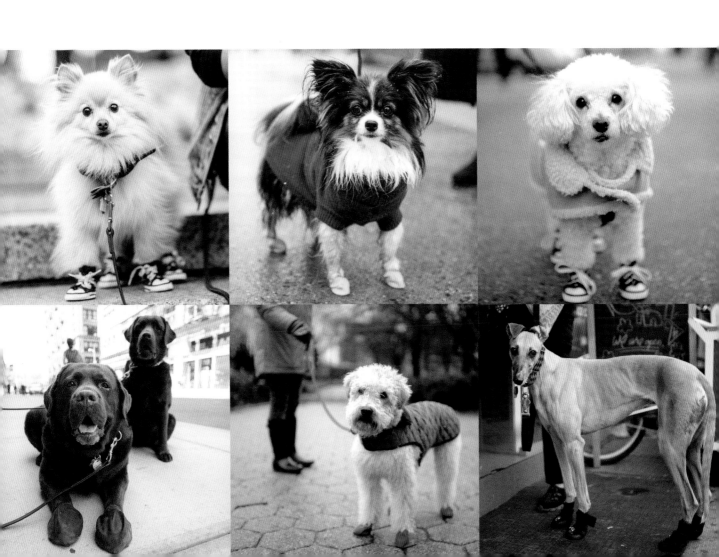

"He got loose during the Brooklyn Marathon.
We got a call that he was at the finish line."

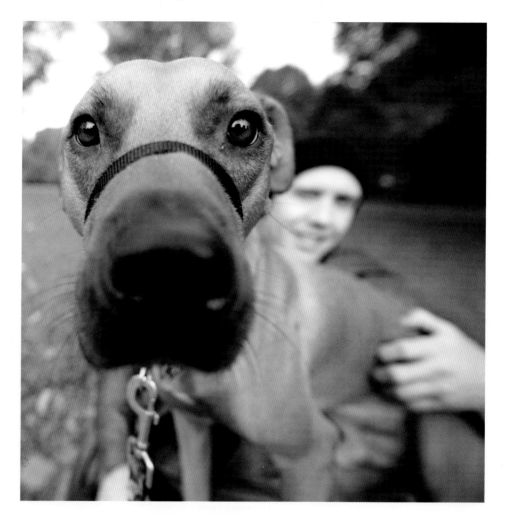

Freddy, *Rhodesian Ridgeback/Labrador Retriever mix, 2 years old*

B Boy gets walked regularly by a member of PAWS NY,

an organization that helps older New Yorkers maintain relationships with their animals.

B Boy, *Golden Retriever, 10 years old*

TOP ROW, LEFT TO RIGHT

Magnus, *Great Dane,*
5 months old

Luna, *French Bulldog,*
13 weeks old

Winger, *Flat-Coated*
Retriever, 13 weeks old

BOTTOM ROW, LEFT TO RIGHT

Buffy, *Labrador Retriever,*
4 months old

Gus, *Cocker Spaniel,*
4 months old

Dante, *Labrador Retriever,*
3 months old

Puppies

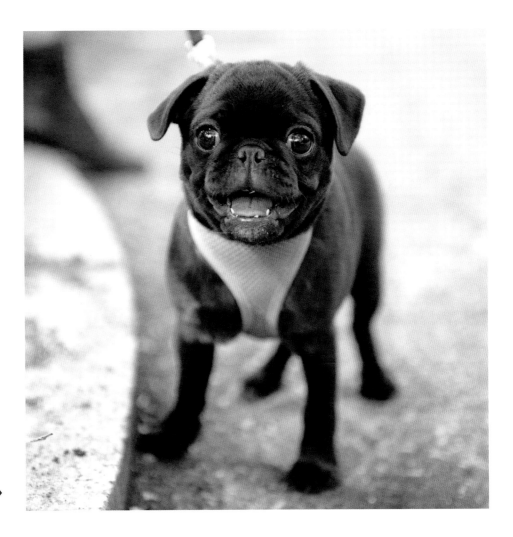

Gimlet, *Pug,* »
4 months old

Only in
New York City

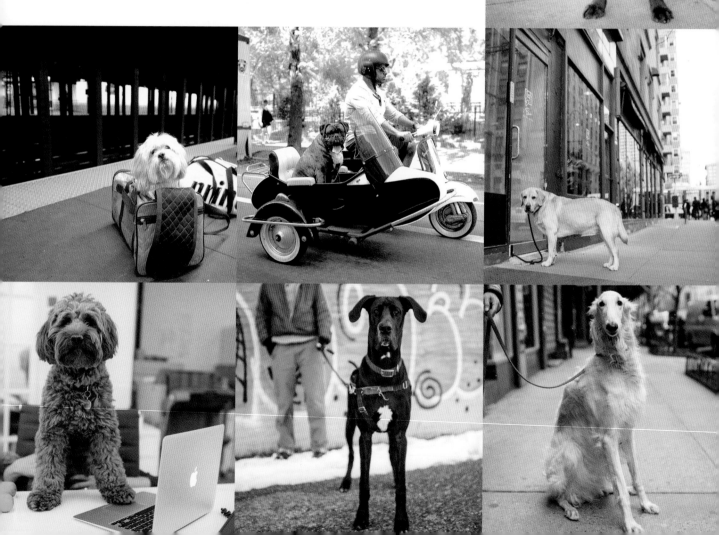

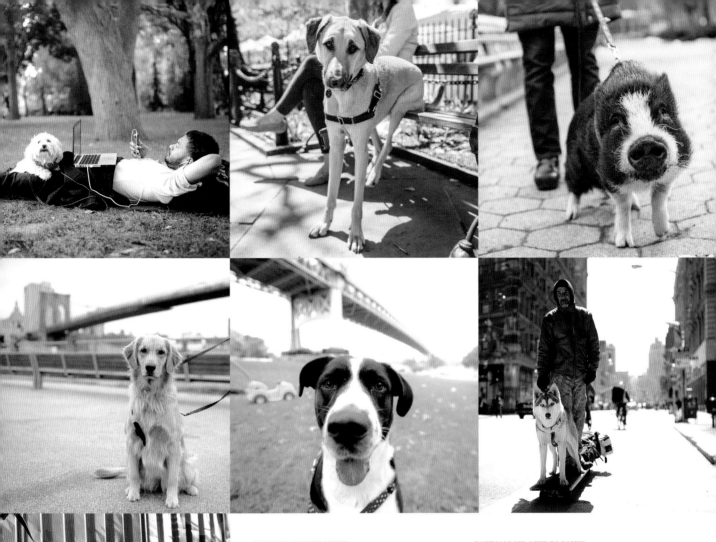

TOP ROW, LEFT TO RIGHT

Nicky, *Labrador Retriever, 11 years old;*
Nana, *Maltese mix;* **Tank,** *Afghan Hound/*
German Shepherd mix, 2 years old;
Queelin, *Potbellied Pig, 4 years old*

CENTER ROW, LEFT TO RIGHT

Poldy, *Lhasa Apso/Poodle mix;* **Boogie,** *Boxer,*
9 years old; **Oakley,** *Labrador Retriever, 5 years*
old; **Brooklyn,** *Golden Retriever, 3 years old;*
Maya, *Border Collie/Pointer mix, 5 years old;*
Leila, *Siberian Husky*

BOTTOM ROW, LEFT TO RIGHT

Norman, *Miniature Labradoodle, 18 months*
old; **Tyson,** *Great Dane, 10 months old;*
Rhett, *Borzoi, 6 years old;* **Banksy,** *Beagle*

After snapping this photo at a red light, I asked the owners what their dogs' names were. They both gave me a confused glance and started signing with their hands. They were deaf. When the light turned green, I gave them my card and gestured "e-mail me." Two days later, I received an e-mail and learned the dogs' names: Medusa and Lucy (out of frame).

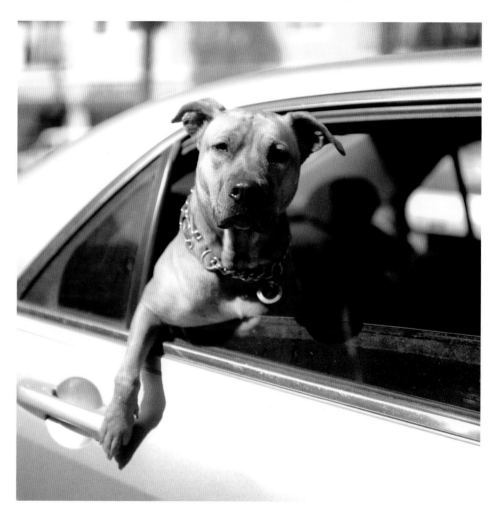

Medusa, *Pit Bull mix , Santa Monica, California*

I was told this dog's name was Juno. I later received an e-mail from the owner stating that Juno was in fact the dog's street name, and that the name she would like to include for his post—his real name—was Phil. Until then, I hadn't known that guide dogs often have false names. This allows the owner both to be polite when people ask what the dog's name is and to avoid having his or her dog distracted while on the job.

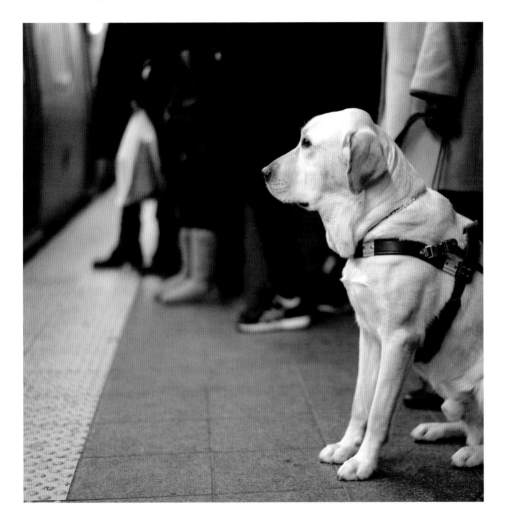

Phil, *Labrador Retriever*

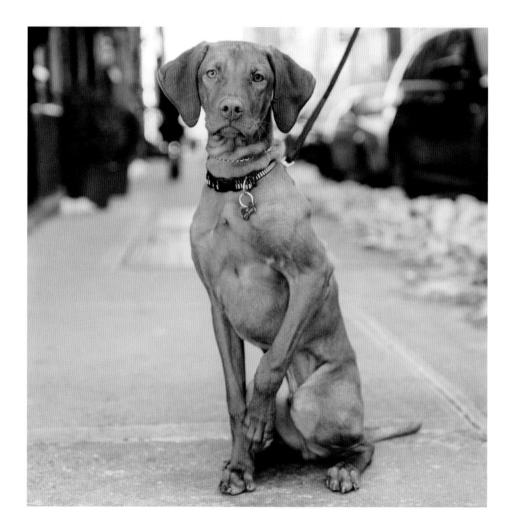

Sunny, *Vizsla, 6 months old*

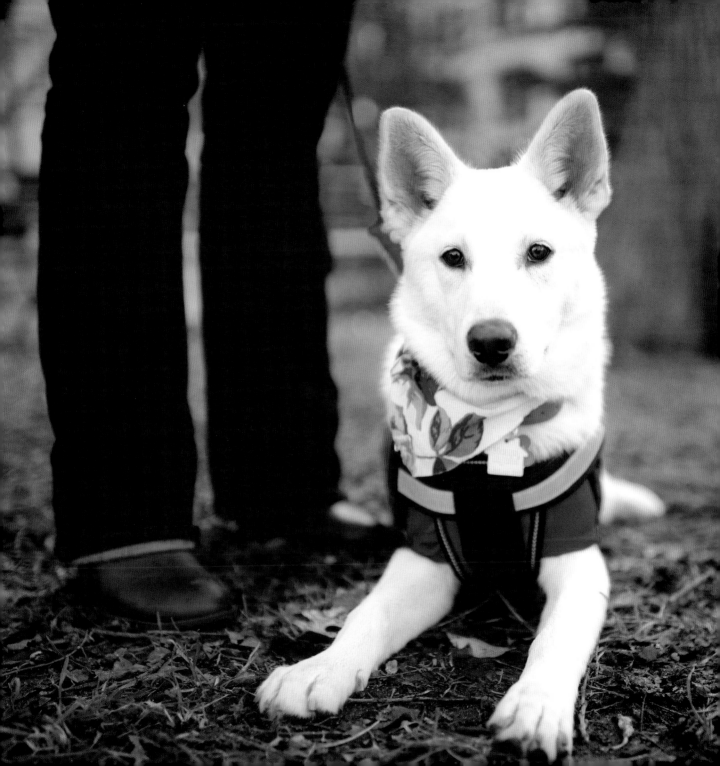

Beautiful Blends

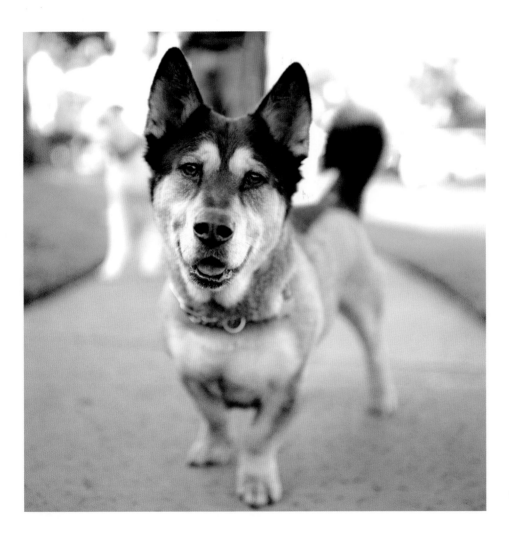

« Roscoe, *Corgi/Rottweiler/ Siberian Husky mix*

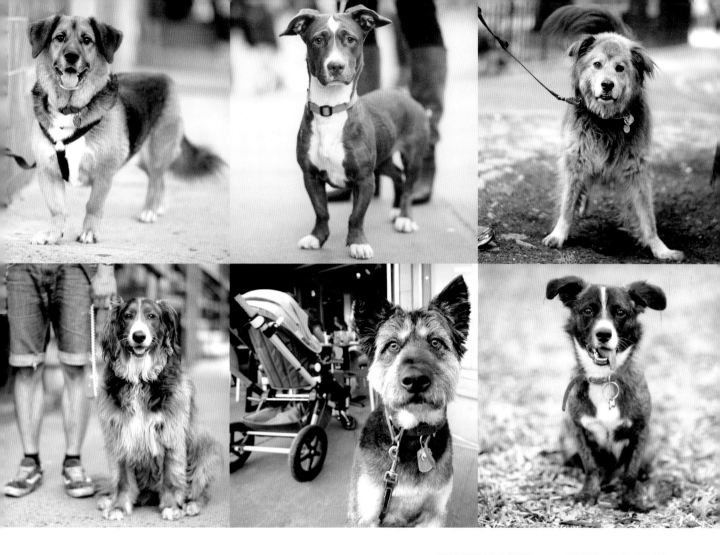

TOP ROW, LEFT TO RIGHT

Dudley, *German Shepherd/
Basset Hound mix*

Pansy, *Pit Bull/Dachshund
mix, 2 years old*

Radar, *Chow Chow mix*

BOTTOM ROW, LEFT TO RIGHT

Munchie, *Irish Red and
White Setter/Golden
Retriever mix*

Darwin, *mix*

Cooper, *Border Collie/
Dachshund mix*

Smiles

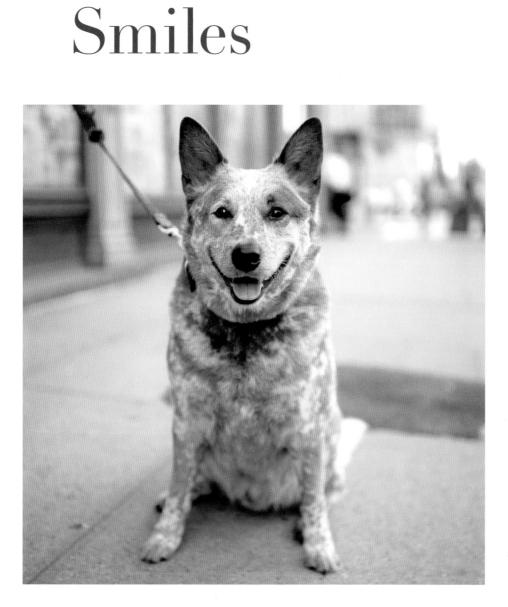

« **Spitfire,**
Australian Cattle Dog

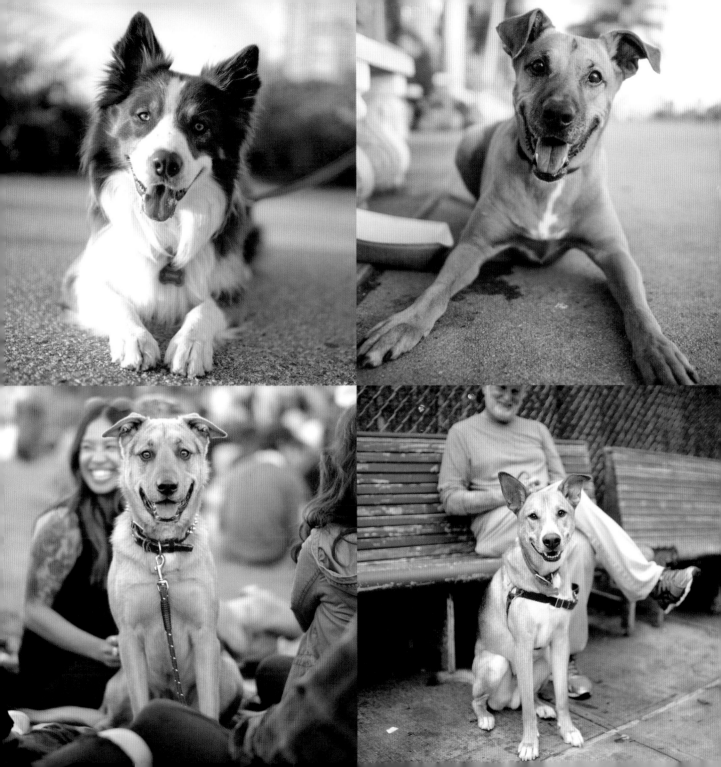

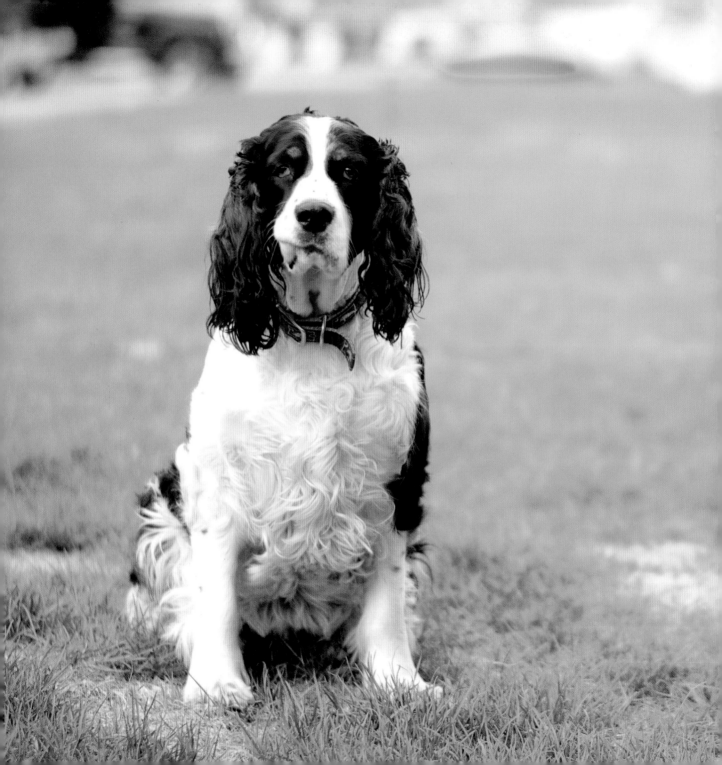

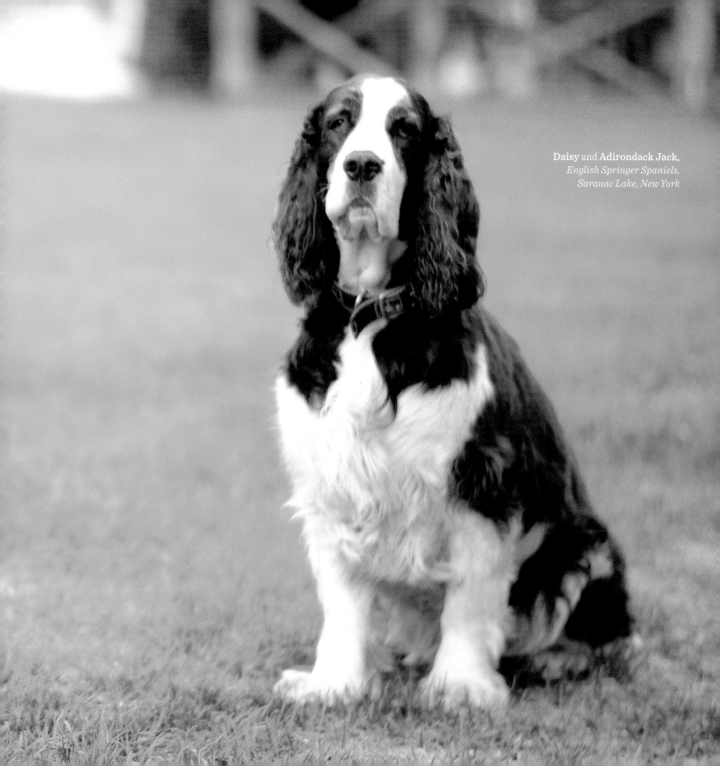

Daisy and Adirondack Jack,
English Springer Spaniels,
Saranac Lake, New York

Acknowledgments

This book, my blog, and my job would not be possible without the thousands of dogs that kindly sat for my photos. If you're sitting next to one as you read this, please give him or her a treat and a scratch behind the ears on my behalf. Thank you.

Dogs wouldn't be the fantastic creatures they are without the caring people behind them. I've had the privilege of being able to meet dogs that serve all types of roles for their owners and others around them. Thank you to the owners and caretakers for allowing me to share these stories to deepen people's understanding of and appreciation for dogs around the world.

I'm grateful to the many people and organizations that I've collaborated with to feature dogs in need of homes. The work you do is not easy, and the many rescue dogs that I get to photograph are happy and healthy because of your work.

The two people who helped me turn my crazy idea for The Dogist into a real thing are Pasquale D'Silva and Jeff Hodsdon. Pasquale never questioned the viability of my project. He knew it was insane, and that's why he backed it. He brought out my inner lunatic. Jeff, in his quiet wisdom, always had the right answer for me and had my back in each evolution of the project. A few of Jeff's photos of me at work are featured in this book as well. Cheers to you both.

I want to thank my dad for teaching me how to use a camera and instilling in me the canine sense of humor that I revel in every day. I want to thank my mom for encouraging me to do what makes me happy and fostering my entrepreneurial spirit, and for her one-of-a-kind banana bread. To my siblings, Henry and Isabel—thanks for laughing at my impersonations of Matilda, our chocolate Lab.

My friends have all been sarcastically supportive—you know who you are. To Adam, Todd, and Jordan, thanks for making room on the couch. I see many Dogist Bumps™ in your future.

Thanks to my literary agent, Janis Donnaud. She understood the true potential of my art. The experience she brought to navigating the creation of my first book has been essential.

To everyone involved at Artisan Books: The talent, efficiency, and enthusiasm you devoted to making this book was more than I could have expected. *The Dogist* is the first big step of many that I hope to share with you guys. Judy Pray, Mura Dominko, Lia Ronnen, Patrick Leonard, Allison McGeehon, Nancy Murray, Lelia Mander, Michelle Ishay-Cohen, and Renata Di Biase, I consider you all Dogists in your own right.

To the many people who have influenced my work—my past photography teachers, my favorite artists, my big eccentric family, my many fans who share in the joy of my work every day—thank you for inspiring me to search for the beauty and humor in everything I create.

Meetup in Washington Square Park
(pages 146–147)

Pepper, *Pit Bull, 5 years old;* Poopface, *Jack Russell Terrier, 9 years old;* Saarinen, *Beagle mix, 2 years old;* Pip, *Cavalier King Charles Spaniel, 7 years old;* Louis, *Scottish Terrier, 3 years old;* Hannibal, *Petit Basset Griffon Vendeen, 9 months old;* Angus, *Border Terrier, 5 months old;* Cooper, *Boston Terrier, 3 years old;* Tempest, *Whippet, 18 months old;* Murphie, *Toy Australian Shepherd, 8 months old;* Molly, *Chow Chow/Golden Retriever mix, 14 years old;* Calvin, *Labradoodle, 1 year old;* Hudson, *mix, 4 years old;* Roxy, *Goldendoodle, 6 years old;* Rooky, *Miniature Australian Shepherd/Chihuahua mix, 18 months old;* Rufus, *Catahoula Leopard Dog, 7 years old;* Oliver, *Shih Tzu/Poodle mix, 2 years old;* Bird, *Pit Bull/Beagle mix, 4 years old;* Bucky, *Pomeranian, 4 years old;* Gobi, *Dachshund/Chihuahua mix, 6 years old;* Colby, *Norfolk Terrier, 9 years old;* Gif, *Pomeranian, 2 years old;* Buckminster, *French Bulldog, 3 years old;* Berkeley, *Belgian Malinois, 2 years old;* Homer, *Dachshund, 3 years old;* Mabel, *Newfoundland, 9 months old;* Pharrell, *Border Collie, 10 months old;* Winnie, *Labrador Retriever, 2 years old;* Tucker, *Chihuahua, 1 year old;* Blue, *Bernese Mountain Dog/Spaniel mix, 8 months old;* Silver, *Schnauzer mix, 2 years old;* Dylan, *Bichon Frise, 7 years old;* Brady, *Miniature Goldendoodle, 5 years old;* Miley, *Pomeranian/Chihuahua mix, 10 years old;* Lucy Snow, *Maltese, 7 years old;*

Cami, *Pit Bull mix, 3 years old;* Briscoe, *German Wirehaired Pointer mix, 9 years old;* Luna, *Shih Tzu, 5 years old;* Audrey, *Pug, 8 years old;* Charlie, *Rottweiler, 4 years old;* Frankie, *Pit Bull, 2 years old;* Golden Lady, *French Bulldog, 6 years old;* Monkey, *French Bulldog, 1 year old;* Rosie, *Miniature Goldendoodle, 3 months old;* Fiona, *Shih Tzu, 3 years old;* Marshall, *Toy Doodle, 5 months old;* Henry, *Boston Terrier, 2 years old;* Stella, *Norfolk Terrier, 3 years old;* Rufus, *Standard Poodle, 5 years old;* Larry, *Whippet, 8 months old;* Bailey, *Chihuahua mix, 2 years old;* Cornbread, *Labrador Retriever mix, 6 years old;* Lulu, *Cavalier King Charles Spaniel, 12 years old;* Maggie, *Havanese, 10 years old;* Boomer, *Spaniel mix, 18 months old;* Wilma, *French Bulldog, 2 years old;* Mouse, *Chihuahua/Dachshund mix, 3 years old;* Missy, *Sharpei/Pug mix, 2 years old;* Tuppee, *French Bulldog, 6 years old;* Rita, *French Bulldog, 10 months old;* Louie, *Shih Tzu, 18 months old;* Hugo, *French Bulldog, 9 months old;* Yoko, *French Bulldog, 11 months old;* Hodor, *Shih Tzu, 9 months old;* Penelope, *Papillon, 1 year old;* Mila, *Pomeranian/Maltese mix, 4 years old;* Kain, *Shih Tzu/Chihuahua mix, 5 months old;* Zoe, *Beagle/Australian Shepherd mix, 5 years old;* Jessie, *Pit Bull/Boxer mix, 9 months old;* Roo, *Feist mix, 18 months old;* Fergie, *Flat-Coated Retriever, 7 years old;* Oliver, *Poodle, 1 year old*

Index

Note: All page numbers refer to captions.

Affenpinscher, 265
Afghan Hound, 92, 149, 226
Afghan Hound/German Shepherd mix, 289
Airedale Terrier, 14, 55
Akita, 138, 143
Alaskan Husky, 109, 135
Alaskan Klee Kai, 56, 58, 89, 243
Alaskan Malamute, 86, 118
Alaskan Malamute mix, 100, 253
American Bulldog/Boxer mix, 253
American Bulldog/Pit Bull mix, 82
Appenzeller/Greater Swiss Mountain Dog/
 Rottweiler mix, 26
Australian Cattle Dog, 56, 136, 171, 269, 279, 296
Australian Kelpie/Rat Terrier mix, 89
Australian Labradoodle, 182
Australian Shepherd, 24, 143, 199, 216, 231,
 253, 269, 304
Australian Shepherd mix, 56

Basenji, 200
Basset Hound, 89, 200, 216, 226, 246, 249
Basset Hound mix, 26
Beagle, 16, 39, 82, 92, 216, 261, 289
Beagle mix, 166, 301
Beagle/Australian Shepherd mix, 301
Beagle/English Pointer mix, 89
Bearded Collie, 61
Bedlington Terrier, 149
Belgian Malinois, 39, 44, 144, 210, 214, 301
Belgian Tervuren, 279
Bergamasco, 129
Berger Picard, 149, 282
Bernedoodle, 182
Bernese Mountain Dog, 17, 24, 41, 76, 118, 220
Bernese Mountain Dog/Spaniel mix, 301
Bichon Frise, 157, 301
Biewer Terrier, 246
Black Russian Terrier, 118
Bloodhound, 81, 92
Boerboel, 211
Border Collie, 56, 268, 296, 301
Border Collie mix, 226
Border Collie/Dachshund mix, 295
Border Collie/Pointer mix, 289
Border Terrier, 301

Borzoi, 64, 289
Boston Terrier, 11, 39, 130, 166, 168, 255, 269,
 276, 301
Bouvier des Flandres, 61, 279
Boxer, 30, 39, 53, 89, 105, 118, 143, 166, 197,
 246, 263, 271, 279, 282, 289
Boxer mix, 56, 82
Boxerdoodle, 182
Boxer/St. Bernard mix, 89
British Columbian Wolf, 237
Brittany, 282
Brittany/Springer Spaniel mix, 49
Brussels Griffon, 61, 255, 265
Brussels Griffon mix, 100
Bull Terrier, 103, 151, 280
Bulldog, 67, 177
Bullmastiff, 76, 91
Bullmastiff/American Bulldog mix, 81

Cairn Terrier, 105, 276
Canaan Dog mix, 62
Cane Corso, 19, 76, 118, 168, 243
Cane Corso/Pit Bull mix, 75
Catahoula Leopard Dog, 246, 301
Catahoula Leopard Dog mix, 56
Catahoula Leopard Dog/Rhodesian
 Ridgeback mix, 26
Cavalier King Charles Spaniel, 15, 89, 102, 121,
 203, 232, 255, 301
Cavapoo, 279
Chihuahua, 58, 89, 162, 191, 226, 276, 301
Chihuahua mix, 126, 226, 265, 301
Chihuahua/Dachshund mix, 301
Chihuahua/Jack Russell Terrier mix, 172
Chiweenie (Chihuahua/Dachshund mix), 255
Chow Chow, 138, 155
Chow Chow mix, 279, 295
Chow Chow/Golden Retriever mix, 26, 301
Cocker Spaniel, 56, 110, 189, 286
Collie, 251
Collie/Alaskan Malamute mix, 26
Collie/Shiba Inu mix, 26
Coonhound mix, 219
Corgi/Rottweiler/Siberian Husky mix, 294

Dachshund, 89, 102, 166, 180, 213, 220, 255,
 272, 276, 301
Dachshund/Chihuahua mix, 301

Dachshund/Corgi/Jack Russell Terrier mix, 100
Dalmation, 65, 240
Dingo mix, 231
Doberman Pinscher, 143, 174, 200
Dogue de Bordeaux, 118, 189, 220
Doodle, 37, 182
Dutch Shepherd/Staffordshire Bull Terrier
 Mix, 95

Eastern Gray Squirrel, 126
English Bulldog, 58, 89, 105, 130, 176, 189, 199,
 203, 207, 216, 269
English Pointer, 68, 71
English Setter, 68, 195, 216
English Springer Spaniel, 261, 299

Feist mix, 301
Field Spaniel, 39
Flat-Coated Retriever, 286, 301
Formosan Mountain Dog, 149
Foxhound mix, 82
French Bulldog, 16, 19, 58, 89, 99, 105, 107, 111,
 126, 130, 143, 150, 170, 172, 184, 193, 200,
 220, 231, 243, 248, 253, 265, 276, 286, 301

German Pinscher, 126, 180, 246
German Shepherd, 39, 43, 44, 47, 105, 143, 163,
 200, 216, 220, 269, 292
German Shepherd mix, 246
German Shepherd/Basset Hound mix, 295
German Shepherd/Collie mix, 26
German Shepherd/Labrador Retriever mix,
 26, 75, 100
German Shepherd/Labrador Retriever/
 Siberian Husky mix, 26
German Shepherd/Shiba Inu mix, 100
German Shorthaired Pointer, 91, 105, 168,
 195, 246
German Shorthaired Pointer mix, 258
German Shorthaired Pointer/Dalmation
 mix, 100
German Shorthaired Pointer/Labrador
 Retriever mix, 26
German Wirehaired Pointer mix, 301
Glen of Imaal Terrier, 149
Golden Retriever, 30, 39, 49, 58, 85, 99, 105,
 114, 136, 140, 155, 189, 220, 256, 285, 289
Golden Retriever mix, 193

Golden Retriever/Hovawart mix, 39, 136
Goldendoodle, 23, 89, 124, 182, 203, 246, 301
Great Dane, 76, 92, 105, 118, 189, 202, 216, 226,
 286, 289
Great Dane/Weimaraner/Mastiff mix, 56
Great Pyrenees, 226
Greater Swiss Mountain Dog, 13, 118
Greyhound, 226, 282

Havanese, 61, 89, 301
Hound mix, 82, 216
Hovawart, 149

Ibizan Hound, 31, 39, 55
Irish Red and White Setter, 92
Irish Red and White Setter/Golden Retriever
 mix, 295
Irish Setter, 43, 58
Irish Water Spaniel, 124
Italian Greyhound, 164, 180, 255

Jack Russell Terrier, 216, 220, 301
Jack Russell Terrier mix, 75
Japanese Chin, 180
Japanese Spitz, 51

Keeshond, 39
Kerry Blue Terrier, 214
Kleine Münsterländer, 17, 152
Komondor, 91

Labradoodle, 41, 49, 61, 105, 124, 143, 182, 192,
 231, 232, 301
Labrador Retriever, 7, 44, 47, 58, 79, 81, 82, 89,
 113, 130, 136, 143, 155, 189, 197, 216, 226,
 234, 246, 256, 282, 286, 289, 291, 301
Labrador Retriever mix, 58, 82, 156, 168, 301
Labrador Retriever/Border Collie mix, 75
Labrador Retriever/Hound mix, 73
Labrador Retriever/Jack Russell Terrier mix, 100
Labrador Retriever/Rottweiler/Bluetick
 Coonhound mix, 113
Labrador Retriever/Siberian Husky mix, 58
Lhasa Apso, 124, 204
Lhasa Apso/Poodle mix, 289
Longhaired Chihuahua, 243

Maltese, 49, 157, 166, 190, 246, 265, 276, 301
Maltese mix, 289
Maltese/Yorkshire Terrier mix, 89
Manchester Terrier, 164
Miniature Australian Shepherd, 168, 189, 276
Miniature Australian Shepherd/Chihuahua
 mix, 301
Miniature Goldendoodle, 162, 182, 203, 301
Miniature Labradoodle, 155, 182, 289
Miniature Pinscher, 164, 166
Miniature Pinscher mix, 55
Miniature Pinscher/Boston Terrier mix, 26
Miniature Poodle, 124, 158, 180
Miniature St. Berdoodle, 182

Miniature Schnauzer, 105, 130, 276
Morkie (Maltese/Yorkshire Terrier mix), 180

Neapolitan Mastiff, 76, 92
Newfoundland, 118, 216, 301
Norfolk Terrier, 301
Nova Scotia Duck Tolling Retriever, 58, 87,
 105, 136, 256

Old English Sheepdog, 92

Papillon, 200, 255, 282, 301
Pekingese, 276
Pembroke Welsh Corgi, 24, 126, 143, 200, 246,
 276, 279
Perro de Presa Canario/Pit Bull mix, 118
Peruvian Inca Orchid, 149
Petit Basset Griffon Vendeen, 301
Pink Hen, 89
Pit Bull, 32, 34, 58, 82, 89, 97, 107, 117, 161, 166,
 168, 189, 220, 225, 231, 253, 258, 301
Pit Bull mix, 82, 89, 172, 224, 269, 290, 301
Pit Bull/American Bulldog/Whippet mix, 246
Pit Bull/Basset Hound/Beagle mix, 279
Pit Bull/Beagle mix, 301
Pit Bull/Boxer mix. 56, 185, 246, 301
Pit Bull/Dachshund mix, 295
Pit Bull/Golden Retriever mix, 231
Pit Bull/Great Dane mix, 87
Pit Bull/Heeler mix, 246
Pit Bull/Labrador Retriever mix, 168
Pit Bull/Labrador Retriever/Boston Terrier
 mix, 189, 265
Pit Bull/Shepherd mix, 282
Pit Bull/Terrier mix, 171
Polish Lowland Sheepdog, 149
Pomeranian, 29, 126, 143, 157, 231, 276, 282, 301
Pomeranian mix, 124
Pomeranian/American Eskimo Dog mix, 192
Pomeranian/Chihuahua mix, 301
Pomeranian/Maltese mix, 301
Poodle, 301
Poodle mix, 222, 223
Poodle/Lhasa Apso mix, 265
Portuguese Water Dog, 61, 91
Potbellied Pig, 289
Pug, 39, 105, 255, 276, 287, 301
Puli, 149

Redbone Coonhound, 92, 216
Rhodesian Ridgeback, 164, 180
Rhodesian Ridgeback mix, 246
Rhodesian Ridgeback/Boxer mix, 296
Rhodesian Ridgeback/Labrador Retriever
 mix, 284
Rottweiler, 24, 108, 114, 172, 253, 301
Rottweiler/Rhodesian Ridgeback/Pit Bull
 mix, 100

St. Bernard, 86, 246
St. Bernard/Collie mix, 100

Samoyed, 103, 253
Schnauzer mix, 301
Schnorkie (Miniature Schnauzer/Yorkshire
 Terrier mix), 166
Scottish Deerhound, 149, 231
Scottish Terrier, 143, 255, 276, 301
Sealyham Terrier, 149
Senegal Parrot, 107
Shar Pei, 180, 229
Sharpei/Pug mix, 301
Sheepadoodle, 182
Shepherd mix, 49, 187, 296
Shetland Sheepdog, 157, 251
Shiba Inu, 39, 110, 123, 168, 189, 203, 204
Shih Tzu, 12, 81, 130, 157, 255, 301
Shih Tzu mix, 123
Shih Tzu/Bichon Frise mix, 89
Shih Tzu/Chihuahua mix, 301
Shih Tzu/Poodle mix, 301
Shih Tzu/Yorkshire Terrier mix, 155
Shilo Shepherd, 246
Siberian Husky, 55, 56, 81, 97, 105, 126, 133,
 145, 168, 231, 267, 279, 281, 289
Siberian Husky/Labrador Retriever mix, 100
Silver Lab (Labrador Retriever/Weimaraner
 mix), 99, 256
Spaniel mix, 301
Spanish Shepherd/Labrador Retriever mix,
 216
Spitz/Pomeranian mix, 174
Staffordshire Bull Terrier, 126
Staffordshire Bull Terrier/White Shepherd
 mix, 84
Standard Poodle, 105, 124, 179, 229, 232, 243,
 279, 301
Standard Schnauzer, 61

Tamaskan, 149
Terrier mix, 82, 89, 170, 244
Terrier/Poodle mix, 263
Thai Ridgeback, 149
Tibetan Mastiff, 92
Timber Wolf, 237, 238
Toy Australian Shepherd, 301
Toy Doodle, 301
Toy Poodle, 166, 265, 276, 282
Treeing Walker Coonhound, 219

Vizsla, 21, 189, 240, 246, 279, 292

Weimaraner, 24, 56, 129, 166
Welsh Terrier, 255
West Highland White Terrier, 91, 105, 162,
 255
Wheaten Terrier, 61, 89, 105, 226, 282
Whippet, 92, 121, 126, 166, 269, 301
Wirehaired Pointing Griffon, 231

Yorkshire Terrier, 89, 157, 166, 180, 243, 246,
 263, 265, 276
Yorkshire Terrier/Shih Tzu mix, 190

Flash (aka The Booty),
Australian Shepherd